THE

American Tintype

THE
American

FLOYD RINHART, MARION RINHART
& ROBERT W. WAGNER

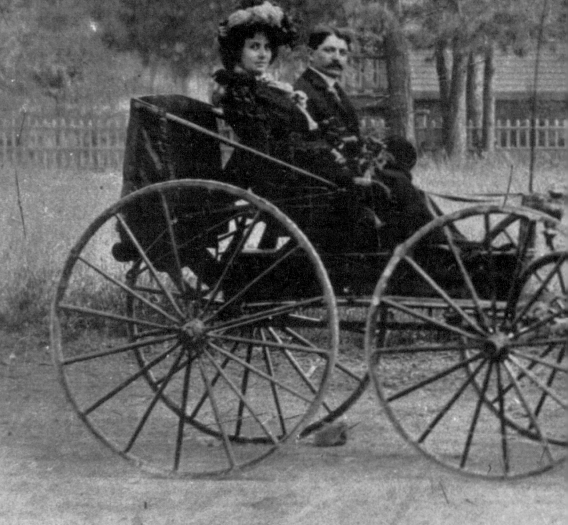

Tintype

 OHIO STATE UNIVERSITY PRESS / COLUMBUS

Publication of this book has been aided by a grant from Furthermore,
the publication program of The J. M. Kaplan Fund.

LIBRARY OF CONGRESS CATALOGING-IN-PUBLICATION DATA

Rinhart, Floyd.
The American tintype / Floyd Rinhart, Marion Rinhart, and Robert W. Wagner.
p. cm.
Includes bibliographical references and index.

ISBN 0–8142–0806–1 (cloth : alk. paper)

1. Tintype—United States—History—19th century. 2. Photography—United
States—History—19th century. I. Rinhart, Marion. II. Wagner, Robert W.
III. Title.

TR375.R56 1999
772'.14'097309034—dc21 98–49828
 CIP

Text and jacket design by Diane Gleba Hall.
Type set in Monotype Bulmer by The Art Dept.
Printed by Thomson-Shore.

9 8 7 6 5 4 3 2 1

CONTENTS

~

FOREWORD

ON February 17, 1996, the individuals who were gathered in my living room were very serious indeed about the American tintype and among the most knowledgeable in the world on its history.

Floyd and Marion Rinhart, photographic collectors and authors whose many books include *American Daguerreian Art, America's Affluent Age, American Miniature Case Art,* and *The American Daguerreotype* (one of the standards in the field) had stopped by, as they frequently did when they were living in Athens and doing research in the University of Georgia Library. Robert W. Wagner, formerly chair of the Department of Photography and Cinema at The Ohio State University, had come down from Columbus, bringing along videographers John and Jean McClintock to document our discussion. As we sat around looking at images and talking, the conversation ranged over the Civil War, politics, immigrants from all over the world, the Wild West, Indians, outlaws, mining camps, tent meetings, families and children, the latest fashions, vacations in the mountains, visits to the boardwalk, and of course, those risqué bathing suits. Indeed, as you look at a collection of tintypes you see the people and activities that were important in American life in the last half of the nineteenth century.

Having the opportunity to know and work with the authors of *The American Tintype* and to see and study their collections has been not just an honor but a rare privilege. They always shared information freely and answered hundreds of questions on the minutest of details with sound

scholarship and good humor. But more than that, they conveyed a passionate love for and understanding of the importance of the tintype. Perhaps we have not thought much of the tintype in the past, but through this new volume readers can gain greater knowledge of the process and its role in photographic history and can gain insight into who we are today as revealed by those unique images we know as tintypes.

It is particularly fitting that Ohio State University Press has published the definitive book on the tintype. For one thing, the American tintype originated in Ohio. In addition, the outstanding Floyd and Marion Rinhart Collection of Daguerreian Art and Other Rare Photographic Images is housed at the Ohio State University Library, and Robert Wagner is an emeritus professor at that university.

The American Tintype fills a void long recognized by scholars, educators, and collectors, for there has been no comprehensive book on the tintype. Most texts on the history of photography have included a few paragraphs on the inventors of the process and its use for casual pictures. The few examples shown were usually uninspired portraits or caricatures of two or three friends who went to town, got drunk, and had their tintype made. The overall impression was that it was readily available and quick and served as cheap, impulsive entertainment. While all of this has some basis in fact—the use of the multiplying camera and its "six views for a quarter" certainly made the images far less precious in comparison to paintings and the recent daguerreotypes—the truth is that no one bothered to look seriously at the tintype. The tintype took on a common character of little value, which carried over into subsequent literature and scholarship.

For many years we have evaluated the tintype on the basis of what it is not. The Rinharts, however, did not come to the study of the tintype by way of the traditions, and perhaps limitations, of formal academic scholarship and therefore brought a fresh perspective to the tintype, seeing it as the visual record of the American scene in the second half of the nineteenth century. They looked at the tintype and enjoyed it for what it was—not for what it never attempted to be. For them, the tintype was an art form unto itself and deserved to be evaluated on its own merits. While their approach to the tintype as an art form was highly refreshing in outlook, their research into the history of the process and its development, along with that of Professor Wagner, was conducted with the utmost scholarly concern for finding and evaluating long-forgotten original source material.

In this effort they were highly successful, and in their book they have clearly, carefully, and thoroughly documented the history of the tintype.

While all of this is of great significance, it is the combining of the facts and putting them into a human context of a specific time and place which gives us new and valuable insights into the importance of the tintype. This book provides the basis for developing an understanding of the hundreds of thousands of visual records of a vital period in the history of our country.

During the time the tintype was popular, our nation became hopelessly divided, fought one of the bloodiest wars in modern history, and then went through the difficult process of healing, eventually emerging as a world power. The people we see in the tintype were the ones who fought the Civil War or mourned the loss of husbands, fathers, and lovers. They were the girls who were longed for by the young men off seeking their fortune. These mothers loved the children in their arms, and the men were the ones who tamed the West. These were the men and women who developed the ways of work and play that became the Victorian era. The American scene at the turn of the century and the fiercely independent and colorful individuals who made up this country were recorded openly, honestly, and in great numbers by the tintype.

The tintype process lacked the inherently aesthetic quality of the daguerreotype, but it had characteristics that permitted a physical intimacy no other process provided. It has also proven to be practically indestructible. It is lightweight; it does not break, tear, or fade; and it can withstand rough handling. Perhaps it was not elegant, but it was practical, readily available, and cheap. On the most basic level, people like having their picture taken. It is a way of saying "This is me, this is the way I looked during the war, at Atlantic City, or with my first child." It is a question of ego, and the tintype made it possible for everyone to indulge their ego for a quarter. Fortunately for us today, having your tintype made was "the" fad of the era. And maybe it was because it was not taken too seriously that the people being photographed relaxed a bit and let others see them in a more personal or informal way—the way they were at the time. There must be something about the tintype that makes it hard to throw away. For once again the ego has won out, and now over a hundred years later we still have the record of those moments in the lives of friends, family, drunks, lovers, and losers who had a moment captured in time.

The authors of this book have also given us a detailed account of the tintype studio and what it was like to have your picture taken. We are

shown the world of the tintype and become involved in the process, as both an observer and a participant. From their account, we can begin to understand the difficulties of lighting, backgrounds, props, posing, and exposure the tintype artist faced. They also give us the feeling of preparing the wet plate, sensitizing it, making the exposure, developing it, placing it in its folder, and proudly delivering it to the eagerly waiting customer.

And then there are the illustrations themselves, a diverse collection that has never been published before. Part 1 has pictures illustrating the personalities and history of the process; part 2 provides a series of images arranged according to the theme of a Victorian family album. One section focuses on the tintype in a "man's world," another on a "woman's world"; there are sections on children, vacations, group portraits, and even fakes and forgeries. With this broad selection we are provided with enough excellent examples to make informed and critical judgments about the tintype and its important role in photographic history.

As is the tradition with other books by the Rinharts, the biographies of practitioners of the art provide a welcome addition for all students, scholars, and collectors. This specialized information is augmented with notes on sizes, plate makers, patents, and other technical data.

Each of the authors of this volume has made a distinct contribution. Floyd and Marion Rinhart have stated the importance of the tintype as a unique art form and its role in photographic history, particularly in the way it gave visual form to our social, political, and personal heritage, our customs and traditions. Bob Wagner brought to this project the keen insight and experience of the creative photographer, film maker, scholar, and writer.

For a quarter of a century, Floyd and Marion uncovered and compiled an extensive body of material, and they continued to open new avenues of inquiry. But the time had come to bring the story of the tintype to a close so it could serve as a reference point for future generations of researchers in the field. With Floyd's failing health, Bob took over the project and has brought to completion this magnificent volume, a fine example of creative collaboration. The authors have successfully explored, defined, and presented this significant but previously underrecognized and under-acknowledged phenomenon: the American tintype.

W. ROBERT NIX

ACKNOWLEDGMENTS

THE authors are deeply indebted to The Ohio State University and to Lucy S. Caswell, Curator of the Floyd and Marion Rinhart Collection. We also wish to express our gratitude to the University of Georgia Library staff, especially to Professors W. Robert Nix and Wiley Sanderson of the university's Department of Art, for their help in researching this project.

At Kenyon College, the place where the American tintype had its beginning, the archivist Thomas B. Greenslade and Professor Thomas Greenslade Jr. contributed their interest and expertise to help illuminate the early history of the melainotype. Among those who permitted photographs from their collections to be reproduced here are Evelyn Bradway, Lakewood, N.J.; Mark Burnett, Westerville, Ohio; Robert Cauthen, Leesburg, Fla.; Frank Dimauro, Patterson, N.C.; J. C. King, Albuquerque, N.Mex.; Norman Mintz, N.Y.; George Moss, Rumson, N.J.; Levon Register, Athens, Ga.; Grant Romer, International Museum of Photography and Film, Rochester, N.Y.; Jane Sanders, Lexington, Ga.; Bruce Sobel, Columbus, Ohio; George Whiteley IV, Atlanta, Ga.; John Wood, Lake Charles, La.; John and Janet Waldsmith, Medina, Ohio; and Michael Williams, Columbus, Ohio. We especially thank George Rinhart for allowing us to photograph examples from his excellent collection of historical images. The late Beaumont Newhall offered us well-documented tintypes of his mother, Alice Lillia Davis (Mrs. Herbert W. Newhall). We have also included some family tintypes: the Nodwell sisters (Elizabeth Nodwell

was Floyd Rinhart's mother); Marion Rinhart's father, Harry Kelly Hutchinson; her paternal grandparents, Addison and Harriet Hutchinson; and her maternal grandfather, William Gifford.

We are particularly indebted to Jennifer Songster, who worked with us as a graduate student and later as curator of audiovisuals at the Ohio Historical Society, for her reading of the manuscript. John and Jean McClintock and Carolyn Huddle also unselfishly contributed their time to this project. For their expert computer assistance we thank Jeffrey A. Wagner and Dr. James D. Bowers.

For their professional assistance both in visits to their offices and by phone we thank Grant Romer, director of Conservation and Museum Services at the Eastman House International Museum of Photography and Film, Rochester; Linda Ayres, director of the Prints and Photographs Division of the Library of Congress, Washington, D.C.; and Carol Johnson, assistant curator. Our appreciation also goes to Barbara Hanrahan, director of the Ohio State University Press; Ruth Melville, managing editor; John Delaine, production manager; and copy editor Nancy R. Woodington, whose perceptions and suggestions contributed to this book.

All illustrations neither attributed nor identified by owner are from the Floyd and Marion Rinhart Collection at The Ohio State University.

A NOTE ON TERMS USED

IN THIS BOOK

MELAINOTYPE Hamilton Smith and Peter Neff Jr. used this term to describe their japanned iron plates, many of which had this name stamped on the edge of the plate. If an image reproduced in this book is known to have been made on one of Neff's plates, it is identified as a melainotype.

FERROTYPE Victor Griswold adopted this term for his japanned iron plates, some of which had the term impressed on the edge. When an image reproduced in this book is known to have been made on one of Griswold's plates, it is identified as a ferrotype. The term had been used earlier by the Englishman Robert Hunt to describe his collodion process. Later, a sheet of highly polished metal on which wet paper prints were dried to give them a glossy surface was also known as a ferrotype plate.

TINTYPE All the images in this book not identified as melainotypes or ferrotypes are referred to as tintypes—a term which quickly came into popular use in America to describe all photographs on metal plates.

TINTYPISTS Photographers who used Neff's plates often specifically advertised their products as melainotypes. Those who used Griswold's plates sometimes referred to themselves as ferrotypists. In this book the term tintypist is used to describe all makers of photographs on metal plates.

PART I

The History and the Process

Chapter 1

PREFACE TO THE TINTYPE

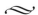

THERE is no tin in a tintype. It is a photograph on a thin iron plate. Curiously, in view of its wide use, the word is absent—or barely mentioned—in many standard reference works.[1] Tintypes were first known as "melainotypes" or "ferrotypes," but "tintype" became the most common term for this uniquely American form of photography. It even figures in a slang expression. The photohistorian Robert Taft concluded: "Just when it was introduced or by whom, I am unable to say—probably some unknown Artemus Ward began using it and the custom rapidly spread, for the phrase, 'not on your tintype' is almost as old as the patent itself."[2] The tintype, like today's ID photo, was considered proof positive of one's identity, or at least existence, and "not on your tintype" served as a particularly emphatic negative. William Gropper used the expression as the title for a series of satirical cartoons in *Vanity Fair* (1935) illustrating "some more unlikely historical situations."

Even after it became archaic, the expression continued to be found in literature, on stage, and on the screen. In 1915 a two-reel Keystone comedy directed by Roscoe (Fatty) Arbuckle was titled *Fido's Tintype Triangle*. Early motion pictures were referred to as "galloping tintypes" in Harry Lee Wilson's novel *Merton of the Movies,* which was made into a silent film in 1924. James Card, in his personal history of the silent film, also recalled that "many who went regularly to the predialogue film" called them "galloping tintypes."[3] "Not on your tintype!" was used both in the film ver-

1. *Webster's New World Dictionary of the American Language,* 2d college ed. (1986), describes the tintype as "an old kind of photograph taken directly as a positive print on a sensitized plate of enameled tin or iron; ferrotype." A recent search of The Ohio State University Library's on-line library catalogue produced three references under "tintype": Edward M. Estabrooke, *The Ferrotype, and How to Make It* (Cincinnati: Gatchel & Hyatt, 1872); Robert Sobieszek, ed., *The Collodion Process and the Ferrotype: Three Accounts, 1854–1872* (New York: Arno Press, 1973), a reprint of A. K. Trask's *Practical Ferrotyper* (1872); and a description of the Floyd and Marion Rinhart Collection of Daguerreian Art and Other Rare Photographic Images, which, with its more than five hundred tintypes, is the source of most of the illustrations in this book.
2. Robert Taft, *Photography and the American Scene* (New York: Dover, 1964), 157.
3. James Card, *Seductive Cinema: The Art of the Silent Film* (New York: Alfred A. Knopf, 1994), 4.

3

William Gropper, satirical painter and cartoonist, in *Vanity Fair*, November 1935, p. 45. Also see Thomas Craven, ed., *Cartoon Cavalcade*, Peoples Book Club ed. (Chicago: Consolidated Book Publishers, 1945), 270. Publishers in the mid-1930s and mid-1940s apparently found the expression "Not on your tintype" an appropriate and understandable headline for Gropper's cartoons.

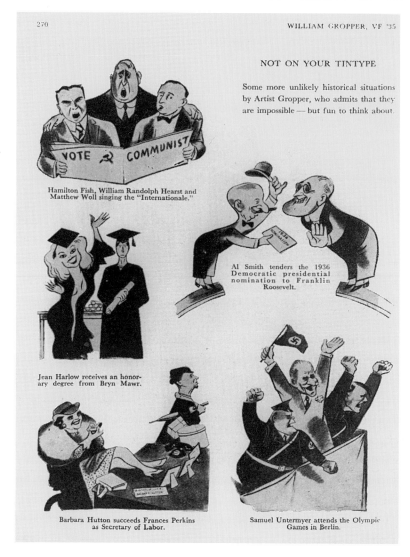

270 WILLIAM GROPPER, VF '35

NOT ON YOUR TINTYPE

Some more unlikely historical situations by Artist Gropper, who admits that they are impossible — but fun to think about.

Hamilton Fish, William Randolph Hearst and Matthew Woll singing the "Internationale."

Al Smith tenders the 1936 Democratic presidential nomination to Franklin Roosevelt.

Jean Harlow receives an honorary degree from Bryn Mawr.

Barbara Hutton succeeds Frances Perkins as Secretary of Labor.

Samuel Untermyer attends the Olympic Games in Berlin.

sion of *Little Lord Fauntleroy* (1936) and in the Broadway play and highly successful film *The Music Man* (1962), whose setting was "River City, Iowa" in 1912. Confident that its readers would understand, *Time* magazine in December 1944 headlined a review of contemporary art: "Is modern art revolutionary? Not on your tintype!"

* * *

THE early centers of photography were Paris, London, New York, Boston, and Philadelphia, but the tintype found its place in the history of photography in two small Ohio towns—Gambier, the site of Kenyon College, and Lancaster, the birthplace of General William Tecumseh Sherman.

Competition between the plate manufacturers Peter Neff Jr. of Gambier and Victor Griswold of Lancaster led to patent disputes and a bitter commercial rivalry referred to in contemporary issues of *Humphrey's Journal* and the *American Journal of Photography* (1859–60) as "The War of the Roses"—a reference to the fifteenth-century struggle for the English throne between the houses of Lancaster and York. The English resolved their dispute with a marriage resulting in the Tudor dynasty, but there was no such reconciliation between the houses of the two Ohio pioneers of the tintype.

Established photographers held the tintype in low esteem. Photohistorians generally viewed it with a disregard bordering on contempt. Taft, for example, while acknowledging its significance in the history of American photography, said that the tintype did "not equal a good daguerreotype, ambrotype, or paper print. The 'whites' are usually gray, which gives the picture a cold, dull appearance, and the range of contrasts is not great. By far the most satisfactory of the tintypes is that made on brown japanned iron."[4] Lee Witkin and Barbara London, in *The Photograph Collector's Guide* (1979), describe tintypes as "cheap, sturdy, and quick to produce, though usually of poorer image quality than the ambrotype."[5] In his 1982 edition of *The History of Photography,* Beaumont Newhall dismissed the tintype as "a process [which] lingered in the backwaters of photography as a direct descendant of the daguerreotype." He added, "Tintyping was usually casual; when the results have charm it is due to the lack of sophistication and to the naive directness characteristic of folk art."[6]

Besides "curious," the second descriptive term of choice for the tintype, melainotype, or ferrotype is "charming." W. Heighway, in his column in the March 1881 issue of *Practical Photographer,* was one of the first to observe: "There is a particular charm about the ferrotype, all its own, which is gaining recognition very rapidly among us. It has been the fashion to sneer at the pictures on iron, but just as similar objections raised to carte-de-visites [*sic*] have been abandoned by dilettantes of art, so will those urged against the ferrotype be less loudly, and less confidently uttered ere long."

The Cleveland photographer James F. Ryder, in his book *Voightlander and I: In Pursuit of Shadow Catching* (1902), wrote that "the so-called tintype which, in turn, superseded the picture upon glass, has shown wonderful vitality," and predicted that "pleasure resorts without them

4. Taft, *Photography and the American Scene,* 163.

5. Lee D. Witkin and Barbara London, *The Photograph Collector's Guide* (Boston: New York Graphic Society, 1970), 44.

6. Beaumont Newhall, *The History of Photography* (New York: Museum of Modern Art, 1982), 63–64.

7. James F. Ryder, *Voightlander and I: In Pursuit of Shadow Catching* (Cleveland: Cleveland Printing and Publishing Co., 1902), 126.
8. Arthur Goldsmith, *The Camera and Its Images* (New York: Newsweek Books, 1979), 72.

9. The daguerreotype, an image formed by a deposit of mercury on a silver-coated copper plate, could be seen either as a negative or as a positive, depending on the angle at which it was viewed.

would seem a hollow mockery." [7] Arthur Goldsmith, in *The Camera and Its Images* (1979), conceded, "Naive tintypes have nostalgic charm." [8] Vicki Goldberg, reviewing the exhibition "The Painted Tintype and the Decorative Frame, 1860–1910" at the Hudson River Museum in Yonkers, reflected, "There never was a Mathew Brady or a Nadar of the tintype, but the pictures make up for any lack of mastery by their disarming earnestness and the charm that age has lent them" (*New York Times,* August 1, 1993).

The tintype, like its predecessors, the daguerreotype and the ambrotype, was an image of the sitter, reversed left-to-right. [9] Produced on sheet iron in production-line fashion with multiple copies per shot, then clipped apart with tin shears at a lower cost than conventional paper prints from a negative, it was clearly a product of the Industrial Revolution. It was so cheap to produce that almost anyone could afford to have an informal likeness recorded, and traveling tintypists made it convenient for average Americans to have pictures of themselves taken at work and at play.

Glimpses of American life—as recorded on tintypes—appear in part 2 below. We see the shy smile of a young bride; the eloquent position of the hands of a recently married couple; and the relaxed, confident expression of a man with a gun. Three girls are pictured on a beach one day in 1878, in one of the earliest photographs with the look of a snapshot. In a tintype of a group at a mountain retreat, we detect a man lounging in a doorway in the background, unaware or unconcerned that he might be included.

Archaeologists examine the most common shards minutely. The tintype, another common relic of a bygone age, deserves the same kind of careful scrutiny. Using a magnifier, one can see the expression in the eyes, the button on a man's jacket, the locket around a woman's neck, and other details that reveal something about the subject and the moment. Do the shiny boots of the members of a work crew suggest that most photographs reveal not only the way we were but also the way we want to be remembered? What are the reflective woman's dreams? Are the two schoolboys carrying *McGuffey Reader*s? Who are Dr. Waldon's patients?

The tintype's popularity peaked during the Civil War, but the best examples appeared as more experienced and more skillful photographers used and improved on the process, among them Peter Britt (1819–1905), who earned a remarkable reputation for the technical and artistic quality of his 11" x 14" melainotypes, now found in the museum in Jacksonville, Oregon. The tintypes—and the biographies of some of those who made

them—published for the first time in this volume are a small sample of the material available in art galleries, historical museums, and archives. Thousands more tintypes will be discovered in antique shops, flea markets, and private collections as their value and public interest increase. One example: a tintype of William H. Bonney, "Billy the Kid," in which he is dressed as a gentleman and armed with a book instead of a six-shooter, turned up in Albuquerque in 1993. A search of the Internet reveals multiple sources of current information on the tintype, including the addresses of sellers and buyers.

This book is intended for art historians, social scientists, students of the history and technology of photography, collectors, and readers who simply enjoy looking at interesting vintage photographs. It is also meant to help place the tintype in the context of the spectacular growth of photography in America between 1840 and 1900.

In the mid-nineteenth century the daguerreotype was being replaced by a process announced in 1851 by Frederick Scott Archer, who used glass plates coated with collodion (a term derived from a Greek word meaning "glutinous"), a tacky, transparent solution of pyroxyline (nitrocellulose) dissolved in ether and alcohol. The collodion was chemically prepared and poured onto one side of a carefully cleaned glass plate, which was then dipped into a bath of silver nitrate, a light-sensitive solution that would bind to the sticky collodion surface. The plate had to be quickly exposed and developed before it dried out and lost its sensitivity. This became known as "the collodion process" or "wet-plate process." Glass negatives so produced opened a new chapter in the history of photography and were widely used to make paper prints, stereo views, and lantern slides well into the 1880s.

In 1852 Adolphe Alexander Martin described to the French Academy of Sciences a way to make a negative collodion image appear as a direct positive on glass with an opaque backing on dark leather, paper, oilcloth, dark waxed linen, or on metal.[10] None of these forms became popular in Europe, but the possibility of making photographs on metal interested a professor at Kenyon College, Ohio. His melainotype soon came into great demand in the United States, and in France and England the making of photographs on japanned iron plates become known as "the American process."

10. *La Lumière*, 1852, 99, 114.

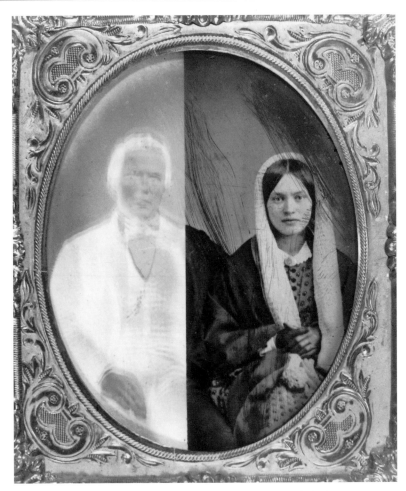

Young couple, c. 1858. Ambrotype. The ambrotype overlapped the daguerreotype, which it sometimes successfully imitated when cased, and immediately preceded the melainotype and ferrotype in America. Patented in 1854 by James A. Cutting of Boston, it was named by Ohio-born Marcus Aurelius Root, then a Philadelphia photographer. The term "ambrotype" is derived from the Greek word meaning "immortal" or "imperishable." Both the ambrotype and the tintype were collodion wet-plate, thin or slightly underexposed negatives (*left*) which, when placed on a dark background (*right*) looked like positives. The difference was that the ambro-type was a glass plate negative backed with dark cloth, velvet, black paper, or ruby glass, while melainotypes and ferrotypes were negatives on dark japanned iron plates. Ferrotypes, which eventually came to be known as tintypes, proved to be less perishable than the short-lived ambrotype.

Chapter 2

THE OHIO PIONEERS
OF THE TINTYPE

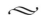

THE MELAINOTYPE

IN 1840 Hamilton Lamphere Smith was one of the first to experiment with improving the daguerreotype process, which had been introduced to the Académie Française in Paris in 1839.[1] At the time Smith was a Yale student, but after receiving his M.A. degree in 1842, he moved to Cleveland, where he continued to pursue his experiments with the daguerreotype.[2] From 1852 to 1854 Smith edited *Annals of Science,* a journal that included various articles on photography. The June 1853 issue contained a brief account of his own experiments with negatives on glass for printing to positive images.[3]

In 1853 Smith was appointed professor of natural philosophy (physics) at Kenyon College in Gambier, Ohio. During his first year as professor he continued his experiments. The first notice of his success in this area appeared in *Humphrey's Journal* (formerly the *Daguerreian Journal*), a widely read periodical devoted to photography. Its November 15, 1855, issue reported: "Mr. Smith says he can take a piece of sheet iron and use it as it comes from a large sheet, without polishing—make a picture and finish it complete in half the time and exposure you can in the old way, and every picture will be good—no failures."[4]

Smith had the help of Peter Neff Jr. Born in Cincinnati on April 13, 1827, Neff studied at Cincinnati's Woodward College; at Swinburn Acad-

1. *American Journal of Science and Arts* 40 (1841): 139.

2. *American Journal of Science and Arts* 35 (1839): 174–75. Smith later became a member of the Cleveland Academy of Natural Sciences. In 1854 he was its corresponding secretary and one of its four curators. For additional biographical information, see *Appleton's Cyclopaedia of American Biography*, vol. 5 (1853), 566.
3. *Annals of Science,* conducted by Hamilton L. Smith, A.M. (Cleveland: Harris and Fairbanks), 1 (1853): 174.

4. *Humphrey's Journal* (November 15, 1855).

Professor Hamilton Smith
with microscope. Daguerre-
otype. Courtesy Kenyon
College Archives.

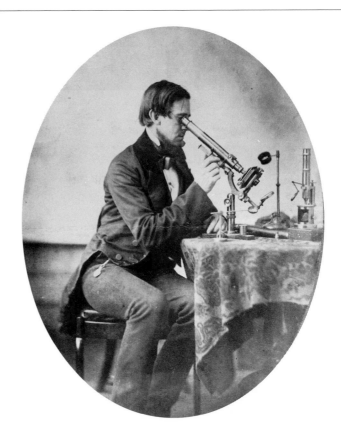

5. Information from an article
found in the Neff files, Kenyon
College Archives, Gambier,
Ohio.

emy in White Plains, New York; at Yale, where ill health forced him to leave after his first year; and finally at Kenyon College, from which he graduated Phi Beta Kappa in 1849.[5] His father thought he ought to be a farmer, but instead he studied at the Bexley Hall Theological Seminary in Gambier, Ohio. He retired from the ministry in 1866 because of a throat problem.

Neff became closely associated with Hamilton Smith in the making of photographs on iron plates, as Neff's own words in the Kenyon College Archives reveal:

> When at Gambier, Ohio, in 1853–'54, I was associated with Prof. Hamilton L. Smith in experiments to perfect his invention of tak-ing pictures on iron plates, and I became enthusiastic with it,—so much so that in 1855, at the Yellow Springs, Ohio [attending his father's private school], I continued their development and the preparation of sheet iron, and persuaded Prof. Smith that if he would apply for a patent, I would prosecute it, and if granted,

manufacture plates and introduce them, he being at no expense whatever. He consented that the patent should issue to William Neff and Peter Neff, Jr., which was accepted and agreed upon.

On February 19, 1856, patent no. 14,300, "For the Use of Japanned Metallic Plates in Photography," was issued to Professor H. L. Smith. The patent was assigned to William Neff and Peter Neff Jr.[6] According to the language of the patent, the process allowed "the obtaining of positive impressions upon a japanned surface previously prepared upon an iron or other metallic or mineral sheet or plate by means of collodion and a solution of a salt of silver and a camera substantially as herein described." The patent described how the iron sheets were prepared, as well as the formula for japan varnish, its application, and baking. In addition to the usual ingredients for black japan varnish—asphaltum, linseed oil, and turpentine—Smith included lampblack and umber for shading. The varnish produced a glossy black enamel-like surface when applied to iron and

6. Peter Neff's father, William Neff, had a brother named Peter. To ensure proper identification, young Peter added "Jr." to his name until his uncle's death in 1879 (Thomas B. Greenslade Jr., "The Invention of the Tintype," *Kenyon Alumni Bulletin* 29, no. 3 [July–August 1971]: 21).

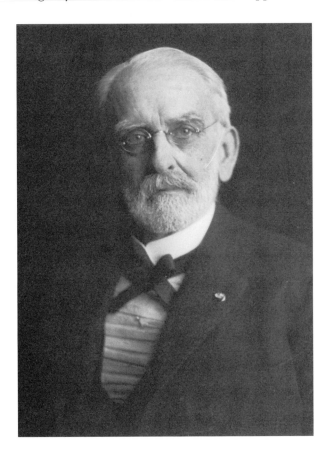

A later portrait of Peter Neff. He and his father were the assignors of Hamilton Smith's patent for the melainotype. Courtesy Kenyon College Archives.

other metals, glass, leather, and rubber. Japanned iron proved to be the most practical, durable, and lightest in weight base for the application of collodion.

Smith and Neff called their process the "Melainotype"—"melaino-" meaning "dark" or "black." Like daguerreotypes and ambrotypes, melainotypes were negatives made to look like positives. Some sitters no doubt complained because the image was reversed, but within a matter of minutes they could take their likeness home either in a miniature case or neatly framed in a paper holder.

Before he died in November 1856, William Neff assigned his interest in the patent and its business to his son, who immediately went to work above his father's stable on West 6th Street, near Cutter Street, in Cincinnati to improve and market his product. In March 1856 he began a collaboration with the Cincinnati photographer Charles Waldack, who ten years later became famous for taking the first photographs inside Mammoth Cave by lighting it with magnesium flares. Neff opened a gallery; he invented what he called "French Diamond Varnish" for protecting both collodion glass plates and melainotypes; and in 1856 he issued 4,000 free fifty-three-page pamphlets entitled *The Melainotype Process, Complete* to advertise his new product.[7] In 1857, with Waldack, he published *Treatise*

7. Reese V. Jenkins, *Images and Enterprise* (Baltimore: Johns Hopkins University Press, 1975), 43.

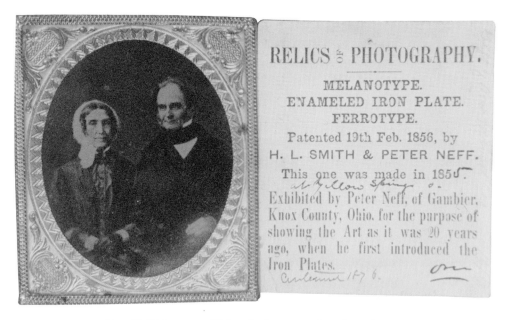

Peter Neff Jr.'s parents. This early tintype may have been shown at the Centennial Exhibition in Philadelphia in 1876. Courtesy Kenyon College Archives.

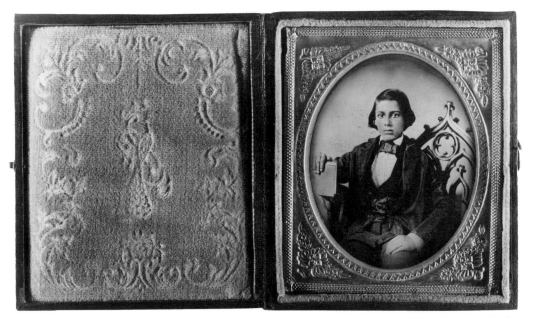

Portrait of a young boy, c. 1856. Melainotype. Sixth-size plate. An excellent example of an early unvarnished tintype taken on a heavy plate and placed in a miniature case like a daguerreotype or an ambrotype.

of Photography on Collodion, an instruction manual for clients and agents in the field.

Humphrey's Journal commented favorably on the melainotype, reporting that "these plates can be furnished at much less price than glass. . . . They are designed for the positive picture and can be easily fitted to lockets, pins, etc."[8] Eastern photographers were impressed, and suddenly the demand for plates became greater than Neff's capacity to produce them.

In March 1856 Neff and Waldack began using a collodion with iodide of cadmium that had been invented in Belgium a year earlier by the well-known photographer Désiré Charles Emanuel van Monckhoven.[9] The correct collodion mixture was very important to the success of a photograph on either iron plate or glass, and the new solution was more resistant to deterioration than previous ones. In 1857 Neff advertised: "The melainotype can be worked along with the ambrotype, in the same bath, with the same collodion, etc., without any detriments."[10]

Neff at first found it difficult to obtain sheet metal thin enough for his plates, but he solved the problem by importing several tons of Taggers Iron from England.[11] The first shipment arrived in the summer of 1856, and Neff established a factory at 239 West 3rd Street in Cincinnati for

8. *Humphrey's Journal* 8 (1856): 99.
9. Waldack and Neff, *A Treatise of Photography on Collodion* (Cincinnati, 1857), 3. Monckhoven is mentioned (although his name is incorrectly spelled) in connection with photography on sheet iron in the *Journal of the Franklin Institute* 66 (1858): 395. Monckhoven introduced into the collodion a protosalt of iron, "which forms in the silver bath a reducing agent which, by its slow decomposition, gives peculiar rapidity to the process." His plates were very thin Swedish iron varnished by heat with a bituminous mixture.
10. Ibid., 45.
11. Edward M. Estabrooke, *The Ferrotype, and How to Make It* (Cincinnati: Gatchel & Hyatt, 1872), 102. "The melainotype . . . was made of 36 iron. . . . The best quality of this iron, now imported . . . is branded 'Taggers Iron Pontimeister, N. 38' and comes in boxes containing, on the average, 440 sheets, weighing 100 lbs." Neff began using a lighter plate, but we do not know when. Very early melainotypes

had black on the back of the plate and were slightly heavier than later ones, which had a mottled bronze color on the back side. Unfortunately, Estabrooke did not specify when the demand for the lighter No. 38 iron began.

12. Ibid., 71.

13. *Photographic and Fine-Art Journal* 9 (1856): 384.

14. Thomas B. Greenslade Jr., "Tintypes," *Graphic Antiquarian,* October 1972, 15.

15. Estabrooke, *The Ferrotype,* 78. A double-image plate is found in the Rinhart Collection. At the time of its discovery some years ago, it was thought to have been an example of one photographer's frugality!

japanning and preparing the plates. The factory had rooms for mixing the necessary chemicals and even space for demonstrating the process and teaching others how to do it.

Some daguerreotype makers and dealers and potential users of the melainotype objected to the $20 licensing fee Neff charged for the process; an Ohio competitor, Victor Griswold, was charging less for his ferrotype plates than Neff was for melainotype plates. The venture did well, however, and patent rights were sold through well-known photography supply houses. Edward Anthony and Company, the largest wholesale house in the country, advertised itself as the agent for the sale of melainotype plates in New York City. The Philadelphia agent was the manufacturer and jobber James Cremer. In Cincinnati Peter Neff Jr. continued to handle the patent rights. It was reported that a number of photographers were duped by a "confidence man" who, posing as Neff's agent, "with his solemn visage and pregnant carpet-bag, made his first appearance in the gallery and, producing his wares, demanded twenty-five, fifty, one hundred, two, and three hundred dollars for a 'room right' license."[12] Although the competition for platemaking was sharp between Neff and Griswold during the "War of the Roses," Griswold never violated the Smith-Neff patent. Making an iron plate was not a patented process—only the method of coating it was—and Griswold was never found guilty of any unethical actions in this regard.

In the fall of 1856 many popular galleries around the country began publicizing the melainotype. Neff was even awarded a bronze medal for his melainotypes at the fair of the American Industrial Institute in New York City.[13] But his work suffered a setback in the summer of 1857, when the Cincinnati factory was destroyed by fire. After the fire Neff moved his manufacturing operation to Middletown, Connecticut, a location with greater sales potential because of its easy access to eastern wholesalers.[14]

Melainotype plates came in standard photographic sizes and were packaged in grooved wooden boxes so that plates did not touch. Most plates were japanned on one side with two or more coats of varnish. Neff also made up and sold his French Diamond Varnish to be used on melainotypes. After the melainotype had been exposed and finished in the usual way, he recommended putting two or more brush coats of this varnish on the back of the plate to prevent oxidation. Plates could also be finished on both sides.[15] The earliest plates were rough, uneven, and nubby, but by the fall of 1858 they were described as being "as true as polished glass."

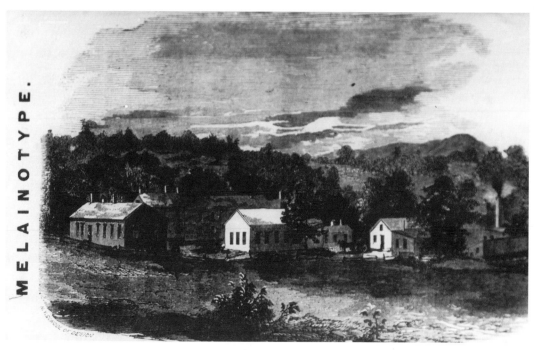

Neff's plate factory in Middletown, Conn. Advertisement from the *American Journal of Photography*, 1863.

An advertisement in *Humphrey's Journal* in the fall of 1859 claimed that the melainotype had found its way into almost the whole of the United States and to many parts of Europe and South America. Licenses could be obtained by applying directly to Peter Neff Jr. of Cincinnati, Ohio.

For the professional photographer, the sheet-iron photograph had distinct advantages over the ambrotype. Bundy and Williams, of Middletown, Connecticut, used the melainotype from its very beginning, noting that after the image was fixed, the drying and casing took less than three minutes: "We can make, finish, and case two melainotypes in the time necessary for one ambrotype."[16] Another advantage was that a melainotype could be cut with common scissors or tin snips, then rounded or shaped as fashion demanded. In 1859 S. J. Thompson, of Albany, New York, described the melainotype as "the most convenient article for lockets and fancy cases."[17]

Neff devoted all his time to the manufacture and improvement of his plates, which filled the bags of the U.S. Post Office during the Civil War. On August 20, 1862, the *New York Tribune* published the following report from a war correspondent:

16. From an advertisement in *Humphrey's Journal* 10 (November 1858).

17. Ambrotypes and glass-covered melainotypes in the form of lockets or sealed in cases are sometimes hard to distinguish. Whether a portrait is on glass or sheet iron, one must remove the image from its container very carefully, and only if absolutely necessary. Sealed tintypes generally suffer less deterioration than sealed images on glass.

Portrait of a little girl, c. 1857. Melainotype. Sixth-size plate. The photographer sealed this melainotype plate to a protective glass, using balsam, just as he would have done for an ambrotype, then put it into a miniature case like a daguerreotype. Few tintypists followed this procedure.

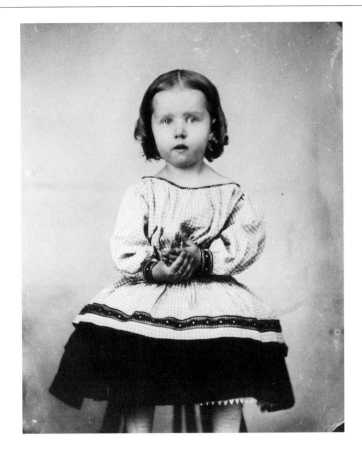

Sailboat, c. 1859. Melainotype. Ninth-size plate. A rare image of the basic transportation system of America's small coastal towns.

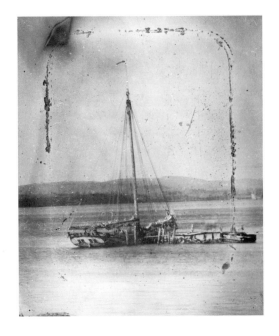

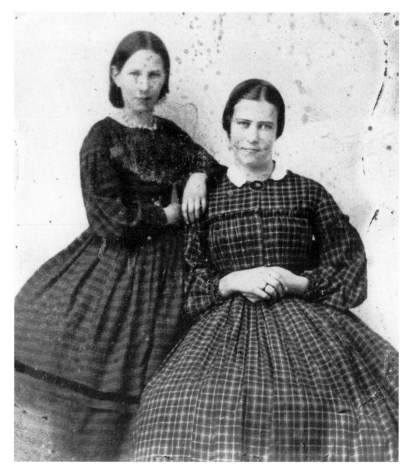

Portrait of a woman and a young girl, c. 1861. Melaino-type. Sixth-size plate. In this melainotype the sheet-iron plate shows some deterioration on the white background, a rare defect.

A camp is hardly pitched before one of the omnipresent artists in collodion and amber-bead varnish drives up his two-horse wagon, pitches his canvas-gallery, and unpacks his chemicals. . . . Their tents are thronged from morning to night. . . . Here, for instance, near Gen. Burnside's headquarters, are the combined establish-ments of two brothers from Pennsylvania who rejoice in the won-derful name Bergstr[a]sser. . . . In one day since they came here they took in one of the galleries, so I am told, 160 odd pictures at $1. . . . The style of portrait affected by these traveling army por-trait-makers is that known to the profession as the melainotype.

In March 1862 Neff introduced what he called the "Excelsior Plate" in response to fierce and cut-rate competition. In the fall of that year he also established an agency for his plates with James O. Smith and Sons of 81

Advertisement for the melainotype. One of Neff's last announcements about his process. From the *American Journal of Photography*, 1864.

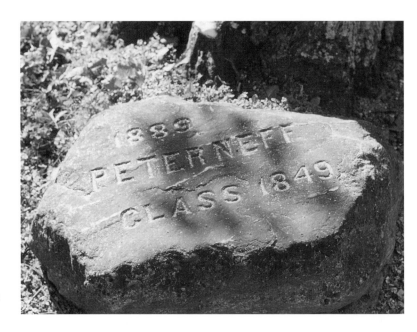

Melainotype !
EXCELSIOR.
Neff's Iron Plates for Collodion Positives,
Were the first Iron Plates ever made, and can't be beat,
They recommend themselves to all Operators.

1-9 per 8 doz. boxes, $0 55.	1-2 per 4 doz. boxes, $1 75.
1-6 " 8 " " 90.	4-4 " 2 " " 2 50
1-4 " 8 " " 1 25.	

A LIBERAL DISCOUNT OFF TO DEALERS.
Apply to JAS. O. SMITH & SONS, 81 Fulton St., New York, N. Y.
PETER NEFF, Jr., Gambier, Knox Co., Ohio.

18. *Humphrey's Journal* 11 (January 1859), advertisement.

Fulton Street in New York City. Prices were $1.00 for ninths and $1.50 for sixth-size plates.[18] When Neff briefly ceased advertising in *Humphrey's Journal*, predatory competitors started a rumor that he had stopped making plates. In December 1862 Neff claimed that certain parties were putting "spurious iron plates" into his boxes and selling them as genuine melainotypes.

Melainotype and Excelsior plates were still being manufactured in the spring of 1863, and although many brands were now on the market, Neff's were still in the lead. To cut shipping costs, cardboard boxes were used instead of wooden ones. Each was neatly labeled "Melainotype. Neff's Iron Plates Warranted" in gold letters on black enameled paper. On the reverse was "Peter Neff, Jr., Gambier, Ohio./NO. 81 Fulton Street, N.Y."

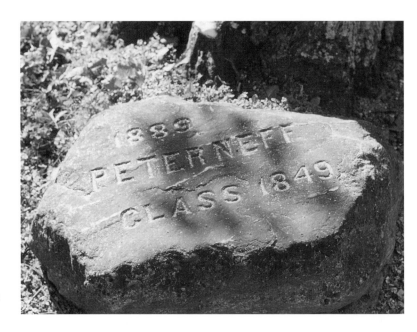

A tribute to Peter Neff on the campus of Kenyon College.

The type, number, and size of the contents were printed on the ends of the box.[19]

Neff now sold the plates himself to save commissions, and buyers applied directly to him or to his New York office. He was still in business in October 1863, but according to *Humphrey's Journal,* he had discontinued making plates by the end of the year.[20] His last warehouse was in Gambier, where he sold his remaining stock by mail order.[21]

Peter Neff and his early partner, Hamilton Smith, both died in 1903. Under a tree on the quiet campus of Kenyon College there is a commemorative rock into which is deeply carved "1888 / Peter Neff / Class 1849."

THE FERROTYPE

AT about the time that Peter Neff Jr. announced his melainotype photographic process, Victor Moreau Griswold, a rival in Lancaster, Ohio, also introduced a thinner, lighter sheet-metal photographic plate that he called a "Ferrotype."[22]

AMBROTYPES, PHOTOGRAPHS,
Daguerrertypes, &c., &c.

THE subscriber is now able to compete with any establishment in the West in the production of Pictures in any of the above arts. The Ambrotype Pictures on Glass, perhaps rival anything in the Photographic line, and place it in the power of every one at moderate expense to secure Pictures of friends or relatives that are warranted to be perfectly durable, and will stand for ever unaffected by any of the influences that are deteriorative to the ordinary Daguerrertype. Pictures executed in any of the above styles, equal to any produced in the West, and elegantly fitted up in cases or frames as may be desired.

No sitting for Children after 2 o'clock P.M.
ROOMS—Creed's Block, over Buck's Store.
Lancaster, Dec. 27, 1856—25tf V.M.GRISWOLD.

Reproduction of Victor M. Griswold's advertisement for his photographic studio in Lancaster, Ohio. From the *Lancaster Gazette,* January 10, 1856. At the time Griswold was still making daguerreotypes, although he was promoting "Ambrotype Pictures on Glass." His ferrotype patent was issued later that year.

19. *Humphrey's Journal* 14 (1862): 95.

20. *Humphrey's Journal* 15 (1863): 48.
21. Just what happened to Neff—and the melainotype at its end in 1863—is not clear. Estabrooke wrote that J. O. Smith of Waterbury, Conn., made plates for Neff (*The Ferrotype,* 100); Jenkins wrote that "Neff sold the Connecticut factory to its local manager" (*Images and Enterprise,* 43 n. 12). Both accounts agree that Neff went out of business in 1863, but neither mentions that the last known advertising address for the melainotype was at Gambier, Ohio, beginning in June 1863. Presumably Neff had a good supply of plates on hand at that location, because he was still in business in October.

After his retirement in 1864, Neff began a study of the oil fields in Pennsylvania and southeastern Ohio that resulted in the famous "Neff Geyser Well," and enactment by the Ohio legislature of the state's first geological survey. In 1866 he discovered that lampblack obtained from natural gas was of superior quality, and he invented equipment for its manufacture, with large sales in both Europe and America. In 1888 he moved to Cleveland, where he became librarian of the Western Reserve Historical Society, to which he contributed his own collections. He died in Cleveland on May 11, 1903.
22. Robert Hunt, *A Manual of Photography* (London: Richard Griffin, 1854), 73–75, first used the word "ferrotype" in 1844 to specify a developing solution using protosulfate of iron. The term also refers to the polished steel, iron, or enameled plates onto which a wet gelatin print may be squeegeed, then removed when dry, producing a glossy surface on the print.

Griswold, whose parents had come from Connecticut, was born on April 14, 1819, in Worthington, Ohio. Beginning at age fifteen, when he first moved to Lancaster, he worked at several jobs, including a stint with his brother, Samuel A. Griswold, publishing the *Tiffin (Ohio) Gazette.* He then began to study painting with William Walcutt, a prominent artist in Columbus, and for several years he painted portraits in a number of Ohio cities. By 1851 he was running a photographic gallery in Tiffin, Ohio; two years later he bought a gallery and established himself in Lancaster.

In 1856, after six years as a practicing photographer, Griswold patented his own method of making and sensitizing very thin iron plates, which he imported from England. He established a factory on the north side of Main Street in the Sifford Building, between Broad and Columbus Streets. Of his early work Griswold later wrote:

> The first Ferrotype plates . . . manufactured for sale were "baked"
> in an oven about six feet deep, four feet wide, and six feet high;
> and this oven was sufficient in capacity to supply the demand for

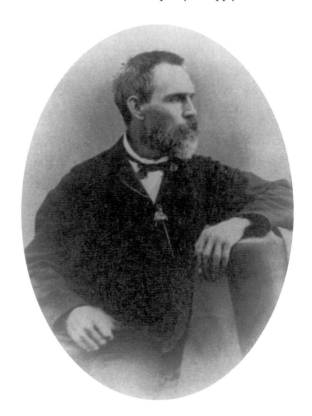

Victor M. Griswold, c. 1870. From Robert Taft, *Photography and the American Scene: A Social History, 1839–1889* (New York: Dover Publications, 1964). Taft says (p. 156) that Griswold was once a student at Kenyon College.

Ferrotype Plates--Egg-Shell & Glossy.

V. M. GRISWOLD,

Patentee and Sole Manufacturer,

442 Broadway, New York, and Lancaster, O.

These plates are now admitted, by disinterested parties, to be

THE ONLY PERFECTLY RELIABLE IRON PLATES.

the *very best* materials are used in their manufacture, (notwithstanding the extraordinary advance in prices during the past year,) upon a formula modified and materially improved since the issuing of letters patent. ROUGH IRON and BENZINE VARNISH, (the two principle constituents of the cheap imitations of the Ferrotype Plates, with which the country has lately been flooded, to the annoyance and loss of confiding purchasers,) have been found to be Wholly Unfit for purposes of positive photography. I have abundant evidence before me that these abortions have about *had their day.*

The public is more clamorous than ever for the Ferrotype Plates!

They are the SINE QUA NON, in the estimation of the numerous experts who are familiar with them.

There is scarcely an ambrotypist or photographer in the country who has not heard, or beheld in glaring capitals, this sentence :

"Warranted equal to the Ferrotype Plates!"

Indeed, this phrase has become stereotyped in the mouths of persons who have something to recommend as a substitute for my plates. What does it mean? Does it not *slightly* indicate that the Ferrotype Plates are held in the HIGHEST ESTIMATION, not only by the photographic fraternity, but even by the makers and venders of *would-be* rival plates? Does it not indicate further that my plates represent the standard desirable to attain, in order to win the substantial favors of consumers? I, therefore, solicit your orders, confident that you will find my plates, on trial, to justify the assumptions herein set forth.

For the benefit of persons not yet acquainted with the merits of my plates, I will name some of their points of superiority :

1st. Excellence of the materials used in their manufacture. 2d. Perfect Cleanliness of the plates from newly opened boxes. 3d. Beauty of Surface. 4th. Ease of Manipulation. 5th. Quick-working qualities. 6th. Safety and Satisfaction in their use. 7th. Susceptibility of being used Repeatedly, with uniformly good results. 8th. Adaptibility to all latitudes.

My plates are all guaranteed, and are sold at prices, by the single box, which make them, considering their excellence, the Cheapest Plates in Market, as follows :

Light.		Heavy.	
1-9 per box of 8 doz...$0.75		1-4 per box of 8 doz...$2.25	
1-6 " " ... 1.25		1-2 " " 4 ... 2.50	
5-4 " " ... 2.00		4-4 " " ... 5.50	

Stock Dealers will be allowed a liberal discount from the above prices. Where $10 worth of plates are ordered at one time, I will make no charge for collection by Express Co. On receipt of fifteen cents in postage stamps, I will forward sample plates by mail. Orders addressed to

V. M. GRISWOLD,

442 Broadway, N. Y., and Lancaster, O.

Advertisement from the *American Journal of Photography,* May 15, 1864. With the demand for photographs declining in the final stages of the war, Griswold became increasingly bitter about "cheap competition."

some months. The Japan-room adjoining this oven was about nine feet square, and here originated the first Ferrotype plates that were given to the world. The work being all done by one man and two boys. Samples of the first plates were sent to nearly all the dealers in photographic goods in the United States, with instructions to give them out freely on trial among their customers.[23]

23. Estabrooke, *The Ferrotype,* 80.

Griswold's use of free samples to promote his plates resulted in an increased demand for this new product, which sold for less than half the price of Neff's melainotypes. During his first year in the business Griswold also offered his plates in two finishes—"egg-shell" and "glossy." These terms for finishes became standard.

Aware of the importance of having the proper collodion solution to

Young woman and child,
c. 1858. Ferrotype.
Quarter-size plate,
stamped "Griswold
Patent."

ensure his plates' quality, Griswold secured a patent, no. 15,326, issued on July 15, 1856, for the addition of albumen to collodion for photographic pictures.[24] A second patent, no. 15,924, issued on October 21, 1856, stated, "Bitumen sensitized as above, will give impressions without the aid of collodion, and renders a collodion film more sensitive, and gives a more sharply defined image than by any other process and may be used for taking pictures on paper or any other smooth, hard substance."[25]

Griswold's output could not keep up with the demand for plates, and about 1858 he moved into a larger factory. Several changes were made to cut costs: an expert japanner was hired, larger sheets of metal were baked in less time, and plates were cut into smaller sizes after baking.[26] The plates were packaged in compact cardboard containers. The factory, employing about fourteen workers, used approximately seven to ten boxes of iron weekly, and before 1860 weekly consumption was as high as forty boxes during a peak period.[27]

24. H. H. Snelling, *Photographic and Fine-Art Journal* 10 (1857): 24ff. Some controversy existed over Griswold's addition of albumen to collodion. Snelling wrote: "We should like to know from what time Mr. Griswold dates his discovery of this combination, as the value of his patent depends entirely upon that circumstance."
25. Hunt, *Manual,* 12–17. The use of bitumen of Judea in photography was not new, as it was used by Nicéphore Niépce in 1826.
26. Estabrooke, *The Ferrotype,* 83.

27. Ibid., 82, 86.

Seated woman, c. 1858. Ferrotype. Quarter-size plate, stamped "Griswold Patent." The plate is unusual, as it has a thick coat of varnish not often seen in early ferrotypes.

During the first few years after the introduction of the sheet-metal photograph, professional photographers were slow to adopt a universal name for it, calling it either a melainotype or a ferrotype, depending on which manufacturer's name was impressed on the edge of the plate. *Humphrey's Journal,* in which Neff was a steady advertiser, continued to use the name melainotype until the fall of 1863, by which time many photographers were calling themselves ferrotypers (as they continued to do well into the twentieth century). The word was easier to say than melainotyper, and "ferro-," meaning iron, was a better description of this kind of photograph. By about 1860, however, the public had begun calling any photographs on metal "tintypes."

In the fall of 1861 Griswold, now faced with competition from eastern platemakers, moved his family to Peekskill, New York, where he opened a new factory along the Hudson River—a factory he described as a "model in all its appointments."[28] The river location gave him the advantage of

28. Ibid., 86.

reduced freight rates to New York City, the largest photographic market in the country.

In 1865, with the great wartime demand for plates at an end, Griswold began experimenting with a new style of ferrotype. His hope was that he could compete with the now popular porcelain or opal-glass photographs, which came in brown tints or were colored by artists working in oil or watercolors.[29] Griswold's new process was, in many ways, a last attempt to capture the carriage trade. The mainstream of sheet-iron photography now depended on price, not on quality, and the old sizes had given way to new shapes for miniature and card-mounted tintypes.

On April 10, 1866, patent no. 53,815 was issued to Griswold for taking opal pictures on ferrotype plates. He began to manufacture a special eggshell-finish plate suitable for the process. He also developed two "opal" solutions for the trade, using a glass negative and printing directly on the ferrotype plate after the two solutions had been used.[30]

The *Philadelphia Photographer* in 1866 mentioned Griswold's "opal-types on iron," saying that they were made by the ordinary wet-plate

29. For those interested in how the opal-glass photograph was made, see *Philadelphia Photographer* 8 (1865): 8.

30. For further information, see V. M. Griswold *A Manual of Griswold's New Ferro-Photographic Process for Opal Printing on the Ferrotype Plates* (Peekskill, N.Y.: Author, 1866). In this pamphlet, Griswold explains the advantages of opal printing with his new ferrotype plates. He states that a 4" x 4" opal ferrotype cost twenty cents to complete, while an opal-glass photograph could run as high as one dollar. A three-step manipulation—all done with Griswold's products—was necessary to complete an opal ferrotype: the opal solution, the sensitive compound, and the enamel. Griswold neglected to explain how to apply the enamel. His brother, Manfred Marsden Griswold, a photographer with a studio in Columbus, Ohio, from 1858 to 1868, claimed that he had "solved the problem of Opalotypes [*sic*] on Iron" simply by using unsensitized rather than sensitized white enamel in the process described by Victor (*Philadelphia Photographer*, 1866, 234–35).

GRISWOLD & CO., Lancaster, Ohio,

Manufacturers of

GRISWOLD'S PATENTED

FEROTYPE AND PAPYROTYPE PLATES.

——:0:——

These Plates have now obtained a celebrity which has never heretofore been extended to any similar article, and will be found upon trial superior to any plate in the market in all successful working properties, being entirely free from any deleterious chemical agents, and as simple and sure as any substance that has ever been used for the purpose.

They require only the same solutions and the same manipulations as glass, and are infinitely superior, as well as being cheaper, when the comparative labor of preparing the plate is taken into consideration.

FEROTYPE PLATES—(*Light*).

1–9 size per box, 8 dozen	-	-	-	-	$ 2 00
1–6 " " 8 "		-	-	-	3 50

FEROTYPE PLATES—(*Heavy*).

1–9 size per box, 8 dozen	-	-	-		2 25
1–6 " " 8 "	-	-	-	-	3 75
1–4 " " 8 "	-	-	-	-	5 50
1–2 " " 4 "	-	-	-	-	6 50
4–4 " " 4 "	-	-	-	-	13 00
8×10 " " 4 "	-	-	-	-	15 00
10×14 " " 4 "	-	-	-	-	16 00

PAPYROTYPE PLATES—(*Light*).

1–6 in packages, 8 dozen	-	-	-	2 40
1–6 in sheets, to cut 15 med's.	-	40 cents. per sheet.		

PAPYROTYPE PLATES—(*Heavy*).

1–9 in packages, 8 dozen	-	-	-	-	2 20
1–6 " " 8 "	-	-	-	-	3 25
1–4 " " 8 "	-	-	-	-	5 00
1–2 " " 4 "	-	-	-	-	6 00
4–4 " " 4 "	-	-	-	-	12 00
8×10 " " 4 "	-	-	-	-	14 00
10×14 " " 4 "	-	-	-	-	15 00

Advertisement from *Humphrey's Journal*, 1859, about a year before the explosion in platemaking. By 1863 the price of a sixth-size plate had dropped nearly 50 percent, to $1.75 a box.

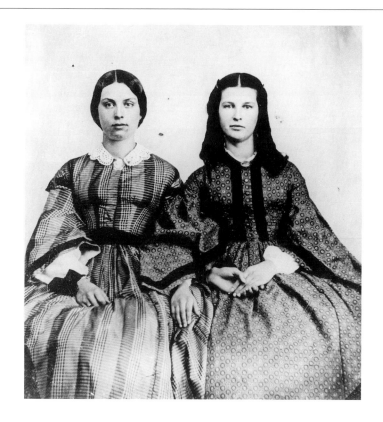

Portrait of two young women, c. 1869. Ferrotype. Sixth-size plate, stamped "Griswold Patent."

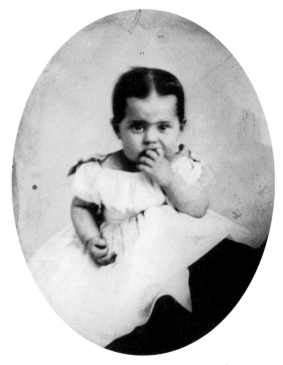

Seated baby, c. 1866. Ferrotype. Sixth-size plate. Probably Griswold's opal-type plate. Stamped "Patent Oct 26, 186(?)."

Vignette of young woman, 1866. Ferrotype. Ninth-size plate.

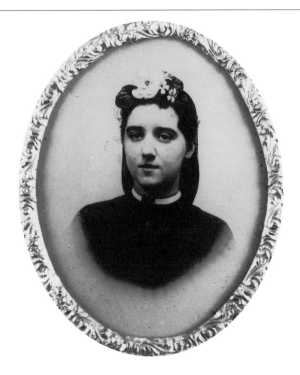

31. *Philadelphia Photographer* 3 (1886): 53–54, 110–11; *Humphrey's Journal* (April 1867) referred to Griswold's opaltypes as "his incomparable opal ferrotypes, a style of picture which is quite fascinating, easily produced and one that will without doubt meet a rapid sale."
32. Griswold did, however, continue to experiment with improvements in photography. At the National Photographic Association's exhibition in June 1869 in Boston, he exhibited—along with ferro-photographs—three inventions he patented in 1869: a drying rack, a plate vise, and a spring clip (*Philadelphia Photographer* 6 [1869]: 221). Robert W. Wagner collected notes on Griswold's life in Lancaster during a May 17, 1986, interview and later correspondence with Charles R. Goslin, a longtime Lancaster resident and historian. Goslin's own notes about Griswold's move to Peekskill and the date of his death are from Goslin's discussions with Samuel A. Griswold, Victor's brother.

process or by the collodion-chloride process on a film that dried white and opaque; portraits and landscapes were supposedly equally beautiful. The editor was very hopeful for the future of white pictures on iron: "The printing is beautiful and sharp and the model tastefully lighted. They are, indeed, very beautiful pictures having a peculiar softness about them quite equal to other ground porcelain glass or porcelain surface paper." After the opal ferrotype plate was toned, fixed, and coated with an enamel, it could be painted with oils or watercolors.[31]

When Griswold announced the opaltype, he was about to stop manufacturing plates. Like Neff, he had become bitter about the unethical and highly competitive state of the photographic trade, which he sharply criticized in his 1866 brochure: "The Ferrotype Plate . . . has been taken advantage of by unprincipled manufacturers who have, with a persistence unparalleled, stolen and engrafted upon their spurious articles every popular feature of the Ferrotype. . . . We originated and first introduced the Egg-shell and Glossy Plates—this idea has been stolen and badly imitated—and do not propose any longer to carry a set of thieves and bad imitators upon our shoulders." With the closing of Griswold's factory in 1867, the pioneering era of the sheet-metal photograph ended, and the center of the platemaking industry moved to Worcester, Massachusetts.[32]

Chapter 3

MAKING THE TINTYPE

AFTER the melainotype was introduced to the American public in 1856, many leading photographers began to advertise the new process in newspapers, city directories, and periodicals. Most also continued to offer daguerreotypes, ambrotypes, and paper photographs.

In New York City, readers of the popular periodical *Albion* learned in December 1856 that the prominent artist and daguerreotypist Thomas Faris and his partner, Mr. Erwin, were making melainotypes in their gallery.[1] Orrin J. Benjamin, of Newark, New Jersey, the Hughes brothers of Nashville, Tennessee, and M. Moulthrop of New Haven, Connecticut, were among other early practitioners of the melainotype, as were William C. North, who introduced the melainotype to Cleveland in April 1856, and Peter Britt, who by 1859 was specializing in scenic views of the Far West. The tintype was a medium especially well suited for informal portraits in the field, but it also competed with studio portraitists, who were using other, more expensive wet-plate processes.

Although popular with the public, the tintype was not favored by many self-styled "photographic artists," whose inexperience with it may have contributed to their lack of respect. G. W. Babb in 1881 pointed out that the better class of photographers, who made tintypes only at rare intervals, seldom made good ones. They always overtimed or overdeveloped, producing a poor, flat picture. Their lighting was wrong, and their tintype portraits lacked brilliance.[2]

1. Faris's gallery had previously been owned by Samuel Root, a veteran photographer.

2. *Philadelphia Photographer* 18 (1881): 116.

Significant improvements had been made in the design of cameras and lenses and in the chemistry of photography, but Mathew Brady would still have been quite at home in any photographic studio of the late nineteenth or early twentieth century. Reputable daguerreian studios easily accommodated ambrotypes, tintypes, and salt and albumen prints. The photographic studio, equipment and settings included, continued to look much the same into the early 1900s.

THE RECEPTION ROOM

JOHN FITZGIBBON, one of the most widely traveled and famous photographers to include tintypes in his gallery, pointed out in 1874 that the reception room was the most important area of a photographic establish-

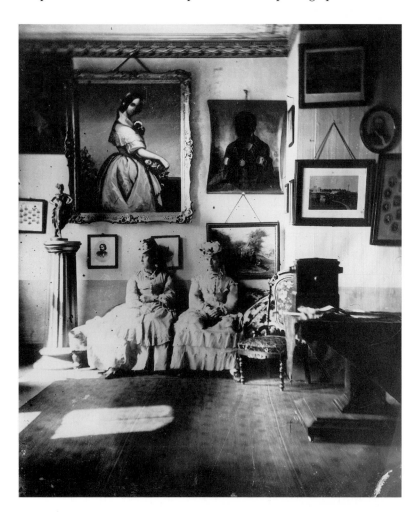

The reception room. Two well-dressed women wait their turn to be photographed, surrounded by paintings, photographs, statuary, and a display camera. Courtesy Library of Congress.

ment—and the one most often neglected by its proprietor.[3] If there was no one in the room to answer questions about different styles and costs of photographs, as was usually the case, impatient customers would seek out a gallery where they would receive immediate attention. Fitzgibbon regretfully recalled that in his St. Louis gallery he had lost hundreds—even thousands—of dollars a year because of his failure to recognize the importance of the reception room.

The reception room was also the showcase in a tintype gallery, and the better ones were designed for the comfort and entertainment of waiting patrons. Walls were hung with the best examples of the photographer's work; there were comfortable chairs and sofas; on a center table were books, magazines, and newspapers; even a musical instrument was often part of the furnishings. Many reception rooms included a Brewster or Holmes-Bates stereoscope for viewing the world in 3-D, since, by 1859, "stereomania" had overtaken the American public.[4] There were also pots of flowers, sometimes an aquarium, and even a few caged songbirds. Miniature cases, frames, and other articles for encasing the portrait were on view. Customers could sometimes leaf through albums with different sizes of tintypes, checking for styles and prices. The owner of the gallery or an attendant took orders and made every effort to keep waiting patrons in good humor.[5]

THE OPERATING ROOM (THE STUDIO)

THE design and accoutrements of the "operating room" or "glass room" —later called the "studio"—depended on the photographer's taste and experience and, to some extent, on the customer's expectations. Brady's National Photographic Art Gallery in Washington, D.C., has been described as "a clutter of cameras, lenses, headrests, painted screens, backgrounds, reflectors, an Italian vase, and a footrest as well as the chairs and props that appeared repeatedly in thousands of Brady pictures."[6] One authority advised: "The photographer must cultivate the art of making the sitter feel at ease in the studio, it being impossible to obtain a successful portrait if there is a feeling of constraint. Avoid the appearance of all unnecessary appliances; make the studio appear as much like an ordinary room as possible, with interesting pictures, books, plants, etc. to divert the sitter's attention from any idea that he is in some strange place. Have everything ready and at hand that may be required."[7]

3. *British Journal of Photography* (1874): 304.

4. John Waldsmith, *Stereo Views: An Illustrated History and Price Guide* (Radnor, Pa.: Wallace-Homestead, 1991), 2.

5. Edward M. Estabrooke, *The Ferrotype, and How to Make It* (Cincinnati: Gatchel & Hyatt, 1872), 36–37.

6. Dorothy Meserve Kuhnhardt and Philip B. Kuhnhardt Jr., *Mathew Brady and His World* (Alexandria, Va.: Time-Life Books, 1977), 52–53.

7. *Cassell's Cyclopaedia of Photography*, 530.

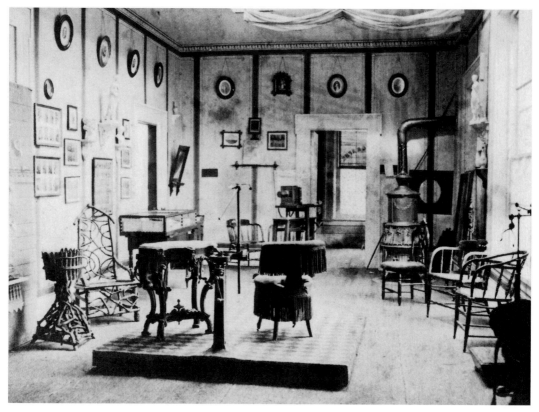

A nineteenth-century photographic studio. Note the skylight, drapes, and furnishings—including a stove—catering to patrons' comfort and tastes.

The principal consideration in designing an operating room was the essential light source—the skylight. Estabrooke wrote: "A properly constructed photographic light should be of northern exposure, top and side lights combined, the side light reaching from the floor to the lower end of the top light, which should be at least ten feet from the floor, the top sash having sufficient pitch to shed the rain-water freely . . . with such a light, properly shaded, a great variety of beautiful effects can be produced."[8] Estabrooke pointed out that light from above, used alone, resulted in "heavy shadows under projecting parts." Side light, when used alone, was "a great destroyer of complexion as every freckle, however faint, was brought out." When top and side lights were used together, however, the result was fine lighting.[9] If the side light was strong and a background scene was used, a movable screen of unbleached muslin, if placed at right angles to the background at the end of the nearest side light, gave a soft illumination flattering to the subject.[10]

8. Estabrooke, *The Ferrotype,* 182–83.

9. Ibid.

10. *Anthony's Photographic Bulletin* 11 (1880): 308.

An interesting studio innovation for making wet-plate photographs at night was introduced in 1869 by G. K. Proctor of Salem, Massachusetts. Proctor's device was an oval enclosure of paper or cloth supported by a light framework. The photographer placed the sitter in the enclosure, adjusted the background, and ignited a small quantity of magnesium in a lamp whose light was diffused by reflection from the paper walls. "Imagine yourself closed up in a bowed wagon-cover, a clock-work begins to hum, a bright light springs forth . . . a few seconds, and the picture is made." In this way a good negative could be made in fifteen to twenty seconds, and a whole-plate tintype in twenty-five to thirty seconds.[11] The smoke from the magnesium flare, however, may have ruined many sitters' dispositions.

11. *Journal of the Franklin Institute* 87 (1869): 230; *Philadelphia Photographer* 6 (1869): 165.

A. K. Trask's *Practical Ferrotyper* stated that a tintype required double the amount of brilliant light used for a good glass plate negative. Illumination sufficient for a negative from which soft, brilliant paper prints could be made would produce only a "dull, smoky ferrotype."[12] Trask used inside blinds to control the light so that any portion of the room could be shut off as needed. Every skylight in the room, he said, should have a set of white or blue (preferably blue French lawn) opaque curtains hung on spring rollers. These were placed at the top of the light and pulled down by a cord running through a small pulley with a catch. The side light was controlled in the same way.[13] The photographer should pull the blinds over the top light before the subject entered the operating room:

12. A. K. Trask, *Practical Ferrotyper* (1872), 32.

13. Ibid., 47. On p. 45, Trask says that C. L. Lovejoy of Philadelphia constructed a set of muslin blinds for the outside of his skylight that filtered a soft and diffused light into his studio. This arrangement also made the skylight room much cooler.

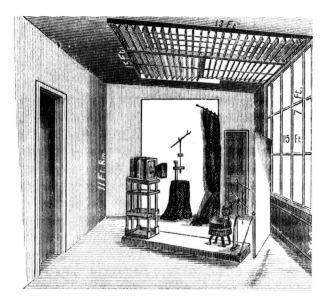

A typical skylight operating room. The drawing shows the dimensions of the windows and shutters. From *Philadelphia Photographer*, 1869.

Otherwise the glare will be found to be too strong for most people, producing a screwing up of the eyes, thus giving a false expression; whereas, by having a subdued light when the model enters, one is able to study features under normal conditions, and to arrange the pose before letting in bright light. Having attained the desired position, the light is arranged by opening the blinds where required. In this way it is much easier to notice the different effects of light and shade than by having the full amount of light open and gradually cutting it off.[14]

14. *Cassell's Cyclopaedia of Photography,* 530.

Such manipulation of natural light continued until the invention of arc and tungsten lighting units gave such control over illumination for portraits that a creative photographer could really begin "painting with light."

POSING

THE tintypist had to use not only his knowledge of light and shade but also his skill in relaxing and positioning the sitter. A pyramidal-shaped arrangement was often used to accentuate the lines of the figure and the

Balding man, c. 1858. Three-quarter view. Ferrotype. Quarter-size plate, stamped "Griswold Patent." "A good background ought to be of neutral tint, ought to be selected as near as possible to give the idea of distance . . . that the figure may stand in bold relief" (*American Journal of Photography,* 1858).

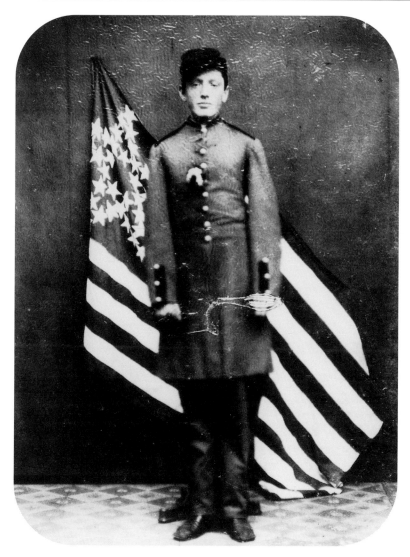

Soldier before flag backdrop, c. 1864. A field studio tintype. Quarter-size plate. The subject may have been a member of the Seventh Regiment, New York State Militia. Note the base of the headrest, making it look as if the subject is the first soldier in a long file.

appropriate accessories. For example, a soldier might rest on his sword or rifle, or a gentleman might place his hand on his walking stick to give balance to the portrait. Although it could be difficult to attain an aesthetic pose for a man, women's figures and dress typically presented a graceful outline (see pp. 17 and 25). Children were supported by parents or by each other. A concealed metal headrest was used to support older children and adults, although the base of the stand was often visible at floor level, making some male subjects look as if they had three feet.

Examination of many tintypes shows that long-faced or hollow-cheeked subjects were typically photographed with their face turned

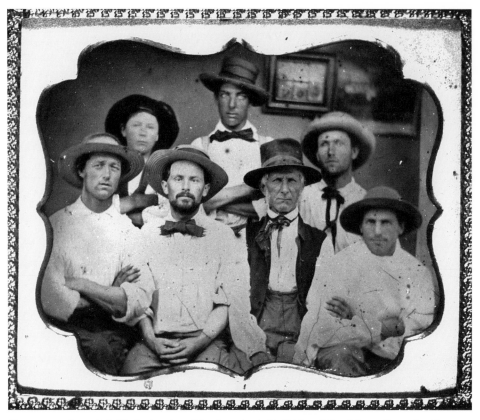

Group portrait, c. 1858. Sixth-size plate. The tintypist A. B. Tubbs of Harrisburg, Pennsylvania, arranged this group in an almost pyramidal composition, with the patriarch central to the image. Courtesy George Whiteley IV.

slightly away from the camera. Profiles were rare. For full-length portraits, the photographer would raise the camera to about two-thirds of the subject's height. The same procedure held for half-length standing figures. When the subject was seated, the lens was at about chin height. Estabrooke suggested that tall people should stand only for three-quarter or half-length photographs, and that short, stout subjects should have bust-style pictures or vignettes. Many photographers with a background in art were influenced by the rules of portraiture, while painters began to be influenced by the photograph's directness.

The group photograph was the best-paying aspect of the tintype business, because everyone in the group wanted a picture. The usual charge was twenty-five cents for each person in the group over the price of a single picture.[15] The experienced operator used a flood light to cover the group, as much light as possible for short exposures, and no headrests.

15. Trask, *Practical Ferro-typer*, 9.

For large groups, a plain background was excellent. Depending on the group's size, two or three separate backgrounds might be joined together. To fill space, a curtain might be draped on one side of the group and a table placed on the other.[16] The photographer instructed the members of the group in the proper placement of the hands and the position of the head and eyes. Above all, it was important to remain still, sometimes for ten to thirty seconds. When standing without moving a muscle or blinking, this is a very long time.

16. *Philadelphia Photographer* 8 (1871): 10.

VIGNETTES AND MEDALLIONS

IN the 1850s many people preferred the "vignette portrait." The vignette was made by interposing a white, oval cardboard frame between the sitter and the camera. The frame, which had an inner notched circle, was attached to a tripod base so that its height could be adjusted. When placed close to the camera and out of focus, the frame created a blurred

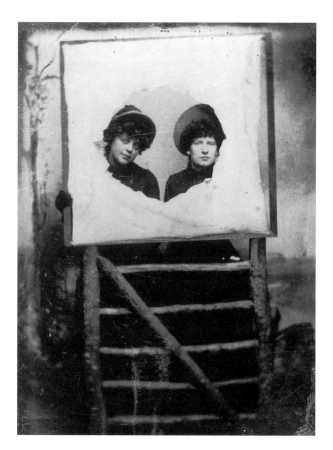

A vignette portrait, c. 1883. Bon-ton. An interesting portrait that shows the vignette frame above a rustic studio fence. Courtesy George Whiteley IV.

dressed statesman, for example, would be unlikely to want a picture of himself in a rose bower. Instead he might choose a setting of painted bookshelves and draperies, with appropriate foreground props suggesting an urban drawing room and a level of literacy and culture. Or, as outdoor scenery became popular, people who rarely left the city might wish to be seen in a rural setting.

The staging of photographs with three-dimensional props and the realism of photography itself may have influenced scenic design in nineteenth-century theater. Daguerre's Diorama, with its trompe-l'oeil backgrounds, realistic lighting, and mobile staging, was fifty years ahead of developments in traditional theater. And the stereo viewer, with its amazingly realistic three-dimensional photographic representations of landscapes—especially series of romantic or comic tableaux and allegories—may also have had some effect on theatrical staging. At the height of the popularity of the tintype and the stereograph in America, the Irish play-

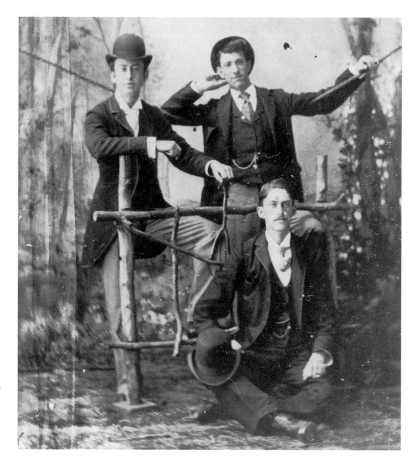

Three men with derby hats, c. 1879. Bon-ton. These jaunty young men are in a rather dramatic pose, one supporting himself on a rope and the others propped up by a section of rustic fence. The artificial grass and the painted woodland background were found in every Victorian photographic studio.

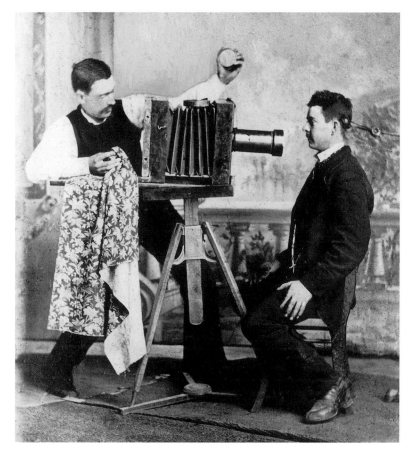

Ready for action, c. 1895. Bon-ton. A theatrical pose by the photographer Warren D. Hover of Warsaw, Indiana. His assistant, a Mr. Shoemaker, sits transfixed as the artist, timer in hand, exposes the plate. Courtesy J. C. King.

wright and actor Dion Boucicault helped establish both the box set and the use of real furniture as acceptable alternatives to painted backdrops.

The photographer appeared as a character on the American stage as early as 1859, in Boucicault's drama *The Octaroon*. The author apparently knew something—although not much—about the photographic process. His character Scudder may well have been a traveling tintypist, as the play's dialogue suggests:

SCUDDER: Just turn your face a leetle this way—fix your—let's see—look here.

DORA: So?

SCUDDER: That's right. [*Putting his head under the darkening apron*] It's such a long time since I did this sort of thing, and this old machine has got so dirty and stiff, I'm afraid it won't operate. That's about right. Now don't stir.

PAUL [*an onlooker*]: Ugh! She looks as though she war gwine to have a tooth drawed!

SCUDDER: I've got four plates ready, in case we miss the first shot. One of them is prepared with a self-developing liquid that I've invented. I hope it will turn out better than most of my notions. Now fix yourself. Are you ready?

DORA: Ready!

SCUDDER: Fire!—one, two, three. [*Scudder takes out watch*]

Later, Dora, eyeing the results, exclaims: "O, beautiful!" The gratified photographer replies:

SCUDDER: The apparatus can't mistake. When I traveled round with this machine, the homely folks used to sing out, "Hillo, mister, this ain't me!" "Ma'am," says I, "the apparatus can't mistake." "But, mister, that ain't my nose." "Ma'am, your nose drawed it. The machine can't err—you may mistake your phiz but the apparatus don't." "But, sir, it ain't agreeable." "No, ma'am, the truth seldom is."[20]

20. Dion Boucicault, *The Octaroon*. In *Best Plays of the Early American Theatre: From the Beginning to 1916*, ed. John Gassner (New York: Crown Publishers, 1967), 194–95. The first performance of the play was at the Winter Garden in New York City on December 5, 1959. See A. H. Quinn, *Representative American Plays* (New York: Century Publishing Co., 1919), 424.

Later in the play, a photograph made in Scudder's "self-developing" camera becomes the crucial evidence that shows a murderer in the act and saves an innocent person from Victorian justice. The dry-plate tin-type camera, and later Edwin Land's Polaroid camera, would surpass Scudder's, and long before the end of the century photoelectronic images would become forensic evidence in cases far more important than the one in *The Octaroon*.

Boucicault's one-time secretary David Belasco (1856–1931) later became one of the great influences on photography, theater, and film, renowned for bringing a sense of realism to the American theater. His spectacular technological effects included the creation of storms and the substitution of floodlights for footlights to simulate sunlight. He was also known for attention to minute details in his productions, including *Madame Butterfly* (1900), *Du Barry* (1901), and *Lulu Belle* (1926). In an expression reflecting the synergistic relationship between photography, the motion picture, and theater, Belasco described one of his sets as "scrupulously photographic in quality to the last spoon and fork."[21]

21. Quoted in Garff B. Wilson, *Three Hundred Years of American Drama and Theatre, from Ye Bare and ye Cubb to Hair* (Englewood Cliffs, N.J.: Prentice-Hall, 1973), 252.

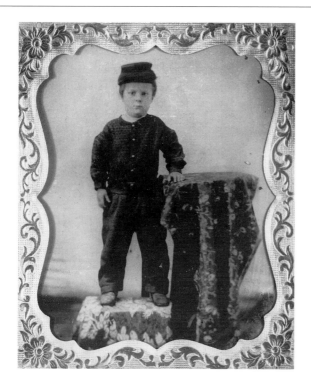

Boy in Union soldier's costume, c. 1863. Quarter-size plate.

Seated woman, c. 1865. Ferrotype. Quarter-size plate, stamped "Griswold Patent." This pleasant-faced woman sits before a typical studio background.

An early headrest. The sitter's head was firmly clamped into position during the making of the portrait. Restless children were sometimes bound to a chair with a sash, placed on a well-padded sofa, or held by a parent, who was often off-camera. From *Photographic Mosaics*, 1870.

ACCESSORIES

THE use of accessories or props goes back to the earliest days of photography. Some props enhancing the human image were symbolic: a leather-covered book in the hand or on a marble-topped table, drapery in graceful folds, Ionic or Corinthian capitals on fluted plaster columns, rail or picket fences, rustic gates, balustrades. Other props were necessary to help keep the sitter's head steady. Children not posed with headrests often sat on a sofa for support; adults posed in deeply carved chairs would rest their arm on the chair and their head on their hand.

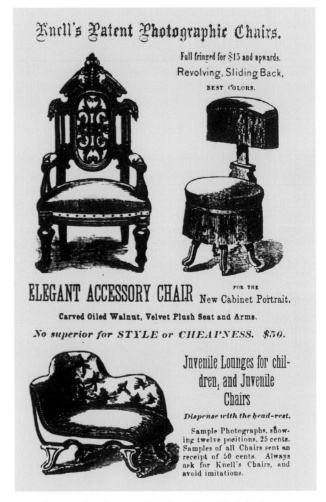

Advertisement for photographic chairs. Special chairs for portrait studios have continued to the present day, although few would now include "carved, oiled walnut, velvet plush seats and arms."

From an advertisement for studio accessories. Decorative vases, stands, and urns were used to add a pleasing touch to portraits that would otherwise be drab. *Photographic Mosaics,* 1870.

There were also obviously contrived artifacts—trailing ivy, artificial grass, imitation rocks, and cardboard canoes for sportsmen who wanted to be pictured against a fictitious lake or river. Most writers of photography manuals, however, advised simplicity in compositions and studio arrangements.

THE CAMERA

THE central piece of equipment in the operating room, of course, was the camera, with its origins in the camera obscura and its future in twentieth-century photoelectronics. The usual studio camera of the mid-nineteenth and early twentieth centuries was a mahogany or rosewood box held together with brass screws and fittings and supported on a substantial stand or tripod. Focusing adjustments were made with a rack-and-pinion system, a bellows extension, and lenses of various focal lengths. Studio portraits were generally made with long focal length lenses—twelve to sixteen inches for an 8" x 10" or an 11" x 14" plate. Wide apertures, on the order of f.3.5., were typical. Brass slides with holes representing various aperture sizes were inserted between the glass components in the lens barrel. They were described by John Waterhouse in 1858 and were called

A nineteenth-century studio camera on an adjustable stand. A repeating back, shown below, enabled two or more exposures to be made on the same plate. Panel A has an aperture the size of the required picture, with grooved rails B and C for the plate holder or the focusing screen. Spring bolt D goes in either of the two slots in the edge of the plate holder to bring each half of the plate into position as successive images are made.

22. Letter from Waterhouse to the *Photographic Society Journal* (July 1, 1858).

23. Published by Susse and N. P. Lerebours, October 1839 (G. Cromer, *Revue française de photographie* [1930], 154). Séguier was apparently also the first to suggest a leather bellows to make the camera more portable (1839). See Josef Maria Eder, *History of Photography,* trans. Edward Epstean (1945; New York: Dover, 1978), 255.

24. Southworth's first patent for a multiplying camera (two images for stereo daguerreotypes) was patent no. 11,304, issued July 11, 1854.

25. Patent no. 30,850 for such a camera was issued to Simon Wing on December 4, 1860.

"Waterhouse stops."[22] The camera tripod had been introduced as early as 1839 by Baron Armand Pierre de Séguier, as an annotated edition of Daguerre's original pamphlet indicated.[23]

In 1855 the Boston photographer Albert S. Southworth was granted a patent for a camera with four lenses, each of which produced an image 13 mm square on a single plate. The camera also had a repeating or sliding back, which made it possible to expose one part of the plate, cover it after exposure, and slide the unexposed part in position for another set of images. Southworth claimed that on a 12" x 15" plate he could make 616 exposures and produce 50,000 pictures in an hour![24]

In 1860 Simon Wing, another Boston photographer, acquired the rights to Southworth's four-lens camera and improved it with a mechanically calibrated device that would fulfill Southworth's promise that up to 616 evenly spaced half-inch images could be made either on an 11" x 14" glass plate or as a tintype.[25]

The tintype was much cheaper than the glass-plate process, as the

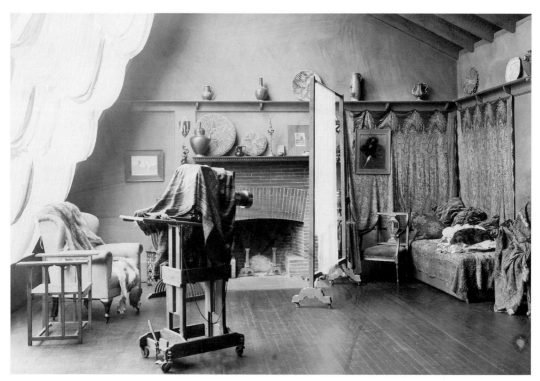

The camera occupies the center of the studio of the Victorian photographer Frances Benjamin Johnston of Washington, D.C. Years later, writer James Agee referred to the camera as "the central instrument of our time." Courtesy Library of Congress.

Stereo view of girl with doll. Tintype on Victoria-size plate (3½" x 5"). Stereo tin-types were not popular because of their lack of brilliance. From the John and Janet Waldsmith Collection.

images could be separated with a pair of tin snips and given to the patron almost immediately. Charles Seely detailed the virtues of Wing's multi-plying camera in a long article in the *American Journal of Photography,* illustrating its merits with half-inch tipped-in paper photographs. Ex-cerpts from Seely's comments were reprinted in the British *Photographic News,* which quoted Wing's amazing description of the camera's ultimate potential: "By making four at a pop, and moving once in two seconds . . . we have our negative in about five minutes; now we will run ten [11" x 14"] plates through the machine; . . . now one man can print from each in about two minutes . . . 30 in an hour; so if we multiply 30 by ten plates, making 300, and then 616 by 300 we have 184,000 photographs." [26] Wing was stretching theory and exaggerating the practical, but the num-bers in his presentation were indicative of the trend toward mass pro-duction and duplication.

Cameras designed to take more than one image on a single plate were in general use when Wing's patent was issued.[27] The twin-lens stereo camera, common by 1860, was much used by Brady, Gardner, and O'Sul-livan during the Civil War. Prints of only half of the stereo negative were usually made, but looking through a Holmes viewer at both gave the best effect. Tintype stereo views were also available, but they lacked the re-flective quality of the albumen prints. Variations on the multiple-lens camera continued to appear into the first decades of the twentieth cen-

Schematic of Wing's multiplying camera.

26. *Photographic News* (August 2, 1861), 361–62. Wing's camera was hailed as a great advance in photography.

27. The history of multiplying cameras goes back as far as 1846. C. C. Shoonmaker claimed that he had made two to five pictures on one plate in 1848 and 1849. Also see *Philadelphia Photogra-pher* 6 (1869): 211–12.

tury. Itinerant tintypists and studio photographers alike favored them for cartes-de-visite.

DARKROOM SECRETS

PREPARING and developing tintypes began and ended in the darkroom, where the mysterious, toxic chemistry of the process produced, as if by magic, an image of a loved one. The darkroom was not completely dark, but rather murky. Coating the plate with collodion could be done in daylight, but for the rest of the process white, or actinic, light from cracks in walls, windows, or doors had to be excluded. The room could be lit by a pane of yellow or orange glass in a small window or skylight, since photographic plates of the time were insensitive to light in the yellow-red range of the spectrum. On dark days a gas jet turned down low was used.[28]

The tintypist's darkroom was a cramped but efficient work space.[29] The recommended size for the darkroom, which adjoined the operating room, was about five feet square or, if rectangular, slightly larger. Furnishings were simple. A principal requirement was a water tank big enough to supply running water for repeated washings of the day's work. Above the water tank was a flat workbench with several troughs leading to the tank's reservoir.

The bench was typically divided into four parts, one for each of the basic steps involved—coating, developing, fixing, and washing the tintype.

28. Estabrooke, *The Ferrotype,* 61–66, contains an excellent account of darkroom arrangements, detailing both the water-tank operation and the apparatus and divisions needed.
29. W. Heighway, "The Ferrotype—How It Is Made," *St. Louis Practical Photographer* 5 (1881): 81.

Advertisement from the *Philadelphia Photographer,* 1864. Photographic developing trays were made of earthenware, gutta percha, porcelain, and glass. The popular "Photographic Ware" mentioned above was an invention of George Mathiot.

One shelf over the workbench or along a wall held a stock of collodion bottles and boxes containing plates of various sizes. A second shelf contained sensitizing bath implements and dishes. A third was used for the developer and the necessary glass bottles, tubes, funnels, and other utensils. Containers of potassium cyanide, used for clearing the tintype, occupied a separate shelf. Cyanide was only one of the toxic chemicals nineteenth-century photographers handled, and while most were aware of the dangers, many were harmed by fumes generated in their small and often poorly ventilated darkrooms. Some darkrooms had only a small opening at the floor level, while others had vents in the ceiling that admitted downdrafts; neither of these circulated the air properly. Improved darkroom designs first appeared in the larger photographic establishments.

Selecting the Plate

The first step in preparing the tintype for exposure in the camera was to select the desired plate size. Tintype plates came stacked in cardboard boxes that usually held from two dozen to eight dozen plates. Ten-by-fourteen-inch plates came two hundred to the box, either in eggshell or glossy finish (after 1870 also in chocolate and black). Having tintype plates ready for use was a radical change. The daguerreotypist had had to buff and polish his silvered plates to perfection to produce a fine image; the ambrotypist had had to clean his glass plate carefully and, in a separate operation, painstakingly polish it. But the tintypist just dusted his japanned iron plate with a cloth or soft brush to ready it for collodion.[30]

Coating the Plate with Collodion

Collodion is a solution of Pyroxylin (nitrocellulose, or "guncotton"), alcohol, and ether. Because of the toxic and highly inflammable chemicals involved, photographers preferred to buy this "plain" or ready-made collodion from a photographic supply house. They could also obtain it from druggists, who concocted it from the formula found in the *United States Pharmacopeia,* since collodion was also used to cover wounds. Wet-plate photographers then added iodide of ammonium, bromide of cadmium, and other sensitizing chemicals to make it into photographic collodion, often including their own special ingredients.[31]

One of the "secrets" of collodion preparation was determining the correct amount of cadmium and ammonium. In the right proportions, these chemicals helped form the creamy, opaque film that hid many of a

30. The reason almost all tintypists preferred collodion as an adhesive over the equally adhesive albumen was that collodion provided a much greater and more positive range of shades, shadows, and special effects.
31. By 1870 tintypists could save themselves the trouble of mixing plain collodion and photographic collodion, since a number of commercial photographic supply houses carried different brands of well-balanced mixtures. W. H. Tilford of St. Louis, for example, listed both "positive collodion" and "silver bath solution" (Estabrooke, *The Ferrotype,* advertisement). Whether tintypists continued to make their own collodion after the mid-1860s is unknown. Both the tintype and the glass negative used the same chemicals, so there is no way to conclude how many tintypists bought their chemicals ready-mixed.

glass plate's defects. In winter the water content in alcohol and ether (if any) had to be kept low. A high water content would produce a network of tiny cracks that marred the portrait's surface. If kept too long, collodion would turn very brown or dark red and lose its sensitivity. Adding a few drops of oil of cloves was recommended to restore it to its former usefulness.[32]

Mixing the photographic collodion in the proper proportions was a matter of trial and error. The mixture had to be clear and devoid of floating particles, yet thick enough to form a film on the iron plate. Experience also taught the operator to know the point at which the film had covered the plate with perfect smoothness, without waves, ridges, or lines, and when it had the proper acidity to retain the desired sensitivity.[33] After being compounded, the photographic collodion was put into a large, lightproof bottle or flask.

To coat a plate the tintypist would grip it with one index finger and thumb, pour the collodion onto the middle of the plate, then rotate and tilt it slightly to ensure a smooth distribution of film over the entire plate. An adept operator could return surplus collodion to the bottle without spilling a drop. Photographic collodion was fast-drying; within a few seconds of pouring, it could be fingernail-tested on the corner from which the surplus liquid had been drained. When the collodion had hardened to a tacky surface, the plate was sensitized in the silver bath.[34]

The Silver Bath

An important darkroom secret was the proper preparation of the silver, or "exciting," bath. The bath included at least four ingredients: silver nitrate, potassium iodide, nitric acid, and distilled water. A drop of the silver nitrate bath would stain the tintypist's skin and the wood parts of the camera. All apparatus and bottles used for the bath had to be kept separate from the other equipment. The bath's ingredients went into an upright, box-shaped gutta-percha dipping vat, a simple homemade wooden box with roofing tar as a liner, or a glass-lined wooden container.[35] The sides of the dipping vat were made slightly concave so that they would not touch the plate. Other working tools included a large, glass-stoppered bottle with a capacity of half a gallon or more, a dipping rod of glass for lifting the plate into and out of the bath, a calibrated six-ounce beaker, and a glass or gutta-percha funnel.

32. Charles Waldack and Peter Neff, *A Treatise of Photography on Collodion* (Cincinnati, 1857), 21. Heighway, in "The Ferrotype—How It Is Made," suggested that a few grains of carbonate of soda could restore aged collodion to its original color. For a collodion accelerator, see *St. Louis Practical Photographer* 5 (1881): 157.
33. Nathan G. Burgess, *The Photograph Manual* (New York: D. Appleton, 1863), 139.

34. Estabrooke, *The Ferrotype*, 152–53, gives a complete account of pouring collodion on a plate.

35. See *Humphrey's Journal* 8 (1856): 323.

The same care and skill used in preparing the collodion was needed for mixing the chemicals for the bath. The strength of the collodion was closely related to that of the bath, each complementing the other. When the compound for the bath was satisfactory, it was filtered through alcohol-saturated cotton to sterilize it. The alcohol was then washed away with water, and the bath was poured through the wet cotton until the milky hue disappeared, and the bath became as clear as pure water. A half ounce of carbonate of soda dissolved in two ounces of water helped make an acid bath more neutral. A small amount of acid in the bath was necessary to produce the desired tone or effect and to complement the photographic collodion. The finest white tones came from adding eight or ten drops of nitric acid to the bath. If the same amount of "glacial acid" (acetic acid) was added for stability, the bath would work with "great regularity." A well-balanced silver bath could last for years in good working order if "more iodide of silver and a few drops of Acid" were added from time to time.[36]

36. Heighway, "The Ferrotype —How It Is Made," 158.

After the collodion dried to a tacky finish, the plate was put on a glass hook-lift and steadily and evenly lowered into the dipping vat. When fully submerged, it was moved around gently for a few seconds and then left in the liquid for about two minutes. Larger tintype plates required special handling in larger vats.

When the plate was lifted from the bath, it was allowed to drain a few seconds before being placed in a plate holder, often referred to as a "photographic frame." The tintypist handled the plate with care while it drained, since any excess fluid, if splashed on the plate, caused dark spots on the finished image.

The operator had to get the wet, sensitized plate in its holder to the camera before the plate dried. In the operating room the photographer had posed the sitter, adjusted the lighting and the focus, and replaced the cap on the lens. After removing the focusing ground glass, replacing it with the place holder, and removing the lens cap, the photographer had to determine the correct timing for the exposure—normally about five seconds for studio portraits. A poor exposure canceled the most artistic posing, the best lighting, and all the darkroom magic. After the lens was capped, the exposed plate was closed off in the photographic frame, removed from the camera, and returned to the darkroom for the final stage of the process—development.

Developing, Fixing, and Washing the Tintype

The standard formula for the developing solution was sixteen parts of water to one part of ferrous sulfate and one part of glacial acid. Pyrogallic acid was sometimes also used. In the darkroom the operator removed the plate from the photographic frame, gripped it tightly on one corner, and in a continuous flowing motion poured enough developer to cover it completely and quickly, tilting the plate to ensure even coverage. Collodion side up, the plate might also be developed in a tray, rocked to prevent uneven development. In the murky light of the darkroom the highlights would first show up on the plate, but before the deeper shadow areas appeared on the backgrounds or drapery, the tintypist (or ambrotypist, since both desired a thin or light negative) would drain the developer from the plate, funneling the surplus into a large container for future use. The plate was immediately and thoroughly washed with water, then placed in a tray of fixing solution, at which point the operation could be conducted in daylight.

The simplest and easiest step in the whole process was fixing the picture, that is, making it permanent by removing the unexposed silver. Two chemical solutions were used for this purpose: either forty ounces of hyposulphite of soda mixed with a pint of water and well-filtered, or cyanide of potassium—the more common choice for tintypes. Potassium cyanide, although highly toxic, could be removed by washing for a minute or two, while plates fixed with "hypo" needed to be washed for at least five minutes before they were completely free of the fixing solution.

The plate was then dried by holding it carefully over a spirit lamp or putting it in a wedge-shaped stand and gently heating it with gas. The completed tintype, if successful, then went to the finishing room for varnishing and coloring.

The tintypists' creed was "Waste not, want not," and they found ways to reclaim some of the silver they used long before silver recovery became automatic in professional and industrial photographic laboratories. In 1881 Heighway wrote, "A first-class silver-saving apparatus may be made of an old felt hat, bound firmly over a hoop. By developing over this, the greater portion of the waste is caught, the rest being retained in the tank."[37]

37. Ibid., 82. All accounts of the tintype process agree on the economy of recovering silver from darkroom operations.

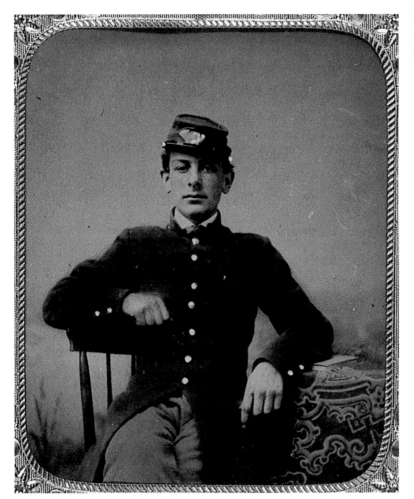

Seated Union Soldier.
c. 1863. Bon-ton. A pristine
gallery tintype.

Portrait of a woman, c. 1859. Tintype. 8" x 10". This portrait follows the traditions of the daguerreotype and of portrait painting. The gray, gold-edged mount is inside a 7" x 10" oval mat.

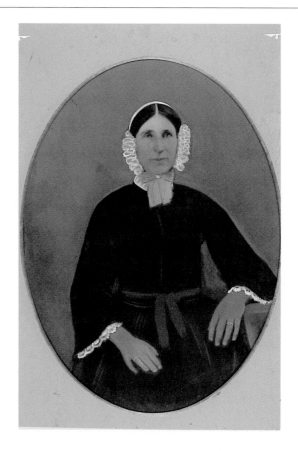

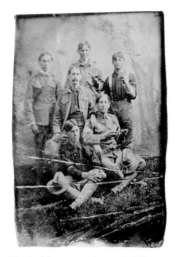
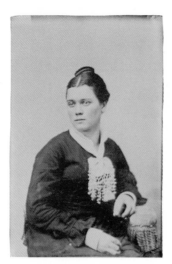
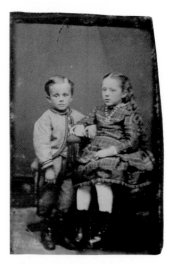

Typical bon-ton plates of different tones, from black and white to chocolate. Collection of Robert W. Wagner.

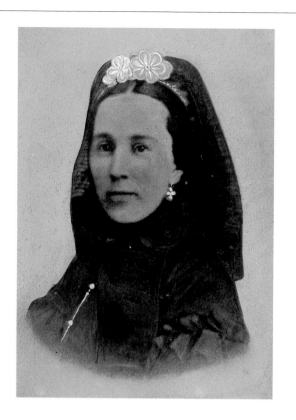

Woman with headdress, c. 1871. Tintype, 6½" x 8½". An artist has etched the ornament on the headdress and other jewelry in white.

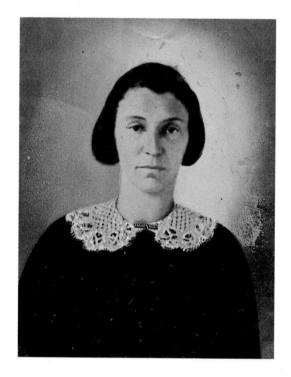

Woman with lace collar and gold brooch. Whole plate. c. 1865. Collection of Robert W. Wagner.

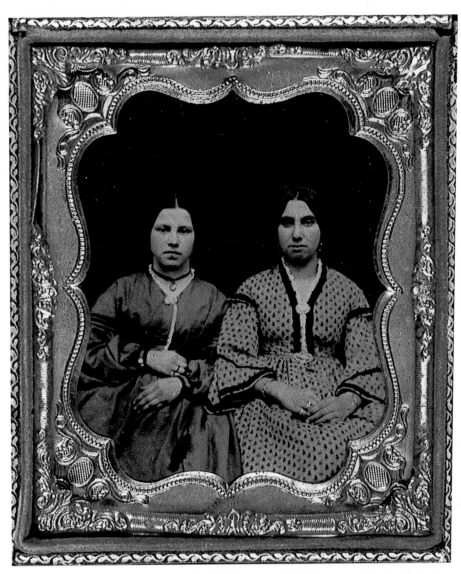

Portrait of two young women, c. 1858. Melainotype. Sixth plate size. An excellent costume piece.

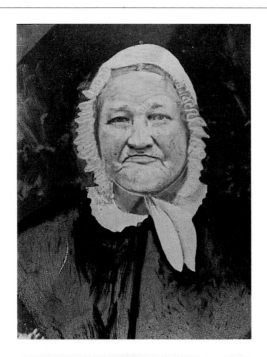

Portrait of an elderly
woman wearing a
matron's cap, c. 1866.
Tintype, 8" x 10".

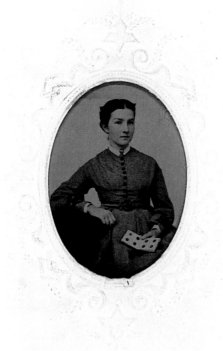

Woman holding gem
album. Gem in paper
mount. Collection of
Robert W. Wagner.

Young man. Oval cut from whole plate. c. 1870. Collection of Robert W. Wagner.

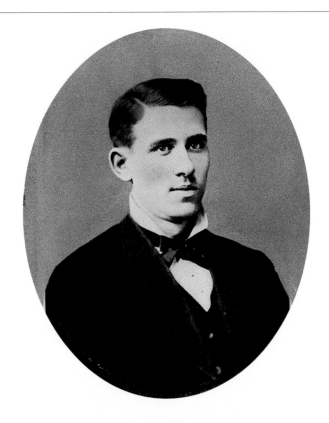

A portrait of woman, c. 1867. Tintype, 8" x 10".

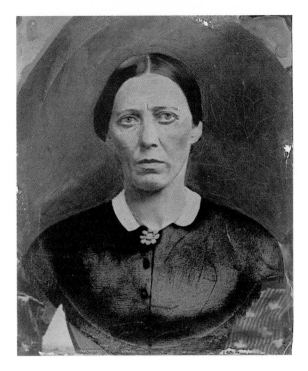

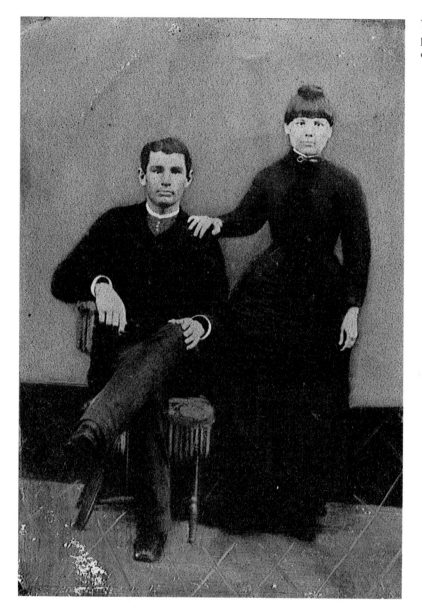

Young couple. Whole plate. c. 1870. Collection of Robert W. Wagner.

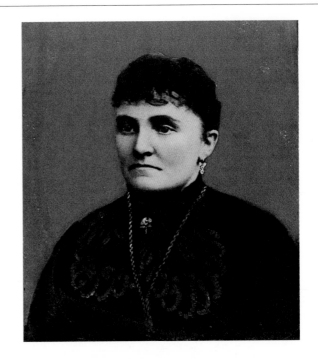

Woman with gold earrings and gold chain, both lightly distressed. Whole plate. c. 1870. Collection of Robert W. Wagner.

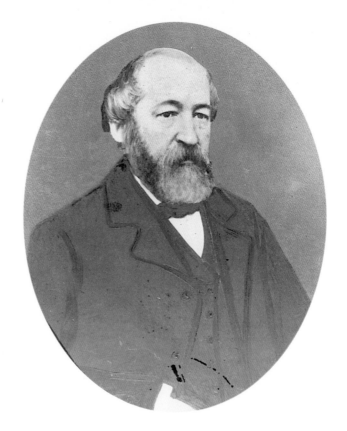

Portrait of John M. Strozier, Wilkes County, Georgia. Tintype, 6" x 9". Finished with India ink. Courtesy Robert Willingham.

Chapter 4

FINISHING, COLORING, AND ADVERTISING THE TINTYPE

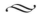

THE delicate daguerreotype had to be placed under glass in a case to protect its fragile surface, and the same was true of the ambrotype glass negative.[1] Although melainotypes and ferrotypes were also sometimes cased, these durable iron-based photographs needed only a coat of clear white shellac or varnish to seal and protect their collodion surface. When the varnish or shellac dried, brush marks and other imperfections were eliminated.

1. See Floyd Rinhart and Marion Rinhart, *American Miniature Case Art* (New York: A. S. Barnes, 1969).

The slowest part of the tintype process was drying the varnish. The problem was partially solved in 1872 by a simple device similar to a roof vent. The lower part of the dryer was a section of stovepipe encasing a spirit lamp. Above the pipe was an 11" x 14" rectangle of sheet metal that formed the base for the drying rack. Two sheets of metal, one on each side, rose at a slant from the outside of the base to the apex. The ends of the rack were sealed, and small ventilation holes were made along the peak. The varnished tintype was placed on the sloping surface, where the gentle heat from the spirit lamp speeded up the drying process.[2]

2. *The Photographic World* (1872): 383.

COLORING THE TINTYPE

THE reproduction of "natural" or "true" color in photography has been a major goal throughout the history of the medium.[3] As early as 1843,

3. See Brian Coe, *Colour Photography: The First Hundred Years, 1840–1940* (London: Ash & Grant, 1978).

PATENT'D OCT. 15, 1863, S. WING, 290 WASHINGTON ST., BOSTON

A gem in a decorative paper mount, c. 1863.

Portrait of a young woman, c. 1864. Wing's patented gem tintype.

to be found in pockets, wallets, or purses—the places where today's snapshots of family and friends are found. The tintype was clearly adaptable to many different purposes.

ADVERTISING THE TINTYPE

ADVERTISING was essential to success, and early photographers often showed a flair for showmanship and marketing. For example, George Parke, who had served as a tintypist's business solicitor, or "caller-out," adapted a song from Gilbert and Sullivan's *H.M.S. Pinafore* (1878) in which Sir Joseph sings of his career in the Queen's navy. Parke changed Sir Joseph into a tintypist's apprentice, one of whose jobs was to "call out" to passersby an invitation to have their likeness taken in his employer's studio. Parke rewrote Gilbert and Sullivan's lyrics:

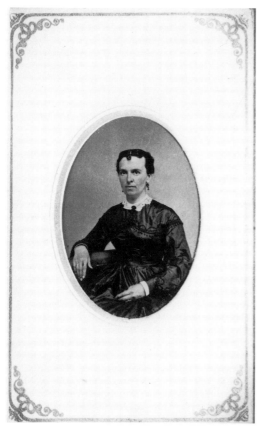

Gem tintype in decorative oval mount, c. 1864.

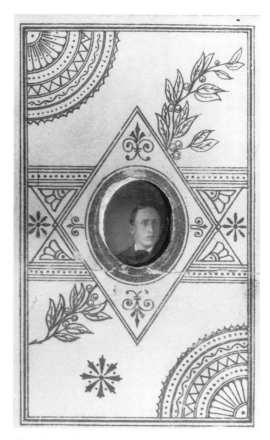

Gem tintype in geometrically designed mount, c. 1869.

When I was a boy I served a term

As a working member of a tintype firm.

And I called 'em out and I called 'em down

And I tramped all over the hull durned town![9]

9. George Parke, "The Tintype Photographer of the Seventies." *Photo-Era Magazine*, vol. 62, 1929, p. 194.

Studio exteriors were covered with signs and billboards. The traveling tintypist posted his ads on his wagon, boat, tent, or seaside concession. He published notices in local newspapers and in photographic journals and magazines. The manuals published by Waldack and Neff, Griswold, and Estabrooke advertised their products while instructing their clients. Tintypists' names rarely appear in histories of photography, but they were printed on the front or the back of the paper mounts into which their photographs were inserted, and they were sometimes pasted on the reverse side of a tintype. A tintypist with broader concerns than how to

Advertisement for E. J. Leland. Leland featured Wing's camera in this notice in the 1866 Worcester, Mass., city directory.

E. J. LELAND,
PHOTOGRAPHER,
Harrington Corner, WORCESTER, MASS.

☞ The only place in the City where Gems are made with Wing's Patent Combination Camera. Photographs of all kinds, from Card to Life Size, finished in Ink, Water or Oil. Ambrotypes and Tintypes, all sizes, with prices to correspond.
All Work Warranted to give satisfaction.
☞ Children taken successfully, as specimens at Rooms will show, where all are invited to call and examine.

focus a camera included on the back of one of his tins a small printed "Petition to the 'Almighty Dollar,' for the benefit of the people":

> O Mighty Dollar, god of our forefathers,
> twofold god of their children, and threefold
> god of their grand-children. We acknowledge
> thy sovereign power over all men. With
> kings, courtiers, and beggars, we bow before
> thy throne. Draw near unto us, we beseech
> thee, in all thy decimal parts. We need
> thee every hour; without thee we can do
> nothing; with thee all things are possible.
> Thou canst marshal armies, create navies,
> unlock prisons, tunnel mountains, build
> subways, buy tintypes, level forests, cause cities
> to rise, the desert to bloom like a rose, thou canst
> outride the wind, harness the lighting,
> put a crupper on the tail of a commet [*sic*], make

D. J. Ryan was part of E. & H. T. Anthony's nationwide network of wholesale dealers. Advertisement from Estabrooke, *The Ferrotype, and How to Make It*, 1872.

D. J. RYAN & CO.,
IMPORTERS AND DEALERS IN
Photographic and Ferrotype Apparatus and Materials,
SAVANNA, GEORGIA.
Southern Depot for E. & H. T. Anthony & Co.'s Goods.
STEREOSCOPIC VIEWS OF ALL PARTS OF THE WORLD.
Mouldings, Frames, Chromos, Albumen Paper, Albums, Glass, etc.

FROM

Tennant & Maurice's
"GEM GALLERY."
OLD DAGUERREOTYPES, AMBROTYPES
AND PHOTOGRAPHS·
Copied and Enlarged from Miniature to Life Size.

5

Gem Pictures for 25 Cents!
FINISHED IN TEN MINUTES,
—AT THE—
"GEM GALLERY,"
No. 311 N. FOURTH STREET,
Opp. Everett House,
ST. LOUIS.
All Styles of Pictures at Moderate Prices.

The back of a carded tintype from Tennant & Maurice's Gem Gallery, c. 1868. The photographer's name and address, when imprinted on nineteenth-century photographs, adds to their authenticity and value. The text shown here advertises prices, fast processing (ten minutes), and copies and enlargements from daguerreotypes and ambrotypes, which by 1868 were already considered antiquated forms of photography.

an alderman out of pesky poor materials,
send [a] lunkhead to Congress, and perpetuate
the memory of a jackass by a tall monument
and a lying inscription. At the Star Studio
Thou art a janus-faced wizard. Thou puttest
the Bible in a man's left hand the sword in his
right; thou leadest one man to the alter [*sic*] and
another by the halter. Thou art the twin-
sister of Charity, yet maker of misers and
murderers, and oft turnest away from the
painter and the philosopher to smile upon
the dude, the dunce and the devil. LUTZ[10]

10. John Waldsmith, who found this "prayer" on the back of a tintype by John N. Lutz, the operator of the Star Studio in Portsmouth, Ohio (c. 1878–80s), observed in a July 26, 1996, letter to the authors, "I enjoy that he has placed 'buying tintypes' between building subways and leveling forests!"

The tintypist made sure that his work went beyond the larger considerations of "art" and "truth" to the smaller but necessary one of keeping his name and business well in the public eye.

The emblem of Albion K. P. Trask of Philadelphia, c. 1872. In 1872 Trask published *The Practical Ferrotyper,* which was both a manual and an example of self-advertisement. Similar books and manuals by Griswold and by Neff and Waldack served the same purpose.

Advertisement for A. B. Farrar's Studio, Bangor, Maine, c. 1870. As competition increased, prices of tintypes plummeted from twenty-five cents for five gems to the same price for three dozen, as in this notice, which also announces photographs made "AT NIGHT, By the Wonderful Invention, Magnesian Light."

Chapter 5

TINTYPE FORMATS
AND MOUNTINGS

STANDARDIZATION of plate sizes began with Daguerre. His often-used 6½" x 8½" copper-based and silver-coated plate became widely known as a whole plate. The daguerreian sizes and formats carried over into the wet-plate era. But because of its durability and flexibility, the tintype lent itself to a greater variety of shapes and sizes.

THE CARTE-DE-VISITE

ONE of these forms was the carte-de-visite, a small paper portrait on a cardboard mount, which became popular in America after its appearance in France. An early suggestion for the use of small portraits as visiting cards was credited to Edouard Delessert and Count Olympe Aguado, who wrote in 1854:

> Up to now visiting cards carried only the name, address, and sometimes the title of the person whom they represented. Why could not the portrait of a person be substituted for the name? . . . At ceremonial occasions the visitor was to be photographed, wearing gloves, the head bowed as in greeting, etc. as social etiquette requires; in inclement weather he was to be shown with an umbrella under his arm; when taking leave a portrait was furnished in traveling costume. From that time the term "carte-de-visite" came into general use for portrait photographs of this small size.[1]

1. *La Lumière*, October 28, 1854.

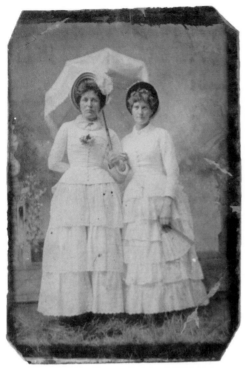 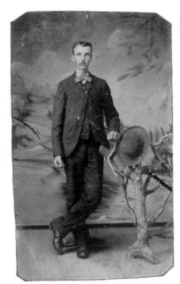 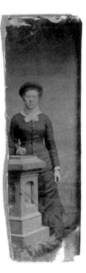

Left: Two women with an umbrella. Bon-ton. c. 1884. The bon-ton approximated the size of a c.d.v., but the dimensions of a finished tintype varied widely. The woman on the left is the grandmother of author Robert W. Wagner. *Center:* Compared to the size of the bon-ton (c. 2⅜" x 3½"), this tintype (c. 1½" x 2¾") was probably made by the photographer to fit a specific case or a paper envelope. *Right:* A tintype possibly clipped by a patron to remove an unwanted person or feature.

In 1857 the duke of Parma was one of the first to have his portrait fastened to his visiting card. A. Ferrier, a well-known and inventive professional photographer working in Nice, was one of the first to produce these cards photographically. However, it was André Adolphe-Eugène Disdéri who popularized, and in 1854 patented, this form in Europe after Napoleon III, on his way to war in Italy, sat for a series of cartes-de-visite in Disdéri's Paris studio. Portraits of kings, queens, military leaders, theatrical personalities, and other notables soon appeared in quantity on these 2¼" x 3¼" paper photographs.

When the American artist and photographer F. De Bourge Richards toured Europe in 1855 and visited Disdéri he became so fascinated with cartes-de-visite that, on his return to the United States, he began to produce them himself.[2] In America they were known as "visiting cards" or simply as "cards." The expression "Isn't he a card!" may have originated from these artless and sometimes amusing nineteenth-century likenesses.

2. *Photographic and Fine-Art Journal* 8 (1855): 349; 9 (1856): 120. Richards wrote an interesting and detailed account of his tour of Europe. His letters provide an insight into European photography as seen through the eyes of an American artist and photographer.

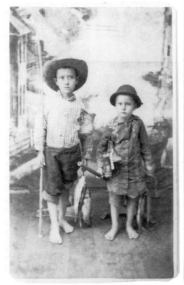

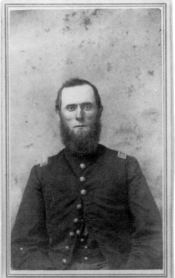

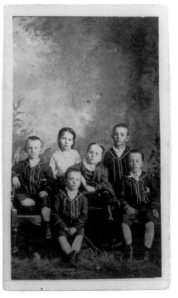

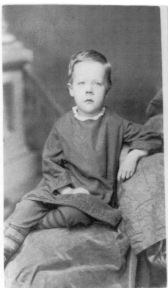

TRUE SYMPATHY.

"Whose little faces are these?"
"Inmates of the Orphans' Home, located at Mt. Vernon, Ohio."
"Bright faces! Pretty, intelligent children! Very much so! Many such children in the State homeless?"
"Hundreds of such!"
"What a pity! I do pity them!"
"How much?"
"I have not put any price upon my sympathy."
"It will not be worth anything to them till you price it and pay the price. But when your pity is valued and the price paid, it can be used for their good. And Solomon says, Prov. 19, 17: 'He that hath pity upon the poor lendeth unto the Lord, and that which he hath given will He pay him again.'"
"Why were these pictures taken?"
"To raise money for the support of the children. Do you wish to help a little? If you give Twenty-five cents or more, you can keep this picture."
The work is supported by charity, and is not sectarian, and homeless children are admitted from any part of the country.

G. W. McWHERTER,
Superintendent.

ADMIRAL DOT.
Thirteen years old ; Twenty-five inches high, and weighs only Fifteen pounds.

Cartes-de-visite, 1860s. Paper prints. *Upper left:* The background is painted, but the fish look real. *Center top:* A union officer photographed by C. Hannaman of Shelbyville, Ill. *Top right:* A group of orphans, as explained on the reverse side (shown lower right). *Lower left:* A child in a relaxed pose by the Wellington, Ohio, photographer and artist W. F. Sawtell. *Center bottom:* A typical commercial c.d.v. featuring the personalities and famous people that made them as collectible as baseball cards are today. This one was published by E. & H. T. Anthony Company at 591 Broadway, New York City. From the collection of Robert W. Wagner.

An American photo-
graphic calling card,
c. 1869. This 2" x 3½"
card was slightly smaller
than the standard carte-
de-visite or gem card.

Rev. W. W. Tait.

At first, few American photographers followed the lead of Disdéri
and Richards. At a county fair in 1859, R. L. Wood of Macon, Georgia,
displayed what were possibly the only cartes-de-visite being made in the
South. By 1869, however, the New York firm of H. C. Rockwell had begun
promoting cartes-de-visite of American celebrities. The fad spread
rapidly, and photographers suddenly enjoyed two new and different
demands—for formal portraits of the great and near great for the collector;
and for personal portraits, sometimes referred to in the nineteenth century
as "facsimiles" or "counterfeits," of the average patron. The 2¼" x 3½"
carte-de-visite (c.d.v.) of 1860 was mounted on a 2½" x 4" strip of light
cardboard. It was neat, compact, and wallet-sized.

In early 1862 the typical c.d.v. pose changed. The fashionable full-
length portrait with a chair, balustrade, column, or scenic mural back-
drop was losing favor. In its place came a new vogue—the vignette and the
bust-style portrait. These poses almost immediately branched into sepa-
rate avenues. One successor to the old-fashioned full-length pose was a
2¼" x 3½" print mounted on a standard 2½" x 4" card. The other one,
possibly because of tight money and the influence of the Wing camera,

was a much smaller and cheaper paper photograph, cut and shaped into an ¾" x 1" or fractionally larger oval, then pasted on a standard c.d.v. mount. The latter photo miniatures were called "gems."

THE GEM TINTYPE

THE history of miniature photographs began in the 1840s when daguerreotypists featured keepsake jewelry with tiny daguerreotypes set in brooches, rings, bracelets, and watch-style lockets.[3] These were beautiful but fragile. The glass negative ambrotype came into vogue in 1854, and it was also used in jewelry, but it proved unsuitable. The metal-based melainotype turned out to be much more durable and easier to work.

The tintype proved its special value in the presidential campaign of 1860, when small tintype portraits of Lincoln and other candidates decorated tokens, medals, and campaign pins.[4] The tintype was tough and

3. Floyd Rinhart and Marion Rinhart, *The American Daguerreotype* (Athens: University of Georgia Press, 1981). For illustrations of daguerreotype jewelry, see p. 313.
4. In the Floyd and Marion Rinhart Collection at The Ohio State University is an ambrotype of John C. Breckenridge (1821–75), showing the use of photography for political purposes. Breckenridge was vice president from 1857 to 1861. The ambrotype was probably used in the 1856 campaign, because by 1860 the tintype had replaced it as an inexpensive token.

A gem as it first appeared in early 1862. The gem was priced far below the c.d.v., its chief competitor. The gem plate, like that for the c.d.v., was mounted on a 2½" x 4" rectangle of thin cardboard. Prongs on the back of the card, shown in black at the right, fastened the tintype to the card. The demand for these inexpensive mementos soon reduced the demand for tintypes in cases.

An uncut gem tintype, c. 1863. Each portrait would fit into a slot in a miniature gem album.

resistant to water, air, and heat—key factors in the survival of both the image and the politician it represented.

In May 1862 *Humphrey's Journal* noted that a small-sized mat especially for gem tintypes was on the market. It was described as "a new style of putting up pictures which has been adapted to please lovers of 'the cheap.' They are taken on Neff's melainotype or Excelsior plates."[5] The new style, a small facsimile of the traditional mat and protector used for miniature cases, was manufactured as a single unit with small prongs on top, bottom, and back. When the gem portrait was placed in a standard card mount with precut slots, the prongs were inserted and bent against the rear of the card to grip the image unit tightly to the face of the card. *Humphrey's Journal* also gave sample prices: "These pictures are taken one dozen or more on one plate and sell from 75 cents to one dollar per dozen. This will increase demand for the celebrated Iron plates."[6]

5. *Humphrey's Journal* 14 (1862): 32.

6. Ibid.

The advantages of the new style of tintype carte-de-visite were described in *Humphrey's Journal* (and reprinted in the *British Journal of Photography*) in the fall of 1862:

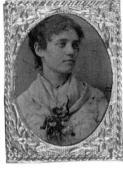

Alice Lillia Davis. Gem matted for placement in a case. Courtesy Beaumont Newhall.

For [the] carte de visite the melainotype plate has been too long and favorably known to need a statement of its advantages over every other substance employed for the ordinary collodion positives. There is, however, a new and important use to which it can be applied, and one which, from its simplicity and rapidity, will commend itself to every operator. For carte de visites to be inserted in an album, the melainotype plates are admirably adapted. It is only necessary to take, first, a somewhat larger positive proof in the style desired for the subsequent carte: this proof can be reproduced in the same, or smaller size, about as rapidly as collodion can be put on the plate. To say nothing about dispensing with silvering the paper, and the tedious processes of toning and washing the photographic prints, the rapidity of the process alone should

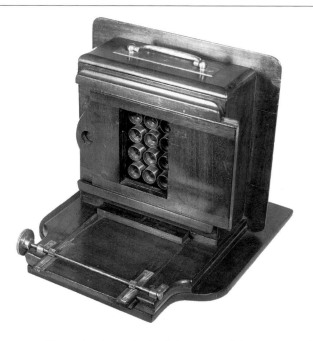

Twelve-lens camera, able to take a dozen little gem portraits at one exposure. Courtesy George Eastman House.

commend it, as also the undoubted durability of the pictures. All that is necessary before mounting, is to varnish them in the usual manner. They can be inserted in an album more readily than the cards, and far surpass them in delicacy of tone, general beauty and minuteness of detail. Many of the [paper] photographs will from defective manipulation, or from the nature of the process itself, fade or discolor in time.

The melainotype is free from any such liability. . . . If the whole trouble and time and expense of preparation are taken into account, it is certain they will be found to be better and cheaper than the ordinary photographs. . . . We commend them to all operators. . . . Many operators who can now take excellent positives cannot furnish the carte de visite, not being familiar with the method of taking good negatives and making photographic prints. Such operators, however, can at once furnish melainotype cartes.[7]

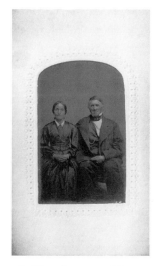

Full-length gem, c. 1864.

In August 1862 Wing's multiplying camera was making a stir in Boston and New York. "We are told that some operators, with only a small room, have netted sixty and seventy dollars per day, or eight hundred dollars per month, by using this new camera. The second size of the Patent Camera will copy and make from the face [more] than thirty different styles of

7. *British Journal of Photography,* November 15, 1862, 438. The reprinting of this article from *Humphrey's Journal* is a good example of the interplay between British and American photographic journals.

An advertisement for a carte envelope. Leading manufacturers of photographic processes such as Scovill and E. & H. T. Anthony advertised widely.

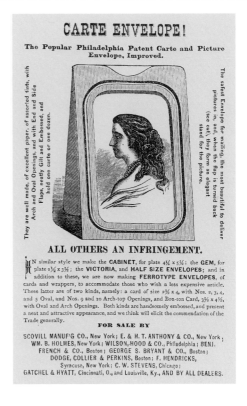

pictures. We hear of parties who recently started in business having leased rooms and hired apparatus, and commenced receiving ten, fifteen, and twenty dollars per day." [8]

8. *Humphrey's Journal* 14 (1863): 78–79.

In the spring of 1863, F. F. Thompson, a correspondent with the British *Photographic News,* reported the latest changes in American photography: "The carte de visite fashion is changing. The old style of showing a full length figure stiffly braced against an impossible railing or column, or savagely holding fast to a chair back, is dropped, and the more artistic style of a simple vignette is now in vogue." [9] Thompson was reporting, not completely accurately, changes that had been taking place for more than a year and a half. Soldiers away from home, however, still preferred full-length images of themselves armed to the teeth and grim of face.

9. *Photographic News* (May 8, 1863): 226.

By the end of 1862 it was evident that the destinies of the multiplying camera and the tintype were connected. Wing began issuing licenses for the use of his camera, charging photographers anywhere from $10 to $2,500, depending on what the market would bear. In the fall of 1863 he was issued a patent for an "Improvement in Photographic Card Mounts,"

the first patent issued for refinements of the carte-de-visite tintype.[10] It is interesting to note that the basic invention excluded paper photographs, although some of the designs in the patent could be used for both tintypes and paper prints.

Wing's invention was simple. It proposed to eliminate the bulge a gem tintype created when glued to a card by having (1) a machine-cut recess on the back of the cardboard that was the same thickness as the metal gauge of the tintype, and (2) a paper flap to seal the tintype to the card. The front of the card would have an oval or other design as the opening, cut to a smaller size than the tintype, to frame the image. The patent also claimed a "design patent" for an embellishment surrounding the opening "stamped or printed with a suitable engraving."

The gem and larger tintype cartes-de-visite, despite their cheapness and the rather low regard in which they were held, were beginning to occupy equal space with the paper carte-de-visite in what was becoming the family album.

THE NINETEENTH-CENTURY PHOTO ALBUM

IN 1860 and 1861 photographic albums made to hold the new card pictures suddenly appeared. Visiting cards were originally simply handed to an acquaintance or, when making a house call or attending a social event, placed on a platter or dropped into a basket in the foyer. The album

10. Patent no. 40,302, issued on October 13, 1863, to Simon Wing.

Photographic albums of the 1860s. The small album, right, often called a "gem album," was made especially to hold ¾" x 1" miniature tintypes. Cartes-de-visite, gem cards, and bon-tons would fit readily into any of the larger albums shown.

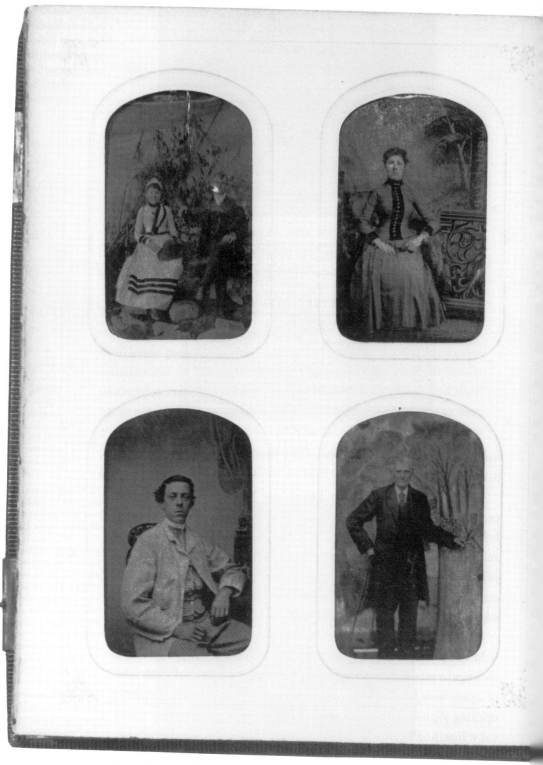

View of an open album, showing a typical leather-bound album for bon-tons or cartes-de-visite, c. 1870.

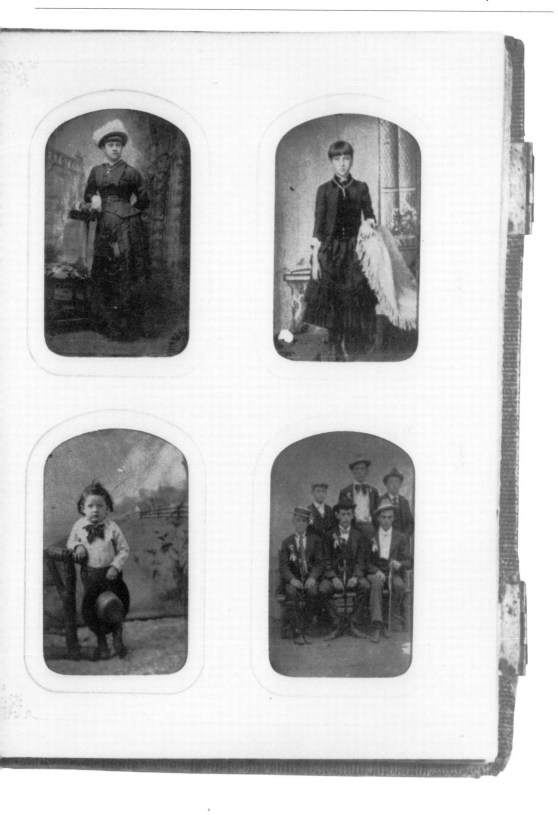

13. Patent no. 32,404, issued
on May 28, 1861, for a photo-
graphic album.

patented an "improved" device for this purpose—a paper flap that sealed
the c.d.v. in place when the album was closed.[13] Soon, however, there
was a better solution: leaving the bottom of the finished glazed paper
unglued so that one or two photographs could be pushed upward into the
recesses in the cardboard.

The Philadelphian Coleman Sellers, an amateur photographer and
inventor of the Kinematoscope (a peephole stereo viewer in which he
could show moving photographic images), was also interested in albums.
In May 1863 he wrote to the *British Journal of Photography*:

> Speaking of card-pictures brings to my mind a conversation I had
> some days ago with Mr. Mitchel, of the firm of J.B. Lippincott and
> Co., of Philadelphia. This firm was one of the first in America to
> go into the business of making albums, and it now stands proba-
> bly higher than any other firm in reputation for producing the
> finer class of albums. Mr. Mitchel says that they employ in this one
> branch of the business about one hundred hands, and yet they
> cannot keep pace with their orders; that their stock in store is

Advertisement for albums,
1865. From Samuel Bowles,
Across the Continent.

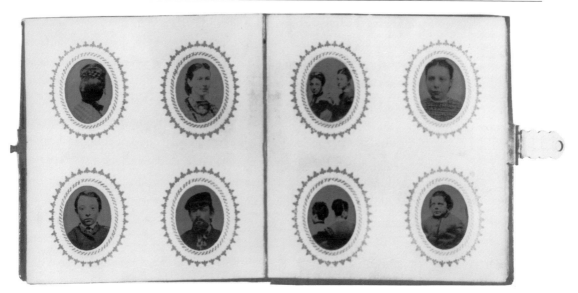

never large, so rapidly do they send them off. The more elegant and elaborate they make them the more they can sell, as their attention has only been directed to the finer class of goods. They have just completed a very large building on Market Street, and into this new establishment they intend to move their album factory. He showed me various processes of the album making, and said that the printing of the gilt margins to the opening and the punching of the sheets were not done by them, but was a separate business; and that their strongest and best kind of binding was what some rival firm once tried to cry down as "the split backs," i.e., each leaf is fastened to the back by a cloth attachment, folded up to the thickness of the card-leaf, and thus making a joint which will fall open flat, as any well-bound book should do, and is dependent on its stitching for its strength, and not on glue. How long this great demand for albums will last no one can tell: it is a growing business, and is said to be in its infancy. A machine has been contrived by a Mr. Theodore Bergner for rounding out the edges of the albums, which is said to perform its work with great rapidity and accuracy.[14]

A miniature gem album, four ¾" x 1" tintypes to a page. Gem albums were inexpensive and very popular during the mid-1860s.

14. *British Journal of Photography,* May 1, 1863, 197.

Sellers, undoubtedly because of his own experiments with stereo viewers, checked with the Lippincott Company again in the summer of 1864 and reported: "Some albums are now being advertised, under various patents,

uniting the stereoscope with the album, and enabling this class of pictures to be kept in book form. J.B. Lippincott and Co. are issuing such an album. They say demand for albums is as great as ever, but more cheap ones are being introduced." [15]

The cheap albums Sellers mentions were probably the "photo-miniature line" of gem albums made expressly for the tiny tintype. In 1864 the gem album in America was all the rage and had no competition in its price range. A paper photograph mounted on a card, which cost at least $1.50 a dozen, could hardly compete with gem tintype at 25 cents a dozen; nor could the cheapest c.d.v. album ($2.50) compare with the leather-covered gem album available for $1.

THE BON-TON

IN the mid-to-late 1860s a new style of tintype began to appear in the family album. About the same size as the carte-de-visite—2½" x 4", with fractional variations due to irregular cutting—it was called "bon-ton," after the French for "good style" or "good form." The name was popular, and the price was well within the means of even the most parsimonious

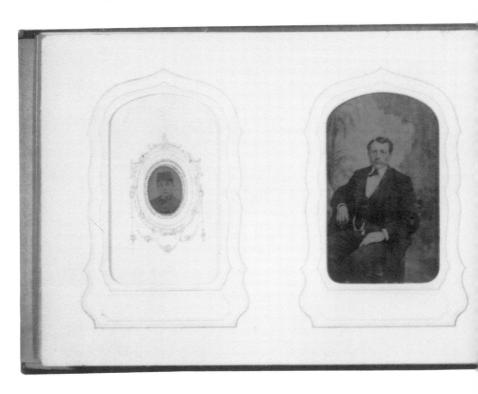

customer. The bon-ton would easily slip into the pocket of an album page, and when it was in place, only the image was visible, since the paper frame hid the hand-cut and often irregular edges of the plate.

Before handing the patron his bon-ton portrait, the tintypist often put it into a paper envelope with the same style opening as the album's. Most envelopes had paper flaps to keep the tintype neat and clean. Envelope making, like album making, was a separate business from photography. In 1877 John Fitzgibbon, after visiting the establishment of Nixon & Stokes —"the great Photographic Envelope Factory" of Philadelphia—wrote:

> The facility by which those articles are manufactured is really astonishing. . . . We saw envelopes and ferrotype mounts turned out by the thousands in a short space of time. First, the paper is cut the right width and is in endless rolls, next the borders are printed or bronzed openings punched out and cut to the right size—all with the same machine. Afterwards, in the finishing room, we saw backs and flaps pasted on by machinery, at, we might say, lightening [*sic*] speed . . . young girls do the handling, machinery does the cutting and mature age the finishing. . . .

View of an open album, showing its adaptability to the carded gem tintype, *left,* and the three bon-tons, *right.*

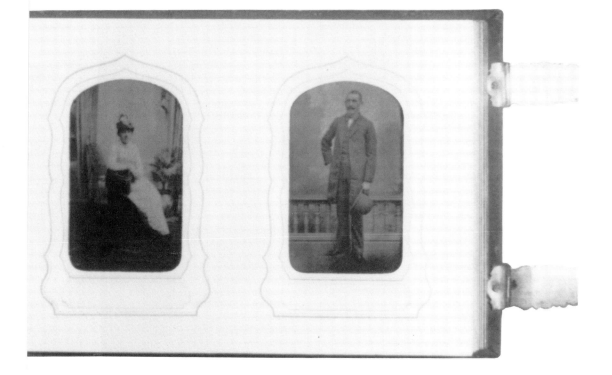

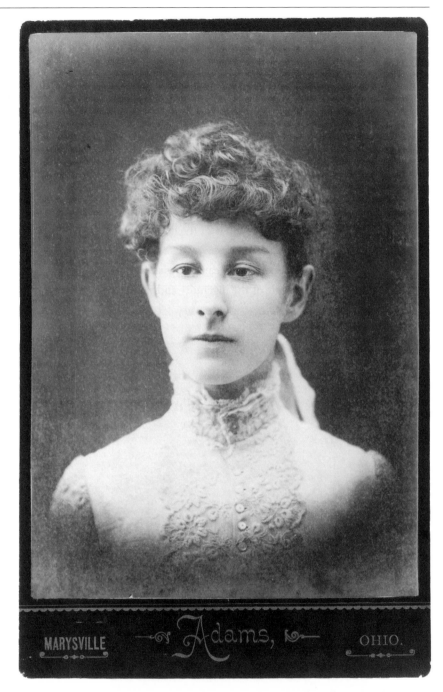

MARYSVILLE Adams, OHIO.

Cabinet card. c. 1885. Made from wet-plate negatives and printed on albumenized paper, cabinet cards became popular in America by the mid-1860s. Their size—a 5½" x 4" print on a 6½" x 4½" mount—made retouching of the negative possible and gave the photographer an opportunity for improved lighting, posing, and decor. The cabinet card did not replace the c.d.v. and the tintype, but its size, detail, and brilliance changed the look of studio portraiture.

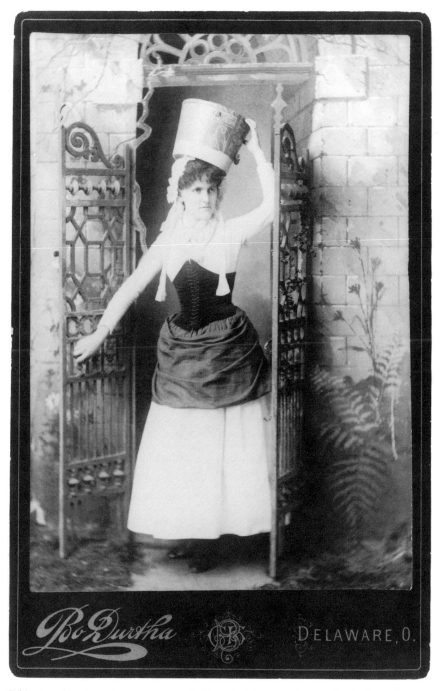

Cabinet card. c. 1885. Napoleon Sarony, in New York City, was famous for his dramatic card portraits, but even small-town photographers, like Bo Durtha, of Delaware, Ohio, saw the possibilities of theatrical posing.

Chapter 6

THE TRAVELING TINTYPIST

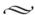

THE first edition of Walt Whitman's *Leaves of Grass,* published in 1885, expresses the impulse of an increasing number of peripatetic tintypists:

> Afoot and light-hearted, I take to the open road.
> Healthy, free, the world before me,
> The long brown path before me, leading wherever I choose.
> Still, here I carry my old delicious burdens;
> I carry the men and women—I carry them with me wherever I go;
> I swear it is impossible for me to get rid of them;
> I am filled with them, and I will fill them in return.[1]

1. "The Song of the Open Road," in *The Illustrated "Leaves of Grass" by Walt Whitman,* ed. Howard Chapnick (New York: Grosset and Dunlap, 1972), 10.

The literal "burden" of the traveling wet-plate and tintype photographer included not only the camera and tripod but also the darkroom—in wagon, boat, or tent. The "delicious" part of the burden was that he also carried with him the memories—and, more important, many images—of common Americans who filled his life as he recorded them for posterity. The itinerant tintypist was a craftsman, socializer, salesman, and storyteller, illustrating his yarns with pictures of people and places to advertise his skill. Often he was called "Professor," since (like the character of the Wizard of Oz) he exercised his powers inside a black box and a dark room.

Henry H. Snelling, longtime sales manager for the well-known E. & H. T. Anthony photographic supply house of New York, considering

these tintypists, reflected: "They have taken up the Gypsy art of ram-
bling and you will meet them in their traveling van in the country, on the
road, or in the village. Here they 'pitch their tent,' bang out their hanger on
the outer wall, 'containing specimens of their beautiful work, most on the
iron-plate ticket—this style for 25 cents.'"[2]

 The great technical advantage of the tintype over the daguerreotype
and the ambrotype was that it was fast, cheap, and durable enough to
send through the mails with little, if any, damage. Its great social contri-
bution was that for the first time in any war in history, the ordinary soldier
in the field could afford to send his image to a loved one and expect to
receive one in return.[3] Letters from the infantryman Owen Johnston
Hopkins, who served in the 42nd and 182nd regiments of the Ohio Volun-
teers, to his sweetheart, Julia Allison, reflect the importance and meaning
of a photograph during those dark days:

> When my hair gets so it will stay back, I will send you a better
> photo, but you must destroy the last one; it wasn't good; I hurried
> the artist too much. I am acquainted with one of the best Pho-
> tographists in Nashville: Henry M. Hall. He is from Toledo.
>
> * * *
>
> I am writing with both of your pictures on the table before me. I
> look at them so much that I can hardly write.
>
> * * *
>
> I am too selfish to let anyone look even at my Julia's Photograph.
> I look at it every night before retiring, and would kiss the dear
> treasure as often, if I wasn't afraid of spoiling it.
>
> * * *
>
> If I only had your *facsimile*, the next two months would be but
> one day.[4]

After reading the last letter excerpted above, Owen asked Julia to destroy
his earlier photos, because the next one she would receive would be
"taken not in the stylish, unbecoming rig of Photo N. 2, but in such as
Abe's Boys wear down in Louisiana." Bewailing the loss of one of her
photographs he explained: "I did not lose yours through neglect. I would
rather have lost my musket."[5] Eventually the historical importance of the
tintype was eclipsed by the work of Mathew Brady, Alexander Gardner,

2. *Anthony's Photographic Bul-
letin* 19 (1888): 369.

3. A few years earlier, during the
Crimean War, Roger Fenton and
James Robertson had taken pho-
tographs of scenes behind the
lines, the aftermath of war, and
military leaders, but common
soldiers could not have afforded
their pictures. Also, unlike the
photographs made by Brady,
Gardner, and O'Sullivan during
the American Civil War, these
pictures did not show the fallen,
bloated harvest of battle.

4. Otto F. Bond, ed., *Under the
Flag of the Nation: Diaries and
Letters of Owen Johnston Hop-
kins, a Yankee Volunteer in the
Civil War* (Columbus: Ohio
State University Press for the
Ohio Historical Society, 1961,
1998), 219, 269, 202, 171. Owen
Johnston Hopkins and Julia
Allison were married in 1865.

5. Ibid., 112, 152.

Gem tintype with "proprietary" stamp. A. D. Stark's Studio. From September 1, 1864, to August 1, 1866, a tax was levied on photographs and other artworks to help pay for the war. A 2-cent stamp was required for photographs costing 25 cents or less; a 3-cent stamp for those priced up to 50 cents; and a 5-cent stamp for photographs costing from 51 cents to $1.00. Such stamps are very useful in dating photographs.

Timothy O'Sullivan, George N. Barnard, and others, all of whom, using large-format wet-plate and stereo cameras, produced what became the photographic history of the Civil War.

After their muskets were finally laid down, and veterans, North and South, returned to their homes, traveling photographers, looking for further adventure and profit, took to the roads and even to the rivers (in flat-bottomed boats outfitted as complete studios). In 1875, in a letter published in *Anthony's Photographic Bulletin* describing photographic boats along the Mississippi River, the correspondent wrote that many of the photograph and ferrotype boats were up to eighteen feet wide and seventy feet long. One of the most interesting was a boat built at Minneapolis that had made the long journey from the foot of the Falls of St. Anthony to the mouth of the Mississippi. The owner of this floating gallery was John P. Doremus, who also had a successful gallery in Paterson, New Jersey. Doremus photographed interesting views along the Mississippi, amassing a

collection of scenes and information about St. Paul and other towns along
the river with the intention of writing a book about them.[6]

6. *Anthony's Photographic Bulletin* 6 (1875): 345–46.

On the deck of Doremus's boat was an 18' x 76' house designed with
an eye to comfort and detail. On boarding the boat, the patron was ush-
ered into an 8' x 16' room furnished with a marble-topped table, water-
color and oil paintings, chromos, and other accoutrements. Folding doors
opened to the 14' x 30' operating room. The house also included a toilet
room for customers, a room for Doremus's use, a private dining room

Doremus's floating gallery, c. 1875. From a stereo view card. Floating galleries were common along the Mississippi
River. In the South the picture season began when the cotton crop was harvested. Yankee photographers were able
to do a brisk business without paying gallery rent, since they lived in their mobile studios. Courtesy George Moss.

and parlor, a stateroom with two berths, a kitchen with a large pantry and storeroom, and a silvering and toning room. Below it all was a three-foot-deep hold ventilated by air shafts and used for storage.[7]

Although the Mississippi River was the favorite waterway for boat galleries, tintypists and other roaming photographers frequented other rivers and lakes, especially near popular resorts, where there were always patrons in a holiday mood. By the 1870s it had become fashionable to go "tenting" through the country, and for the traveling photographer this may have been a pleasant way to spend the summer.[8] Seaside resorts from Maine to Cape May, New Jersey, were full of vacationers ready to have holiday tintypes taken. Wherever there were people there were tintypists—from camp meetings to Coney Island.

A colorful tintypist who operated along the famous Atlantic City boardwalk was an Englishman by the name of Harry Smith. He had once worked in London, where he was reported to have photographed the Prince of Wales. Another Englishman, visiting Atlantic City in 1894, wrote of his experience with Harry's operation:

> As for me I go and get photographed. A couple of bathers in blue
> jerseys and short drawers come out as I go in, for Harry Smith
> announces he makes a specialty of bathers. He has two attitudes
> for them; one shading the eyes and looking off right, in the stage-

7. Ibid.

8. *Photographic News* (July 20, 1877): 339.

The Cliff House, San Francisco, c. 1900. Two visitors in front of a mural background.

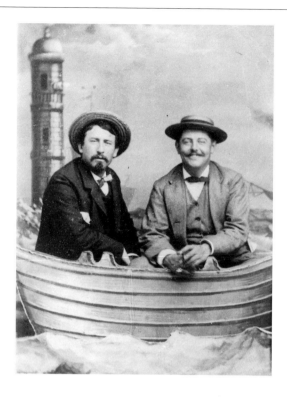

A boardwalk portrait, c. 1882. An unconvincing rowboat with a painted lighthouse was the favorite background of the English-born Atlantic City tintypist Harry Smith.

seaman fashion; the other sitting in a section of a boat, a life-belt round the neck, an oar in the hand. For me, a walking gentleman, he brings forward a rickety piece of balustrade, an imitation india-rubber plant, and a background of a lighthouse and a sea-gull.... Times are simply hawful, Harry says; nothing doing, nobody got any money. He was the pioneer of the tin-type (eight for twenty-five cents) in Atlantic City; has been here eighteen years and generally gets washed out by the sea every winter. Pays five hundred dollars a year for his little bit of a place; eighteen years ago could have bought it out and out for two.... "Not so bad, eh?" he says affably, handing me eight visions of myself alternately very black and very white, like underdone badly-burnt toast. Then he offers me a large collodion-stained fist to shake, and turns briskly to the lady bathers who are arranging their long thin locks coquettishly [*sic*] before the studio glass.[9]

9. *Cornhill Magazine,* November 1894.

The attraction of wandering photographers to eastern watering holes, amusement centers, and rivers was matched by their excitement at the promise of the western frontier. Among those who ventured beyond the

The portable darkroom
and equipment of Alexan-
der Gardner. Courtesy
Library of Congress.

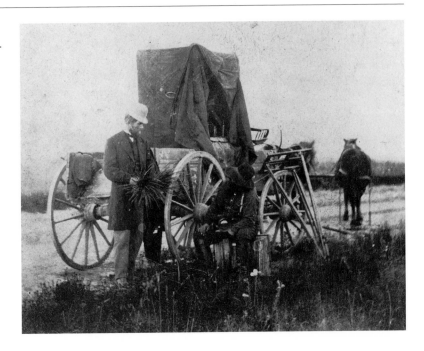

Mississippi even before the Civil War were the daguerreotypists J. F. Fitz-
gibbon, Peter Britt, John Plumbe, Robert A. Vance, Charles R. Savage,
C. E. Watkins, and C. N. Carvalho (who was the photographer for the
Fremont expedition in 1853). Some photographers found less of a future
in the silver image than in a gold one, dropping their cameras for picks
at the rumor of a new strike. Others, however, settled down as studio
entrepreneurs.

For example, Joseph Buchtel, of Stark County, Ohio, reached Port-
land, Oregon, set up a studio, and advertised in the local newspaper "all
new styles of pictures and new patents which have been adapted by other
artists including ambrotype photography, patent leather pictures, ferro-
types, sun pearls, pearls on watches, and latterly the mezzotints and rem-
brandts." [10] In 1861 "melainotypes" were being advertised by the studio of
E. M. Sammis of Olympia, Washington. [11]

European photographers of the early wet-plate period were also
wandering about the world with their heavy equipment and supplies:
Maxime Du Camp in the Middle East on tour with Gustave Flaubert in
1852, Francis Frith in Egypt in 1858, John Thompson in China in 1868,
the Bisson brothers in the Alps in 1869.

American photographers' views of the West were equally exotic, since
very few citizens of the United States had seen the Colorado River or

10. Ralph W. Andrews, *Picture
Gallery Pioneers, 1850–1875*
(New York: Bonanza Books,
1964), 101.
11. Ibid., 107.

Pike's Peak, let alone the Nile or the Alps. Some who had first familiarized Americans with the horrors of war also introduced them to the wonders of the American West. Alexander Gardner photographed the historic peace conference between the Arapahoe and Cheyenne and the U.S. government at Fort Laramie in the Wyoming Territory. Timothy O'Sullivan took the first beautiful pictures of the Canyon de Chelly in northern Arizona. Captain A. J. Russell documented the construction of the Union Pacific Railroad. William Henry Jackson provided the first wondrous views of what was eventually to become Yellowstone National Park.

The tintype continued to be a prolific but one-of-a-kind and rarely published photograph (although Peter Britt's 11" x 14" melainotypes can be found in the Jackson, Oregon, museum). As more and more tintypes are discovered, it becomes evident that it was the tintypist who captured on sheet iron the countenances, costumes, and customs of millions of average Americans. Tintypes' simplicity and informality derived from the fact that many of them were made outside the studio—on farms and streets, at county fairs, amusement parks, and seaside resorts—portraits of the ordinary American at the close of an era in our national history, and the end of a chapter in the history of photography in America.

Timothy O'Sullivan, working for the U.S. Geological Service in 1871. 8"x 10¾" print. O'Sullivan descended the Colorado River in a boat that included a dark tent for developing wet-plate negatives. He is shown here in the Black Canyon of the Colorado—the present site of Hoover Dam. Courtesy Library of Congress.

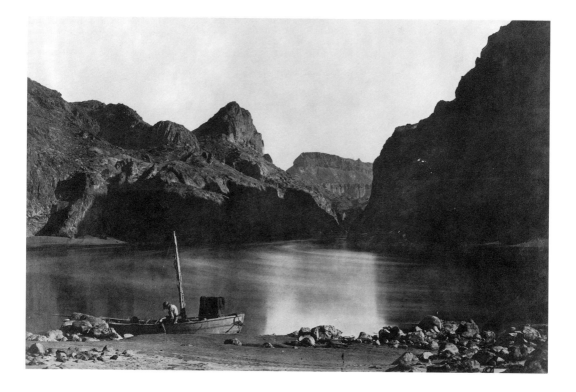

Advertisement for a
photographer's tent.
From Estabrooke, *The
Ferrotype, and How to
Make It,* 1880 ed.

A photographic darkroom
tent, c. 1875. From a stereo
view card.

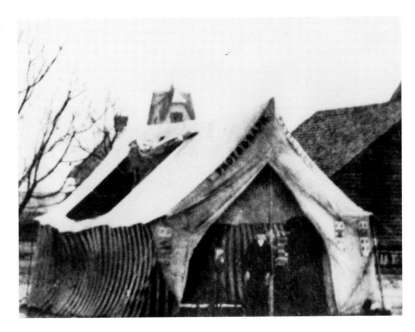

The traveling "salon" of E. G. Davis, Leominster, Mass., c. 1873. From a stereo view card. Note the glass-covered display case by the entrance. Itinerant photographers found such compact, mobile galleries ideal for visiting small towns and villages.

A traveling photographer, c. 1871. Half of a stereo view.

Country scene, c. 1861. Half-size plate. An unusual outdoor tintype showing two men and a dog in an oxcart. In the landscape behind them, a road stretches toward some distant hills.

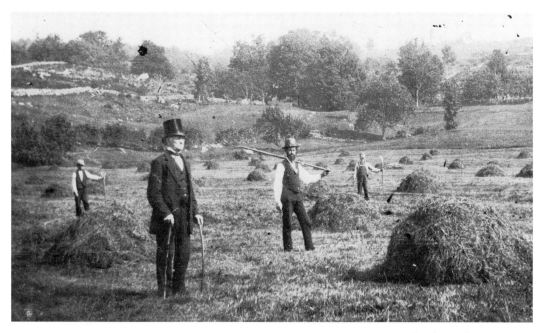

Gentleman farmer, c. 1864.
Sixth-size plate. A rare
haying scene.

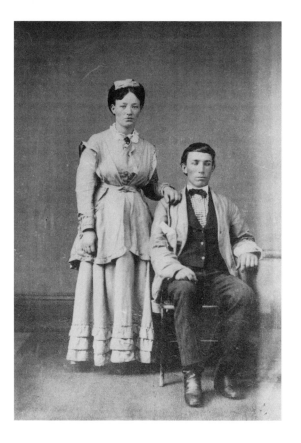

A country couple, c. 1880.
2½" x 3¾". The costumes
worn by this pair are
undoubtedly their Sunday
best. The tintype was prob-
ably taken by an itinerant
photographer.

The grindstone, c. 1867.
Sixth-size plate. This
unusual group portrait
is an informal exterior
view of a typical chore—
sharpening farm tools.
Private collection.

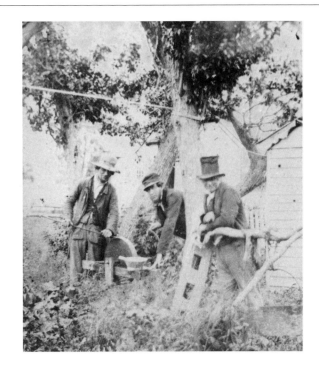

A farm family, c. 1878. Sixth-
size plate. The farmer, pail
in hand, possibly returning
from chores, finds his family
assembled for an itinerant
tintypist's camera. One of
the six women holds a small
child. The backdrop is their
substantial farmhouse.

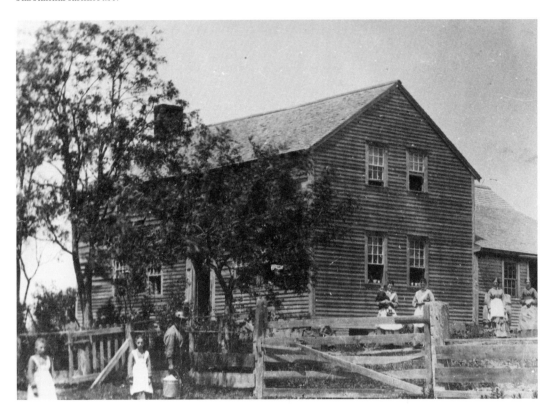

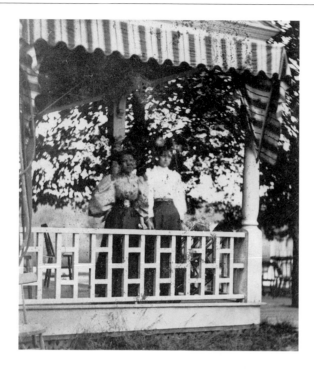

Women on porch, c. 1900. Bon-ton. The veranda, though a common gathering place for Victorian families, was an unusual setting for a tintype.

Pioneers of Daytona, Fla., c. 1886. Half-size plate. Tintypists were active in Florida in the 1880s, photographing in the many towns springing up all over the state. In this example a small girl and four others stand by as a man with a hoe works against the background of a row of banana trees and palms. Courtesy Robert Cauthen.

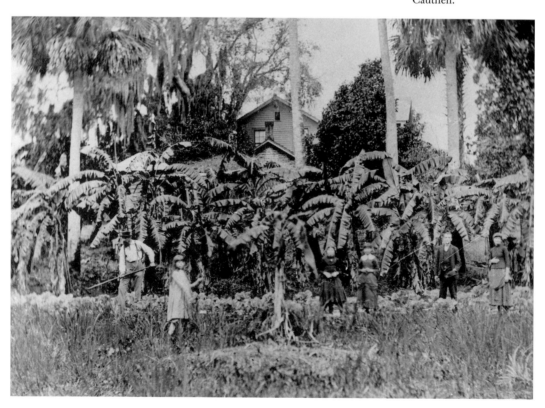

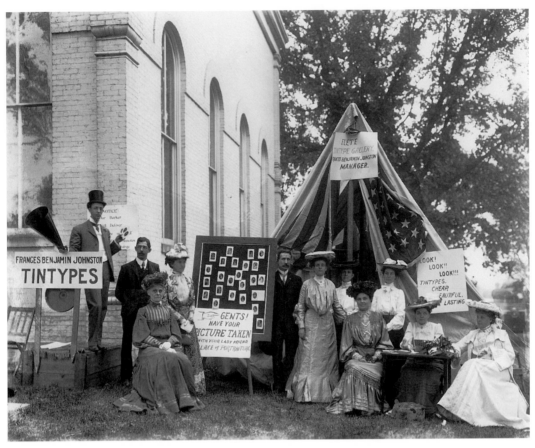

Frances Benjamin Johnston (standing in center with flat, white hat) as a traveling tintypist, May 1903. Johnston, who was a widely exhibited photographer and author, also had a studio in Washington, D.C. (see illus. on p. 44). Her caller-out with his megaphone is standing at the far left. Courtesy Library of Congress.

Chapter 7

THE INDUSTRY, THE AMATEUR, AND THE ART

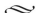

THE golden years of Neff's melainotype and Griswold's ferrotype were over by the early 1860s. Reese Jenkins, in his historical analysis of technology management in the American photographic industry, contrasted the business practices, experience, and personalities of these two tintype pioneers:

> The Griswold firm, although lacking capital, had the advantage of Griswold's fifteen years' successful experience in the photographic industry, whereas the Neff operation, with substantially more capital than Griswold's, was led by a man who possessed less business creativity and stamina and who had considerably less photographic experience. Griswold was persistent and creative in both marketing and technology; Neff was not. Griswold closely integrated the marketing, production, and administrative functions. Neff delegated such functions in a more decentralized style of operation.[1]

Griswold rejected Neff's offer to buy him out, and Neff declined Griswold's offer to merge. Both lost their businesses. What Jenkins refers to as the "duopolistic" (or Neff-Griswold monopolistic) structure of the marketplace disappeared as the tintype industry expanded.

1. Reese V. Jenkins, *Images and Enterprise: Technology and the American Photographic Industry, 1839 to 1925* (Baltimore: Johns Hopkins University Press, 1975), 44.

Photographic technology was changing rapidly. In 1887 the Phenix
Plate Company introduced the "argentic dry plate," which had a sensi-
tized gelatin emulsion, as a ready-to-use tintype plate. Even though no
mixing of chemicals or coating of the plate was involved, many tintypists
were not yet ready to give up the tried-and-true wet plate for the instant
dry plate. Phenix was a bit premature with the new dry plate; not until
1893 could they safely say: "It is . . . more uniform than those previously
turned out and requires less exposure, develops quicker and its whites are

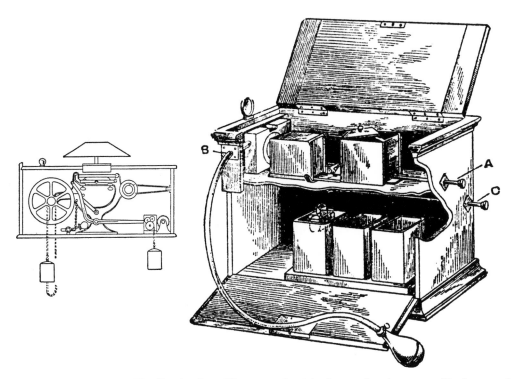

Two line drawings. The one on the right shows a dry-plate camera like those used
by itinerant tintypists. The box in the center of the top shelf could hold forty fer-
rotype plates. Each plate was drawn from its sheath with a rod (A) and pushed into
a horizontal position behind the small fixed-focus camera (left on top shelf). After
checking the pose of the subject through a small viewfinder above the camera, the
photographer activated the shutter (B), pressing the bulb for the desired exposure
time. The exposed plate dropped into a movable wire cradle with a control knob
(C). The photographer developed, fixed, and washed the plate while it was still in
the cradle by turning a knob to positions marked on the rod. After the darkroom
work was finished, the front panel was lowered and the finished plate removed.
With a little practice, the finished tintype could be given to the customer in about
one minute.

The drawing on the left is of a clockwork printing machine, patented in 1885 by
J. Urie of Glasgow. The machine used a continuous band of bromide paper that
moved the length of one print automatically after each exposure to the negative.

cleaner and more brilliant, but the greatest improvement of all is in the matter of drying which can be done without injury to the plate in from two to four minutes."[2]

Ferrotype dry plates came in packets like other dry plates and were used with semiautomatic cameras. Developing took eight to twelve seconds in warm weather, twelve to twenty seconds at normal temperature, and up to a minute in cold weather. After developing, the plates were rinsed in water and fixed for between ten and thirty seconds. They were then rinsed again, dried, varnished, and handed to the customer.[3]

With ready-made plates and a semiautomatic camera it was possible to make a tintype at night. A container of forty 1½" x 1½" tintype plates in sheaths was placed on top of the camera. When the lens was focused, a lever moved a plate into position for exposure by flashlight powder. In two simple movements the exposed plate was sent to the development tank, where the developer, the fixer, and the wash water were actuated by three separate pneumatic balls. In 1892 the *British Journal of Photography* reported: "Exposure time at night was about 2 seconds with the bright light coming from 6 to 8 grains of magnesium powder blown through a spirit flame. A strong developer was used; strong enough to bring out the image in less than a minute. With the developer a small quantity of 'hypo' was used as a restrainer to bring out a bright image."[4]

After 1900 booths housing completely automatic machines made their debut. These were particularly popular in resort areas. The studio tintypist, with his scenic murals, props, and amusing repertoire of stories, was gone forever, though the itinerant tintypist continued to roam.

THE INDUSTRY

PHOTOGRAPHY fast became an industry around which other industries clustered. Plastic, the great twentieth-century product, had its origin in the Union case for daguerreotypes, patented in 1854 by Samuel Peck, which was pressure-molded from a compound of sawdust and shellac. The leather industry, book publishing, and allied trades were involved in the production of albums. The paper industry supplied envelopes, cards for stereo views, and tintype mounts. There were even companies specializing in tintype painting, such as the North American Portrait Company of Jamestown, New York, and D. L. Hildreth's studio in Philadelphia. As early as 1860, Cincinnati's famous photographer Charles Fontayne

2. "Index Rerun Photographic," *Outing Company* 5 (January–December): 43–45, reprinted from the *American Photographer*. In 1871 the English physician and amateur photographer Richard Leach Maddox published his description of the first practical dry-plate emulsion using cadmium bromide with gelatin instead of collodion as the binding element. In 1877 the F. L.C. Wratten Company began making a gelatin dry plate fifteen times more sensitive than the old collodion wet plates. In 1880 George Eastman offered dry plates and in 1888 the Kodak I camera, which used roll films for amateurs. The wet-plate era was over, and a new chapter in the history of photography was about to be written.
3. Bernard E. Jones, ed., *Cassell's Cyclopaedia of Photography* (London: Cassell and Co., 1911), 240. The formula one developer used for the dry-plate tintype is:

Sodium carbonate (pure)
 4,, 200 g.
Sodium sulphite
 2,, 100,,
Hydroquinone
 1/4,, 1.25,,
Potassium bromide
 290 grs. 29,,
"Hypo" fixing solution
 (as below)
 1/2 oz. 25 ccs.
Warm water to
 20 oz. 1,000 ccs.

4. *British Journal of Photography*, December 16, 1892, 811.

5. *Cassell's Cyclopaedia of Photography,* 48. Fontayne's automatic printing process involved a band of sensitive paper and a large condensing lens concentrating sunlight on the negative. Also see "Photography and the Mass Market," in *The Story of Popular Photography,* ed. Colin Ford (London: National Museum of Photography, Film and Television, 1989), chap. 2.

was using an automatic printer to produce two hundred paper prints per minute.[5] Many of the early labor-intensive, manual photographic processes disappeared under the innovations of the Industrial Revolution.

That the tintype was a real industry was made clear by the appearance of competitive brands of tintype plates. Unlike Neff and Griswold, the new plate manufacturers were opportunists, not photographers or inventors. In 1861 Newark, New Jersey, became a center for the new plate industry. That year, three employees of the Chadwick Leather Company formed a partnership for making tintype plates. The new plates were named "Eureka," a popular catchword.

After the Eureka factory opened, a fourth Chadwick employee, Charles L. Robinson, started another tintype platemaking establishment. Most of his plates were sold to smaller New York photographic jobbers who used their own private brand names for the plates. A few months later M. Roche, another Chadwick employee, also opened a plate factory, choosing the popular wartime name "Columbia" for his product. At first he sold only to wholesalers, but when the war ended and demand dropped, he let selected New York tintypists buy his wares.

Adding to the growing competition, Horace Hedden and his son, Horace M. Hedden, opened their own plate factory in Newark. Their new factory was well organized, and they soon signed contracts with two large New York supply depots—George Chapman, who marketed the plates as "Chapman's Celebrated O.K. Plates," and J. W. Willard and Company.

6. Edward M. Estabrooke, *The Ferrotype, and How to Make It* (Cincinnati: Gatchel & Hyatt, 1872), 98–102.

Newark remained a center for platemaking during the war, but beginning about 1863, the entire industry began to move to Worcester, Massachusetts.[6] In that year the Heddens (whose quality plate was called "Phoenix") began negotiating a merger with Dean, Emerson and Company of Worcester, a well-financed and successful manufacturer of photographic mats and preservers. With the demand for miniature cases declining, Dean, Emerson was on the lookout for a new source of revenue. The firm shrewdly concluded that the new, inexpensive, card-mounted tintypes would find a wide market.

The Heddens, with financing now secured, moved their entire facility from Newark to Worcester and immediately worked toward increasing production. The plate's name was changed to "Adamantean," and the prestigious wholesaler E. & H. T. Anthony of New York was appointed sales agent. When Samuel Emerson retired in 1865, the firm's name was

changed to John Dean and Company. In 1867 the Heddens also left. The Adamantean, however, continued to have a high volume of sales.

THE CHOCOLATE PLATE

AFTER leaving the Dean Company, the Heddens immediately opened a new factory and, with their superior knowledge of production, made a plate that competed successfully with the Adamantean and other plates. The elder Hedden revived the name "Phoenix Plate Company" and personally supervised the entire operation to ensure that the ovens were evenly heated and that the plates were as free of imperfections as possible. The plates continued to be manufactured in a glossy black and an eggshell black finish until March 1, 1870, when Horace Hedden obtained a patent for his chocolate-finished plate.[7]

7. Patent no. 100,291, issued March 1, 1870.

The chocolate plate was the first important change in the appearance of the tintype since its introduction in 1856. A journalist reported: "This

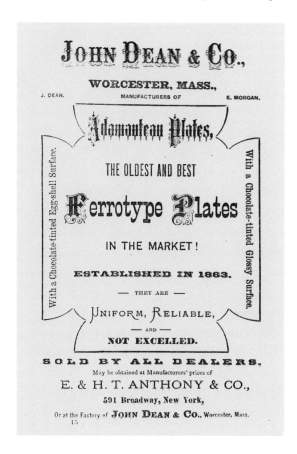

Advertisement for John Dean & Co. featuring the chocolate-tinted plate, c. 1872.

Advertisement for Scovill's
New York and Liverpool
outlets, featuring ambrotype
and ferrotype supplies,
c. 1872.

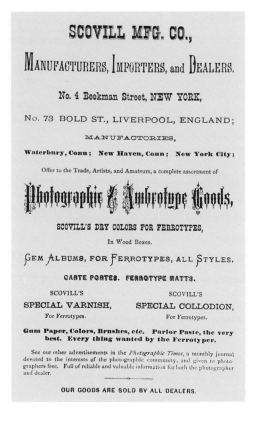

8. See Estabrooke, *The
Ferrotype*, 98. Estabrooke also
reported that Victor Griswold
had experimented with plates
of different shades of blue,
green, red, and chocolate in
1857 and 1858, but had no suc-
cess in selling them and had
dropped the idea (p. 82). Such
plates are extremely rare today.

plate created a sensation among the Ferrotypists throughout the country, and the pictures made on the chocolate-tinted surface soon became all the rage."[8] The chocolate plate (some called it the "chromo-ferrotype") came in three shades of chocolate: light, medium, and dark. The light plate was a bright yellowish-red tone and was made especially for the summer season, when light clothing was worn. According to Estabrooke, "With these summer costumes some very beautiful effects are produced." The medium shade, with its warm, agreeable tint, became a favorite of patrons wearing either light or dark clothing. The dark chocolate was not very different in pictorial effect from the standard black tintype plate, although the tone was warmer.

The Phoenix Plate Company had enlarged its facilities before intro-ducing the chocolate plate, but the enormous demand for the new plate necessitated further expansion. Another factor in Phoenix's financial suc-cess was the reaction of the Scovill Manufacturing Company of Water-bury, Connecticut, and its branch in New York City. Scovill, a strong competitor of E. & H. T. Anthony, had introduced its own "Sun" brand

in 1870. After spending a considerable amount of money, the company abandoned its endeavors after the chocolate plate came out, opting instead to become the general agent for what they called the "Phenix," their name for the Phoenix plate.

Hedden also obtained an English patent for his chocolate plate, and in early 1872 he sent to London T. S. Estabrooke, who opened the first "American Ferrotype Gallery" in England. When Scovill became the general agent for the plate, an English wholesaler was appointed the English agent. By 1874 Hedden and Scovill had made a serious effort to promote their line of photographic supplies overseas, but they were unable to excite much interest. Ironically, in 1873 the Phenix's arch-competitor, John Dean and his Adamantean chocolate-finished plate, won the Medal of Progress at the World's Fair in Vienna. The humble tintype had returned to the Continent, although only a few European photographers were interested in what they referred to as "the American process."

England had long played a part in the production of iron plates. In

PHENIX

Ferrotype Plates,

EGG-SHELL, GLOSSY, CHOCOLATE-TINTED.

(Patented March 1, 1870.)

All Sizes, from 1–9 to 10 x 14. Use None but the Phenix.

THE PHENIX PLATE COMPANY,

WORCESTER, MASS.

Are now making the most popular brands of Plates in the trade.

For example of work on them, see **Trask's Practical Ferrotyper.** In his comments on the pictures, Mr. Trask says:

"The largest portion is made on the egg-shell, chocolate-tinted plate, manufactured by the Phenix Plate Company, Worcester, Massachusetts, and I must compliment them on their success in manufacturing the best egg-shell, chocolate-tinted plates I ever used. They have overcome all the objections I have heretofore found, and mentioned on other pages. There are no signs of the black comet. The plates are perfectly clean, the surface is hard, and the collodion flows smoothly, without spilling. They also give the picture that rich, warm tone, which can not be had with the black plate. I can not help congratulating the Ferrotype world on the successful manufacture of this valuable plate, as it will create a new era in the Ferrotype business, and the Phenix Ferrotype Plate Company are entitled to great credit. I have not spoiled one picture in a whole day's work on account of imperfections in the plate. This is a great saving of time and material."

We could not ask a better Testimonial than this.

[See next page.]

Advertisement for Phenix ferrotype plates. Horace Hedden was the patent holder for chocolate-tinted plates. Trask's testimonial calls them "the best egg-shell, chocolate-tinted plates I ever used."

Advertisement for John Dean's Adamantean plate, which won the Medal of Progress at the 1873 World's Fair in Vienna. E. & H. T. Anthony & Co., the plate's distributor, added a short history of the tintype to the advertisement. From Estabrooke, *The Ferrotype, and How to Make It,* 1872.

THE ADAMANTEAN PLATES.

Magna est veritas et prævalebit.

THE manufacture of Japanned Iron Plates is no new thing, and their employment in connection with Photography dates back to the old Ambrotype day. The first who used them for that purpose was Mr. PETER NEFF, of Cincinnati; subsequently Mr. V. M. GRISWOLD entered upon the manufacture of them. After the lapse of time, the GRISWOLD plates became almost exclusively used. As the demand for them increased, other persons were induced to go into the manufacture, and among the first was Mr. JOHN DEAN, then of the firm of DEAN & EMERSON, and now of the house of JOHN DEAN & Co. From the beginning, Mr. DEAN's plates were a success, and, as he subsequently obtained by purchase all the formulæ of Mr. GRISWOLD, his house is now possessed of all the theoretical and scientific knowledge that has been hitherto acquired in this relation, combined with the skill and experience which years of practical application to the business necessarily affords.

A knowledge of these facts, and experience in using the plates for years, puts us in a position to say, without hesitation and without fear of contradiction, that the **Adamantean Plates** are the very best in the market. A great effort has been and is now made to induce buyers to purchase other plates; but such efforts are severe in their reaction, and in no manner, except spasmodically, affect the public demand for the **Adamantean**. The public may rest assured that the reputation of these plates will always be sustained, as Messrs. JOHN DEAN & Co. are wide awake and permit no opportunity of improvement to escape them.

In connection with the Japanned Plate, the Varnish for protecting the picture must always be considered. It is not an uncommon thing to meet with Ferrotype pictures of an unpleasant yellow, bilious look, which arises from the use of an improper varnish. The Varnishes manufactured by us are too well known to need a distinct notice; but it is probably proper to observe that our **Diamond Varnish** is especially made for such pictures, and has the quality of never turning yellow by lapse of time.

E. & H. T. ANTHONY & CO.

1856 Peter Neff Jr. had found that thirty-six gauge flat sheet iron, manufactured by the English mill Taggers, was greatly superior to the American product for use with his melainotype. By the early 1870s, however, the English connection had all but lapsed. Only one firm—Phelps, Dodge and Company of New York—held a franchise for importing tintype iron. In New York, the lack of competition led to speculation on the price of a hundred-pound box (440 sheets) of plate iron by the larger wholesale firms, and by 1871, just before the depression of the following year, the cost of a $22.00 box had almost tripled.[9]

9. For a list of tintype plate manufacturers operating from 1856 to 1904, see appendix 4.

COMPLAINTS ABOUT PLATE QUALITY

IN the early 1870s many tintypists were grumbling about the plates they were buying. When the chocolate plate appeared, The Ferrotype Association of Philadelphia sent a letter to the *Philadelphia Photographer* complaining: "Many have greasy substances on their face impossible to clean off [that] also prevent the collodion from flowing freely. The Japan sometimes runs on the back of the plates and remains in a soft state when the plates are packed, causing many to adhere together. It is also on the edges at times and flows back on the face of the plate. Some are found that seem soft; the greasy plates have that appearance, as though they were not baked enough . . . also found in packing, several on top and bottom very dirty and worthless."[10]

In 1871 the association urged members to "correspond with some plate manufacturers to see if quality can be improved as plates on the market are of very inferior quality."[11] In 1872 Henry T. Anthony, of the E. & H. T. Anthony photographic supply house, also disturbed by the direction tintypes had taken, wrote: "The great defect of ferrotypes . . . is their dirty yellow tint and their lack of brilliancy. . . . I have come to the conclusion that [the] yellow tone is caused by a combination between traces of sulphate of iron left in the film and the cyanide of the fixing solution. To remedy, I tried washing well with a solution of tannin or gallic acid applied after plate developed and washed, and before being put in the fixing solution. The results were perfect whites and great brilliancy."[12]

But by the end of the 1870s, complaints about tintype plates had all but disappeared. John Fitzgibbon of St. Louis, an old-time photographer, recommended John Dean's tintype plates, which, he said, "might be used for a looking glass if you did not need them for ferrotypes, so shining and glossy were they."[13]

THE AMATEUR AND THE ART

IN time the best of the manufacturers, photographers, and patrons established the importance of the tintype on the American scene. The art world, however, was slower to see it as an important, indigenous, and unique American medium. The tintypes selected as examples for this book are some of the best and most interesting, and they reflect the tintype's great variety. Some were made by tintypists who called themselves

10. *Philadelphia Photographer* 8 (1871): 77–78.

11. Ibid., 368.

12. *Anthony's Photographic Bulletin* 3 (1872): 752.

13. *St. Louis Practical Photographer* 3 (1879): 727.

"art photographers" and advertised their studios as "art galleries." Like the photographer and painter Victor Griswold, many of these tintypists had a background in art.

Quite a few tintypes, especially those made by itinerant photographers and amateurs, show a striking resemblance to snapshots. As the tintype and the amateur's photograph began to attract their interest, historians of art and of photography began to appreciate their influence on modern art. References were made to a "snapshot aesthetic." Beaumont Newhall, the author of the classic *History of Photography,* pointed out:

> Until George Eastman in 1888 showed that anybody could take a snapshot by aiming a Kodak camera and pressing a button, tintypes (or ferrotypes) remained the easiest way to have your picture taken. . . . In the days before the snapshot camera, it was the tintype man who made souvenirs of you [Alice Lillia Davis, Newhall's mother] and your best friend riding sidesaddle, or that day when the gang piled into the victoria for an afternoon of tennis. The fun you had—three of you girls wearing Frank, the fat boy's belt, and the boys kneeling before you so eloquently pleading and

An English gem tintype by the Anglo-American Photographic Company, Birmingham, England, c. 1875. Front and back views

A Scottish gem tintype, c. 1873. Front and back views.

you trying to act disdainful but not able to keep a straight face. And then you and Sally and Mae and Alice all under one blanket. You scratched on the back of the plate "Dr. Waldon's patients, Sept. 4, 1887" and it went into your memory book where your son found it long years afterward.[14]

Every photograph, from Nicéphore Niépce's eight-hour exposure, "View from His Window at Le Gras," to Harold Edgerton's electronic flash of a drop of milk at one millionth of a second, is a sample of a discrete instant in time. Some show more decisive moments than others; some are more snapshotlike than others; some are more beautiful than others.

Lady Elizabeth Rigby Eastlake, a nineteenth-century author and the wife of Sir Charles Lock Eastlake (himself a painter, art historian, and museum director), philosophized:

> Every form which is traced by light is the impress of one moment, or one hour, or one age in the great passage of time. Though the faces of our children may not be modelled and rounded with that truth and beauty which art attains, yet minor things, the very

14. Beaumont Newhall, "The Story of the Tintype," in *Annual of Photography* (New York: School for Modern Photography, 1952), 158–63. Several of the tintypes mentioned in this quotation are included in *The American Tintype*; see pp. 106, 107, 108, and 170.

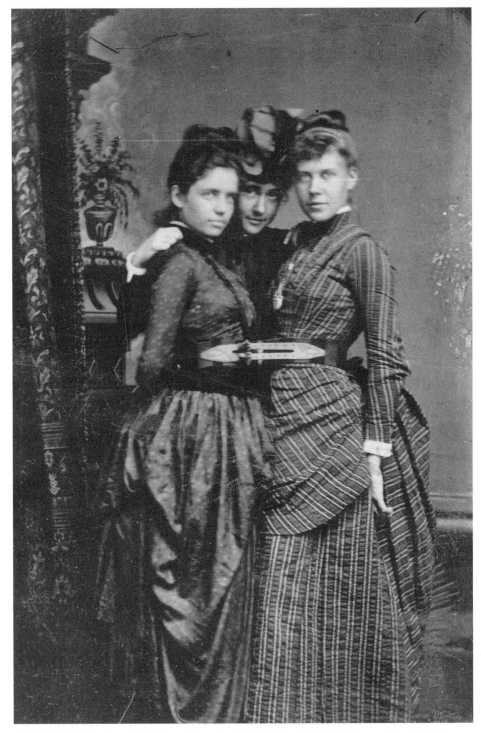

Alice Lillia Davis, left, and friends, wearing "Frank, the fat boy's belt." Tintype, 3⅜" x 2⅝", taken August 9, 1887, at Elmira, N.Y. Courtesy Beaumont Newhall.

shoes of the one, the inseparable toy of the other, are given with a strength of identity which art does not even seek. Though the view of a city be deficient in those niceties of reflected lights and harmonious gradations which belong to the facts of which Art takes account, yet the facts of the age and of the hour are there, for we count the lines in that keen perspective of telegraphic wire, and read the characters on that playbill or manifesto to be torn down on the morrow.[15]

15. *London Quarterly Review,* American ed., 1857, 241–55.

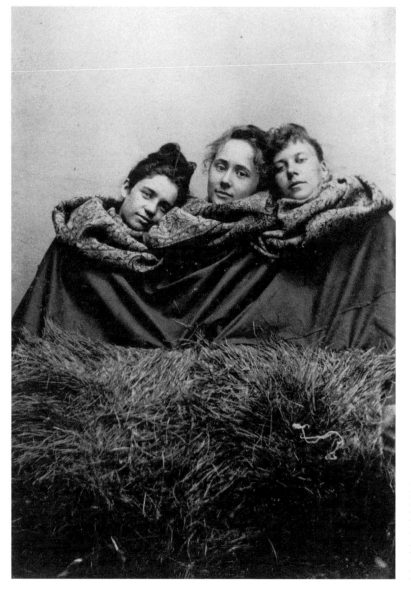

Bon-ton, taken at Elmira, N.Y. Alice Lillia Davis, left, scratched on the back of the plate, "Dr. Waldon's patients. Sept. 4, 1887." Courtesy Beaumont Newhall.

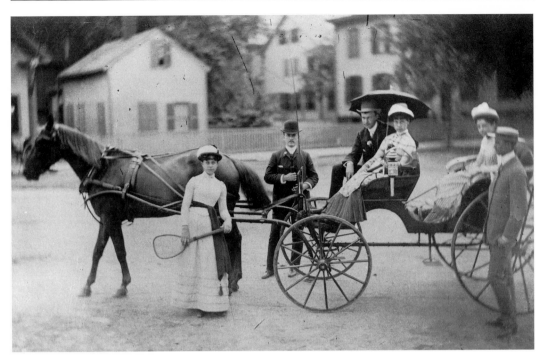

A tennis outing, Lynn, Mass., c. 1885. Tintype, 4" x 6¼". The girl in the rear seat of the carriage is Alice Lillia Davis. An exceptional outdoor scene. Courtesy Beaumont Newhall.

The twentieth-century photographer Steven Halpern has noted, "Where the Victorian portrait suggested permanence, the snapshot suggests transience. They are souvenirs of experience. They are physical keepsakes of a subjective world, whereas the Victorian portraits are physical keepsakes of a material culture." He concludes, however, "Today, the snapshot is now as stereotyped and as false a presentation of reality as the Victorian portrait had become by the end of the century. Before long the snapshot, too, will be like its Victorian counterpart, a form of nostalgia."[16]

Photographer Lisette Model described a snapshot as having "no pretense or ambition. . . . Innocence is the quintessence of the snapshot."[17] Her description also applies to the common, charming tintype.

16. *The Snap-Shot,* ed. Jonathan Green (Millerton, N.Y.: Aperture, 1974), 67.

17. Ibid., 6.

THE AMATEUR TINTYPIST

IN the early history of photography everyone was an amateur. The term *snapshot* connoted the taking of an "instantaneous" photograph by an "amateur" photographer using a handheld camera. More than twenty years before Eastman's handheld 1888 Kodak, an amateur pointed a

Bon-tons reflecting different plate colors. The chocolate in the upper right is also lightly tinted. The three-quarter view (*upper left*) and the portrait (*lower center*) are unusual. The group at the lower right appears to be in uniforms of the Spanish-American War period. While durable, tintypes are subject to damage from bending (see beer drinkers, *lower left*), scratches (*upper center*), and adhesion of paper or other mounting materials (*upper left*).

"pistol" containing a wet plate two inches square at Queen Victoria.[18] (The analogy of the camera as weapon extends throughout photographic terminology: the camera is loaded with a cartridge, aimed through the barrel of a lens, and shoots the subject.)

The earliest developers of photography knew that amateurs would be their biggest market, and patent wars were fought over that market from the beginning. The manuals by Daguerre and François Gouraud and the

18. Cecil Beaton, *British Photographers* (London: William Collins, 1944), 22. The "gunman," when arrested, turned out to be Thomas Scaife, the patentee of what he called "the pistolgraph"—a handheld camera 3" long and 1½" wide made entirely of brass and triggered like a pistol. It included a wet-plate workbag accessible

through a flap fitted tightly around the operator's hands and arms. See also Thomas Scaife, *Instantaneous Photography: Manipulation of the Pistolgraph* (Greenwich, England, 1860); Josef Maria Eder, *History of Photography,* trans. Edward Epstean (New York: Dover, 1978), 358; and Brian Coe, *Cameras: From Daguerreotypes to Instant Pictures* (New York: Crown Publishers, 1978), 53.

19. Alexander Black, *Photography Indoors and Out: A Book for Amateurs* (Boston: Houghton, Mifflin, 1898), 52, 53.

20. Green, ed., *The Snap-Shot,* 49.

21. Samuel Childers, *American Notes and Queries* (November 1943): 123.

writings of Neff, Griswold, Estabrooke, and Trask were intended to guide anyone who ventured into photography, not just aspiring professionals. In 1859 the Scovill Manufacturing Company advertised in *Humphrey's Journal,* under the heading "Photographic Art": "The Operator, or Amateur, can here obtain everything that has been found useful in his practice." By 1886 E. & H. T. Anthony was offering a choice of three complete tintype outfits. "Ferrotype Outfit No. 1 . . . for those who wish to start on a small scale" included a gem camera, lenses, plate holders, a camera stand, head-rest, darkroom equipment, a box of quarter-size plates, a pint of silver bath, a bottle of varnish, and other chemicals and accessories, including colors, brushes, and even a copy of Estabrooke's book *The Ferrotype, and How to Make It.*

In 1898 Alexander Black published a book directed specifically at the neophyte. Black, who deplored the use of the term *tintype,* noted that thousands of ferrotypes were still being made by professionals or semi-professionals. But he went on to say, "Recently the amateur has been interested in taking up the 'dry' ferrotype process and with prepared plates and a simple method of development, dainty little pictures are quickly finished."[19] Some of these "dainty little pictures" on iron have the look and the spirit of the snapshot and exhibit the snapshot aesthetic. As the American master photographer Paul Strand concluded, "The snapshot has nothing at all to do with amateurism or casual photography. It can be used by many people for many different reasons; by amateurs and by professionals, and also by artists."[20]

There was no Mathew Brady or Henri Cartier-Bresson in the history of the American tintype. The tintypist was, at least and perhaps at most, a folk artist. The last nineteenth-century wandering tintypist was reputed to be Charles Tremear, who died in 1943 in Detroit, where he had settled down to run the Greenfield Village Studio in Henry Ford's early American community. As a traveling tintypist, Tremear had had a team of four horses to draw a gallery and darkroom. He used a four-lens camera, charging fifty cents for four tintypes made on a full plate.[21]

Tremear was not, however, the last of his kind. Professor W. Robert Nix, of the School of Art at the University of Georgia and an authority on nineteenth-century photography, recalls that in 1952 or 1953, while touring on a Greyhound bus, he sat next to an elderly gentleman who turned out to be a tintypist traveling with his camera, processing tanks, and dry tintype plates, with which he was making portraits at three for fifty cents.

Ferrotype Outfit No. 1.

For those who wish to start on a small scale, the following outfit will suffice for a beginning :

1 ¼ Gem Camera and Holders, with 4 1-9 Gem Lenses, to make 4 1-9 Gems on ¼ Plate
1 Short Head Rest
1 ¼ Excel. Camera Stand
1 ¼ Rubber Bath and Dipper
1 4 x 5 Rubber Dish
2 No. o Rubber Funnels
1 3 oz. Collodion Vial
1 3 oz. Graduated Glass
1 Alcohol Lamp
1 Box Ferro. Colors, Brushes, etc
1 ½ Pint Jar Pearl Paste and Brush
1 Quill Duster
1 Instruction Book, The Ferrotype and How to Make It ...
1 Box ¼ Ferro. Plates
500 No. 4 Ferrotype Envelopes
1 Pint Silver Bath Solution
½ lb. Ferrotype Collodion
1 lb. Acetic Acid
¼ lb. Cyanide Potassium
1 lb. Sulph. Iron, in bottle
1 Bottle Varnish
1 Pint 95° Alcohol

Total $37 95

Those who wish to make single pictures, 1-9, 1-6 and 1-4 sizes, can do so with this outfit by adding a ¼ E. A. Portrait Lens, with central stops, which will cost, extra, $8 75.

The same outfit as above, but instead of ¼ Camera, Stand, Bath and Dish, we will send ½ sizes, $38 70.

With ¼ E. A. Lens$46 70.
With 1-3 E. A. Lens 52 50.

MANUFACTURED BY

E. & H. T. ANTHONY & CO.,

591 Broadway, New York.

Advertisement for E. & H. T. Anthony & Co.'s Ferrotype Outfit No. 1. By 1886 photographic supply houses were targeting the amateur as well as the professional photographic market.

He had a hearing problem, but his real problem, the old man complained, was obtaining iron plates![22]

Cheap paper and Polaroid imitations of daguerreotypes and tintypes are now being made and put in envelopes for tourists and visitors at some historical centers and amusement parks. A few studios attempt to be more authentic, some using 5" x 7" sensitized dry plates on an aluminum base. Customers are encouraged to dress in Victorian fashion, and these new tintypists keep props for that purpose. In March 1996, at the American Tintype Gallery in the Eastman House of International Photography in Rochester, New York, Mark Osterman and Frances Scully Osterman conducted a wet-plate collodion workshop that covered glass-plate negatives, ambrotypes, and tintypes.[23]

There has been a revival of interest in early photographic forms among contemporary photographers, some of whom are making daguerreotypes

22. Interview with W. Robert Nix, February 17, 1996.

23. For contemporary photographers interested in nineteenth-century processes, see *Wet Plate Collodion Workbook* by Notch Miyake, Mark Osterman, and Roger Watson (Rochester, N.Y.: George Eastman House International Museum of Photography and Film, 1996). Also see the *Collodion Journal* on all aspects of wet-plate photography.

and platinum prints and using other nineteenth-century processes. Like tintype collectors, such photographers are rediscovering a lost chapter in the history of photography. As John Szarkowski points out: "Many of the most innovative workers of the past generation have found inspiration and precedent by leap-frogging backwards, beyond the time of their immediate predecessors, to a more distant photographic past. As a rule, photography has not developed in a disciplined and linear manner, but has rather grown like an untended garden, making full use of the principles of random selection, laissez-faire, participatory democracy, and ignorance."[24]

24. John Szarkowski, *Looking at Photographs* (New York: Museum of Modern Art, 1973), 11. For the transition from nineteenth- to twentieth-century photography, see *Photography: 1900 to the Present*, compiled by Diana Emery Hulick with Joseph Marshall (Upper Saddle River, N.J.: Prentice Hall, 1998).

PART II

A Victorian Family Tintype Album:

Glimpses of American Life,

1856–1900

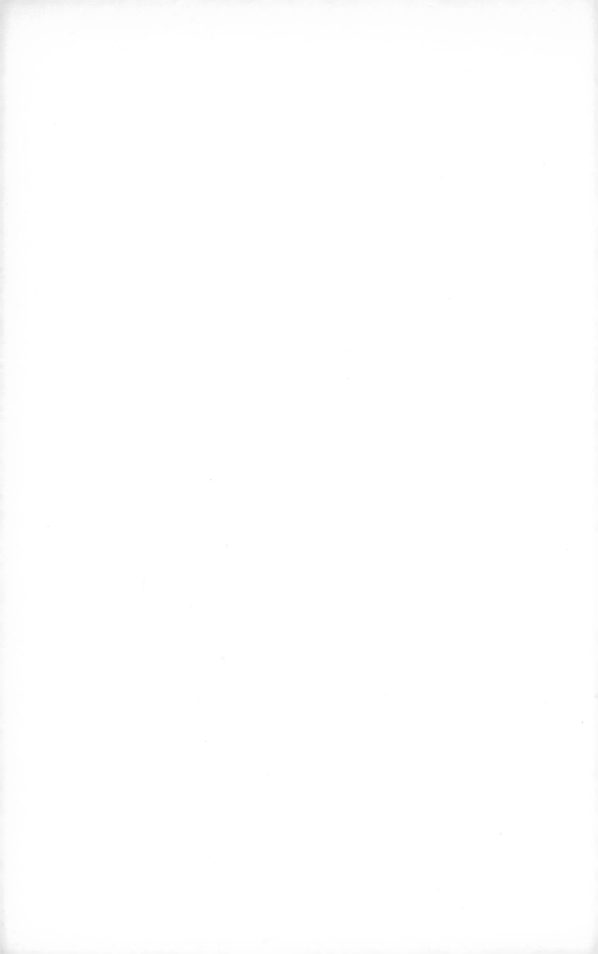

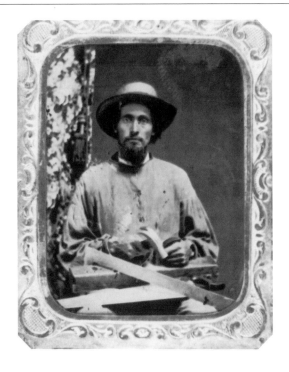

A carpenter, c. 1865. Sixth-size plate. From the earliest days of photography, symbols of a sitter's profession were held in the hand or placed on a nearby table. Costumes or related background scenes contributed to the meaning of the portrait. Private collection.

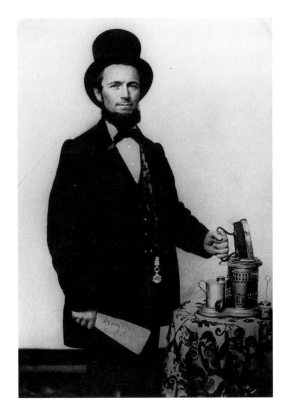

Oscar E. Morrill, Chelsea, Mass., 1863. Melainotype. Morrill is shown with his patent for a "sad iron," issued December 1, 1863. The fire inside the stove is hand-tinted red.

Young men with cigars.
c. 1873. Bon-ton. Smoking
was one of an American
boy's rites of passage.

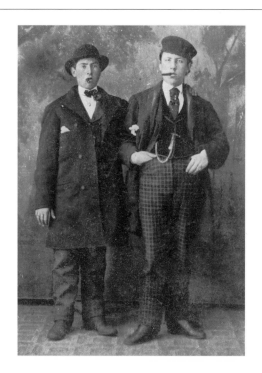

Western portrait, c. 1870.
Half-size plate.

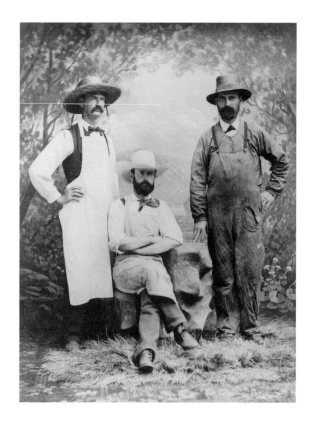

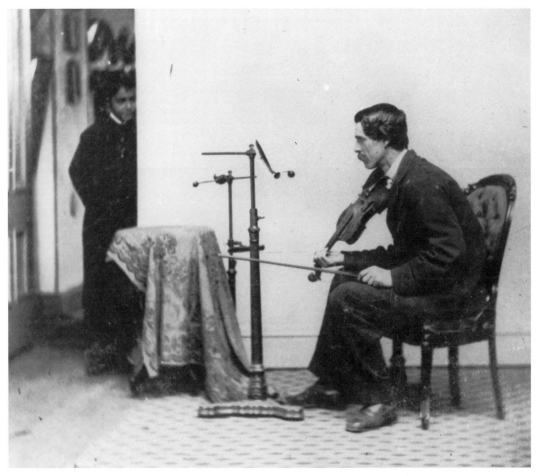

The musician, c. 1877. The violinist is posed using a photographer's headrest as a music stand. Was the bystander on the left there for a reason, or was he supposed to be clipped off in the final photograph? Courtesy Frank Dimauro.

Man with dog and
gun, c. 1879. Bon-ton.
An excellent outdoor
tintype.

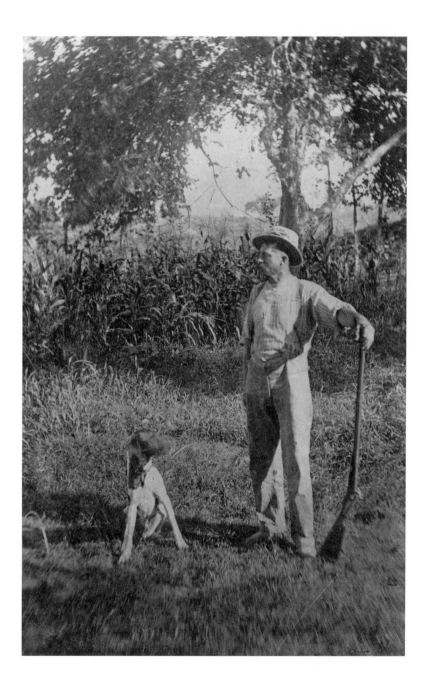

Seated man in doorway, c. 1874. Bon-ton. This interesting outdoor portrait was probably taken in front of the young man's place of business. The sitter exudes the confidence of youth and American enterprise.

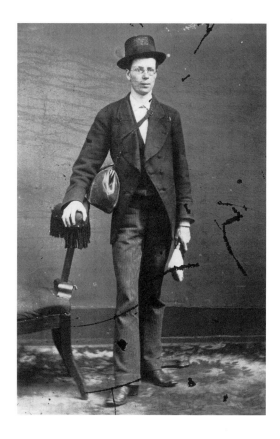

Man with whisk broom, c. 1875. Bon-ton. The satchel and broom possibly indicate that this subject was a traveling salesman. Courtesy J. C. King.

Detective with a gun,
c. 1875. Bon-ton. Private
collection.

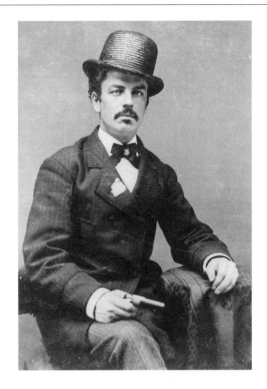

Portrait of a policeman,
c. 1879. Bon-ton. Courtesy
Frank Dimauro.

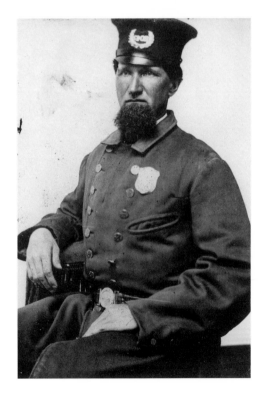

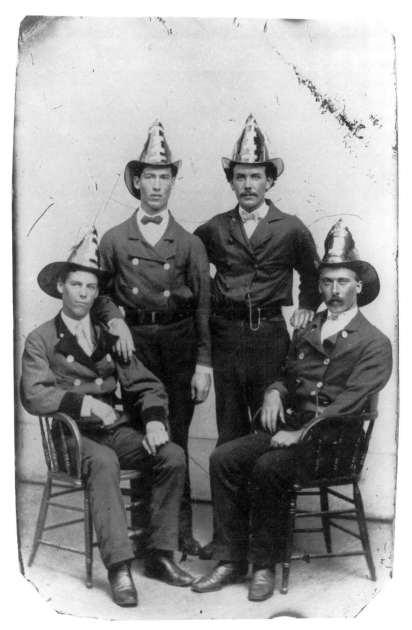

Firemen, c. 1880. Bon-ton. The tintypist posed the men well. Note the studied yet informal placement of the hands in this group portrait. Courtesy Frank Dimauro.

Two gentlemen from
Georgia, c. 1895. Bon-ton.
This interesting tintype,
with its makeshift back-
ground and bench, was
probably taken by an itiner-
ant tintypist. The ill-fitting
suits were probably the
subjects' Sunday best.
Courtesy Jane Sanders.

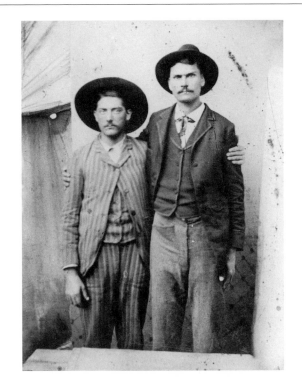

Man with rope, c. 1885.
Bon-ton. The subject may
be a climber of some sort
or simply a rope salesman.

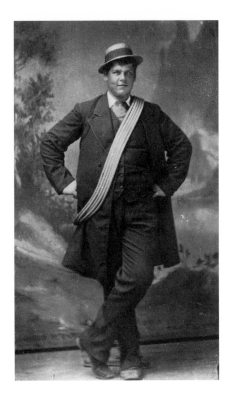

A friendly game of cards, c. 1879. Bon-ton.

Caught cheating, c. 1879. Bon-ton.

On the siding, c. 1885.
3¼" x 4½". A proud work
crew wearing their Sunday
best. Courtesy Mark
Burnett.

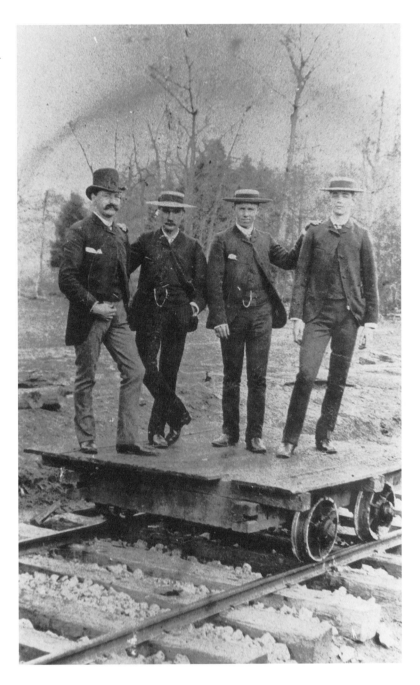

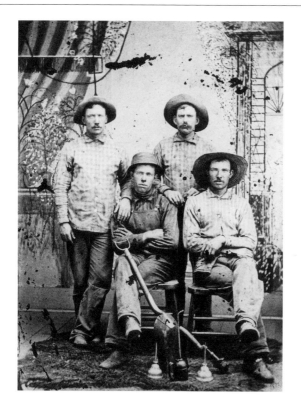

Railroad workers, c. 1890. Bon-ton. This group includes a fireman and a maintenance crew. A western tintype. Courtesy J. C. King.

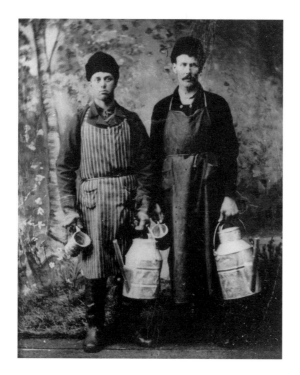

Men with watering cans, c. 1895. Bon-ton. Private collection.

Gentlemen about town,
c. 1890. Bon-ton. The
well-dressed subjects, the
ornate chair, and the back-
ground suggest that this
group was photographed
in a well-appointed city
studio.

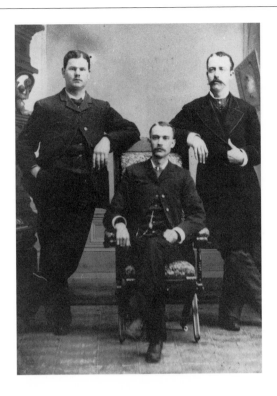

Men with fire extinguisher,
c. 1896. Bon-ton. This tin-
type was found in Rolla,
Mo. Courtesy J. C. King.

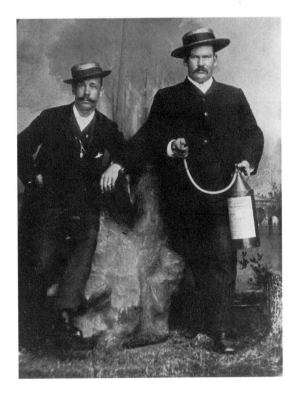

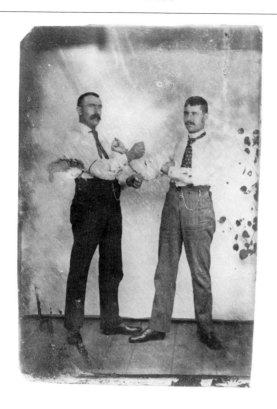

John L. Sullivan, left, and friend, c. 1885. Bon-ton. Sullivan (1858–1918) was the bare-knuckle heavyweight champion in 1882. Wearing gloves, he lost to James Corbett in 1892. Sullivan retired in 1896.

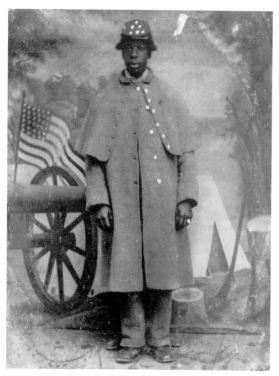

Union soldier from a black regiment. Hand-tinted tintype with gold buttons on overcoat. The painted background simulates a battleground campsite. The back of this photo contained a tax stamp, which means it must have been taken in about 1865.

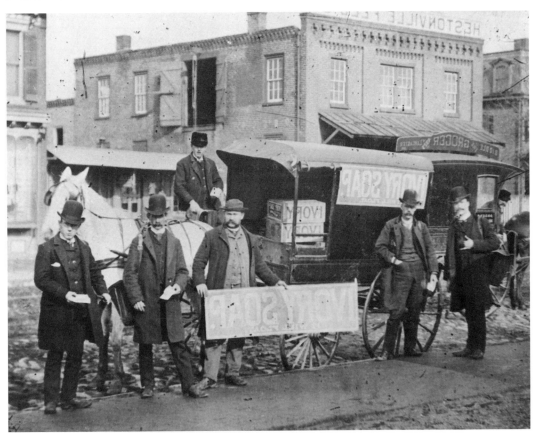

Ivory soap wagon and employees, Hestonville, Pa., c. 1895. 4½" x 6½". This remarkable tintype shows boxes stacked in the wagon and men holding samples of Ivory soap. The sign on the building reads "Hestonville Feed Company." (Remember that the tintype process produced a reversed image.) Courtesy George Rinhart.

Chapter 9

WOMAN'S WORLD

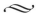

AN English lady, after three visits to the United States in the 1870s, wrote that lawn tennis had become popular and that many women were expert players. She was impressed by how "very attractive these bright American girls look in their tight-fitting jerseys and short skirts."[1] One of photography's contributions is the recording of women's costumes, which, along with hairstyles and hats, help establish the date of a portrait. Women's fashions changed continually. The rather austere dress of the 1840s became more elaborate during the 1850s, and the dress of the 1860s was plain compared to the bustles, ruffles, and fancy hats worn in the 1870s. Tintypes caught this fascinating nineteenth-century fashion parade.

In 1863 William Makepeace Thackeray humorously wrote that for a Victorian man the ideal mate would be "an exquisite slave . . . a humble, flattering, smiling, tea-making, piano-forte-playing being who laughs at our jokes, however old they may be, coaxes us and wheedles us in our humours and . . . fondly lies to us throughout life."[2] This stereotype of the Victorian woman began to be changed by such women as Carry A. Nation, who smashed bottles and bars; Jenny Lind, who helped make the stage a respectable career for a talented singer; Harriet Beecher Stowe, who wrote a classic and controversial novel; and Susan B. Anthony, who fought for women's suffrage and dress reform. One afternoon on Boston Common a woman appeared in a pair of full-cut trousers which became known as "bloomers," after their wearer, Amelia Bloomer. Oliver Wendell

1. Emily Faithful, *Three Visits to America* (New York: Fowler & Wells, 1884), 76.

2. W. M. Thackeray, quoted in Ronald Pearsall, *The Worm in the Bud: The World of Victorian Sexuality* (Harmondsworth: Penguin Books, 1983), 110–11. Also see Duncan Crow, *The Victorian Woman* (London: George Allen & Unwin, 1971).

3. Catherine Bowen, *Yankee from Olympus* (Boston: Little, Brown, 1945), 102.

Holmes, a proper Victorian gentleman, cautiously observing her at a respectable distance, thought she was "queer" but "handsome."[3]

Of course, women were also photographers. Frances Benjamin Johnston (1864–1952), a traveling tintypist, became one of the most important portraitists in Washington, D.C. She also photographed coal mines in Pennsylvania, the Mesabi Range, the Columbian Exposition (1893), and the Louisiana Exposition (1904). With her Hampton Album (1899), she created one of the first photographic documents about the education of African Americans and Native Americans, as they lived and learned at the Hampton Institute in Virginia. Examples of Johnston's work are in both the Museum of Modern Art and the photo archives of the Library of Congress.[4]

4. See James Guimond, "Frances Johnston's Hampton Album: A White Dream for Black People," in *American Photography and the American Dream* (Chapel Hill: University of North Carolina Press, 1991), 23–53. Also see William Culp Darrah, "Nineteenth-Century Women Photographers," in *Shadow and Substance: Essays on the History of Photography,* ed. Kathleen Collins (Bloomfield Hills, Mich.: Amorphous Institute Press, 1990), 89–103.

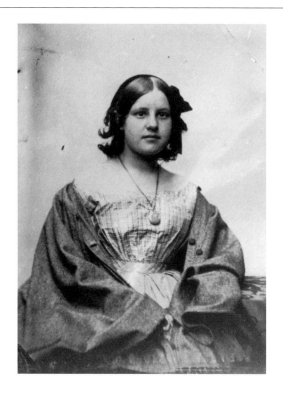

Portrait of a young woman, c. 1858. Sixth-size plate. One of the interesting aspects of photography's early years is the fascinating parade of women's costumes.

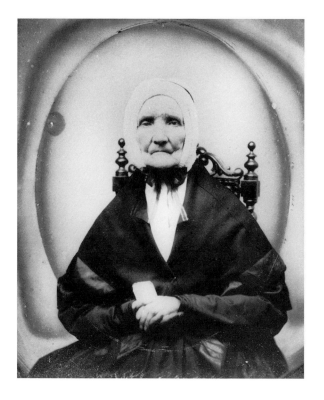

Elderly woman wearing matron's cap, c. 1857. Melainotype. Sixth-size plate.

A fashionable young
woman wearing a bustle,
c. 1880. Bon-ton.

Two young women on a
rustic bench, c. 1886.
Bon-ton.

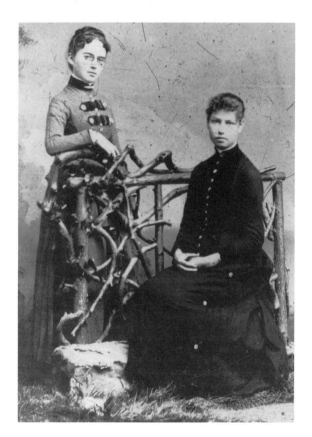

Portrait of a young
woman, c. 1878. Bon-ton.
An excellent example
of an elaborate outdoor
costume of the era.
Private collection.

Four young women,
c. 1873. Bon-ton. An
excellent group tintype
displaying a variety of
costumes. Three of these
women are looking away
from the camera rather
than toward it, as in the
traditional pose.

Portrait of a woman, c. 1875. Bon-ton. The fine lighting and the pose are in the tradition of the daguerreotype.

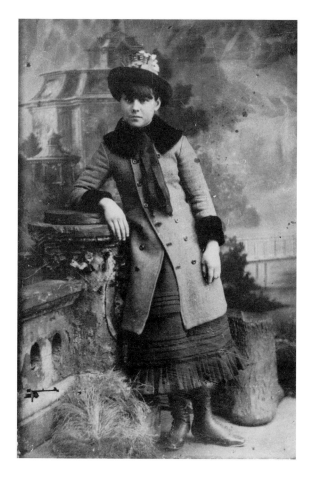

Portrait of a young woman, c. 1878. Bon-ton. The tintypist has posed his subject before a backdrop picturing a Victorian mansion. Props clutter the foreground.

Portrait of a young
woman, c. 1880. Bon-ton.
Neither the subject nor
the photographer seemed
to know quite what to do
with the sitter's hands in
this tintype.

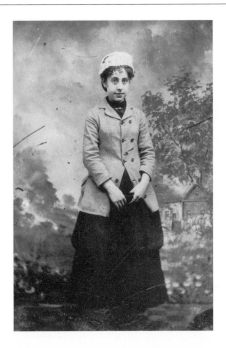

Two young women, c. 1883.
Victoria. The slim sleeves
and two-piece costumes
are characteristic of the
1880s. Note the different
hairstyles and the orna-
mental pedestal.

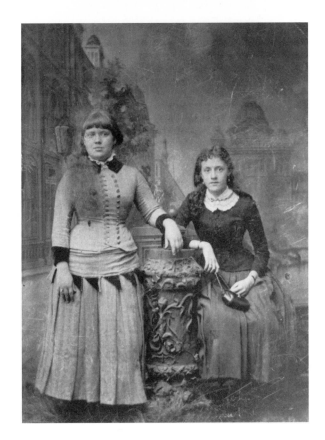

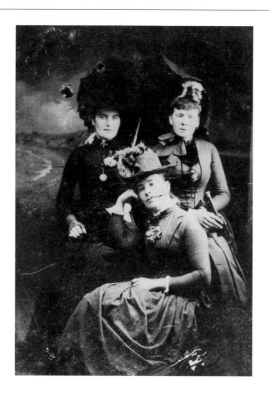

Three handsome women, c. 1884. Bon-ton. This trio seems intense, alert, and individualistic. What may look like a straw in the mouth of the woman in the foreground is a scratch on the surface of the tintype .

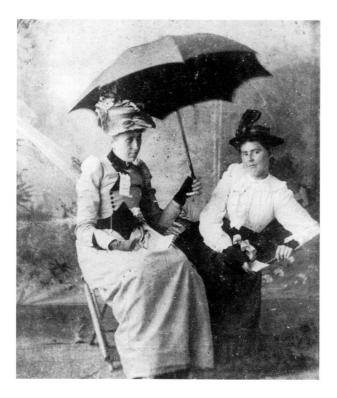

Camp-meeting delegates at Ocean Grove, N.J., c. 1891. Bon-ton. Two women take time out from religious activities for a visit to what was probably an itinerant tintypist, many of whom set up shop at camp meetings during the summer months.

A southern portrait,
c. 1895. A mother and
daughter, dressed in their
simple Sunday best, pose
before a makeshift back-
ground embellished with
plant forms.

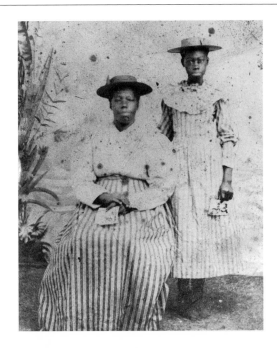

Woman on elephant,
c. 1900. Bon-ton. By an
unknown circus or itiner-
ant tintypist. Courtesy
Mark Burnett.

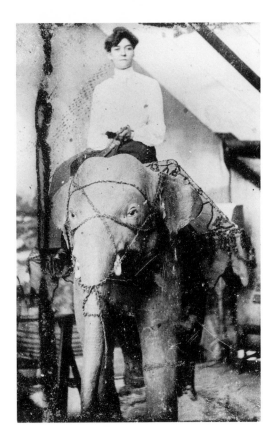

Chapter 10

DIGRESSIONS
AND DIVERSIONS

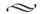

CLOWNING AROUND

IN a time when God, Money, and Work (not necessarily in that order) prevailed, a visitor from abroad might conclude that Americans had little time for leisure. But tintypes show fun-loving males whiling away the hours with idle conversation, cardplaying, sports, and evenings on the town, and females willing to be recorded clowning around in front of a tintype camera because it was an accessible, cheap, and painless process. The resulting record was seldom taken too seriously.

A derby-hatted patron, securely clamped in a headrest, watches the "birdie" as the photographer, his camera perched on an improbable stand, times the exposure, c. 1874. Bon-ton.

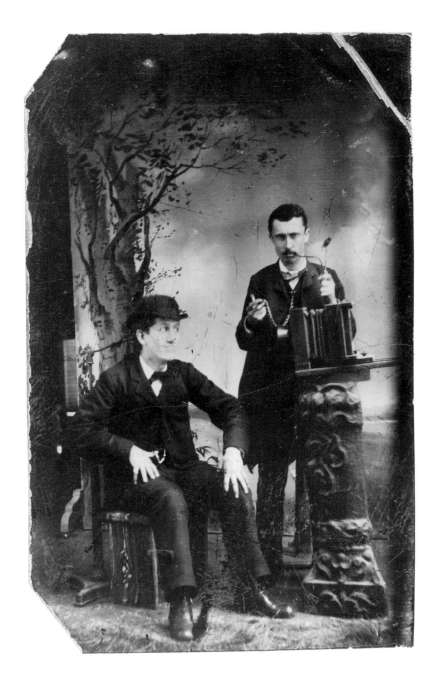

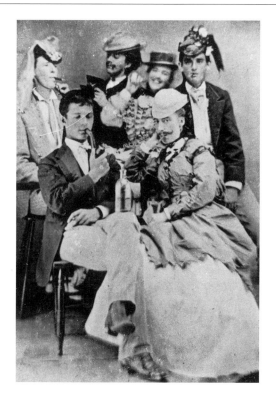

A college powwow, c. 1877. Bon-ton. As part of Presentation Week, an event at Yale College, freshmen held "powwows" during the hours of the president's reception: "As it grew later and darker, Freshmen, covered as to their faces with burnt cork, Freshmen with striped pants, Freshmen with hooped skirts, Freshmen with hoofs and tails, Freshmen with big beards and bobtail coats.... Freshmen with all sorts of conceivable and practical disguises ... march[ed] slowly across the college-yard ... for the purpose of celebrating their entrance upon Sophomore year" (*Harper's Monthly Magazine*, 1864).

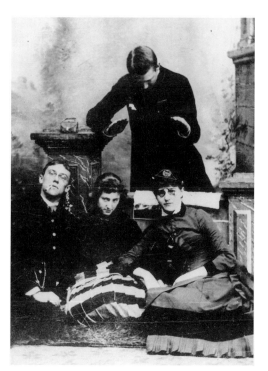

The benediction, c. 1877. The viewer is left to interpret this 2½" x 4" tintype.

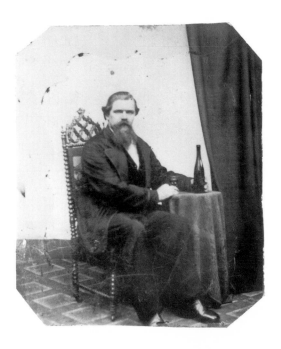

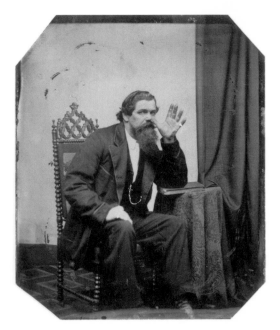
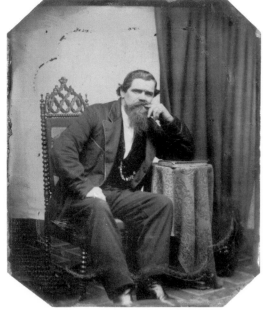

Drinking man "cocking a snook." Ferrotype. Sixth-size plate. Sequential narratives, especially in tintype form, are rare. Courtesy Grant B. Romer.

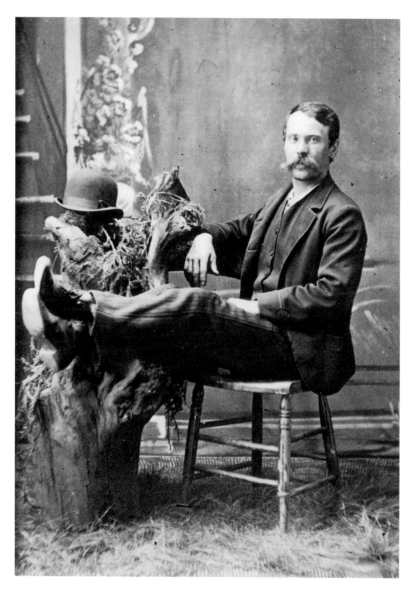

Taking it easy, c. 1892. Bon-ton. An unusually informal pose. "If there is any man whom you wish to conciliate, you should make a point of taking off your hat to him as you meet him" (*Decorum*, 1881). Courtesy J. C. King.

Out on the town, c. 1879.
Bon-ton. Drunks were a
rather common subject for
the tintypist, and pictures
like this one gave impetus
to the growing temperance
movement.

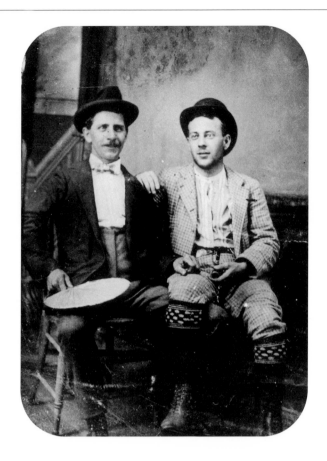

A threesome, c. 1890.
Bon-ton.

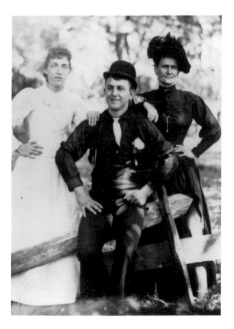

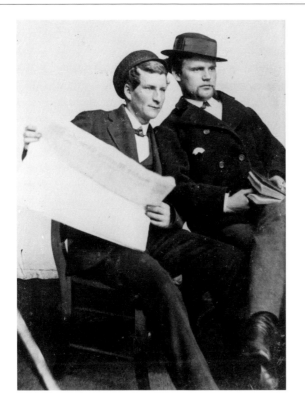

Two young men with newspaper and book, c. 1878. Bon-ton. Keeping up with the latest news and reading recent books and magazines were important leisure activities. The attention of these two seems, however, to be fixed on something off-camera.

A "funnygraph," c. 1877. Bon-ton. Tintypes like this were a fad in the 1870s, and such settings are still found in amusement parks and tourist spots.

THE ENTERTAINERS

IN the 1870s popular entertainment included amateur performances of makeshift theatricals, sometimes staged in tents or barns. They were often produced as benefits for a local charity, as demonstrations of local talent, or just as ways to relieve the boredom of life in small-town America.

In towns both large and small, the appearance of professional traveling troupes—theater groups, minstrel and vaudeville shows, and circuses—created a special excitement. Magic-lantern shows abounded, and with Edwin S. Porter's short-story film *The Great Train Robbery* (1903), Americans were off to the movies, sometimes called "galloping tintypes."

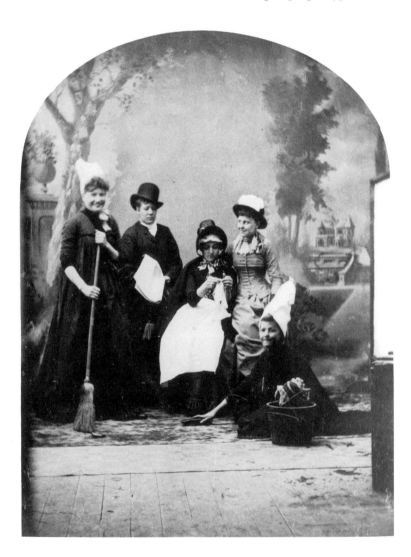

Theater group, c. 1880. Half of a stereo tintype. The scene is from an unidentified stage production.

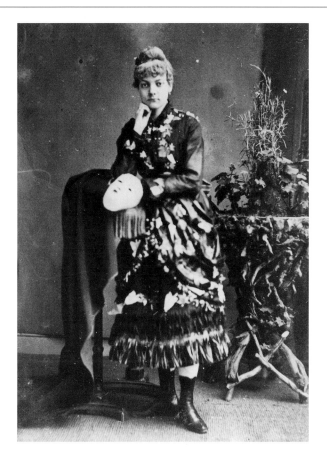

Nellie Magill, 1873. Bonton. This young lady from Pennsylvania is part of a theater group in the Greek tradition. An interesting pose enhanced by an ornate rustic pedestal and plants.

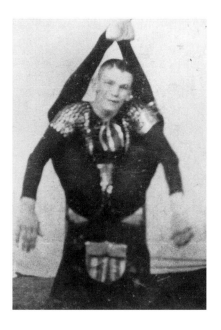

Contortionist, c. 1865. Gem. This young man was probably a performer with a traveling circus. Courtesy Michael Williams.

Julia Taylor, 1873. Bon-ton.
Another young lady from
Pennsylvania represents a
thespian after the Greek
tradition.

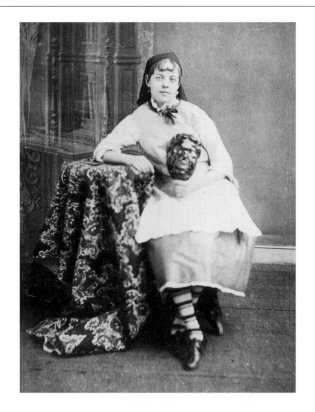

"Dell Cabin," c. 1875. Bon-
ton. A member of the Julia
Taylor theater group.

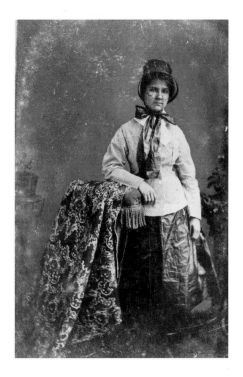

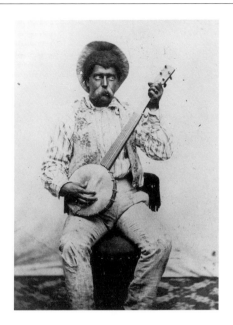

A performer with Homer's Variety Minstrel Show, 1874. Bon-ton.

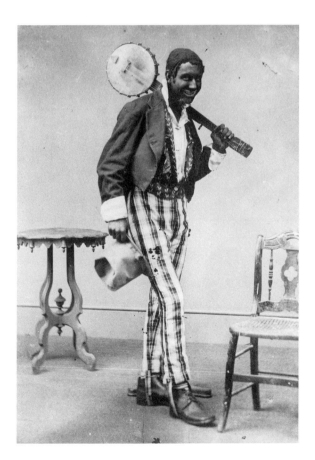

J. F. Holloway, 1874. Bon-ton. A gallery tintype of a twenty-three-year-old minstrel.

Woman with a gun, c. 1875. Bon-ton. The costume suggests that this woman was a performer, possibly with a Wild West show. It may also be Mrs. M. A. Maxwell, whose achievements as a huntress were widely known.

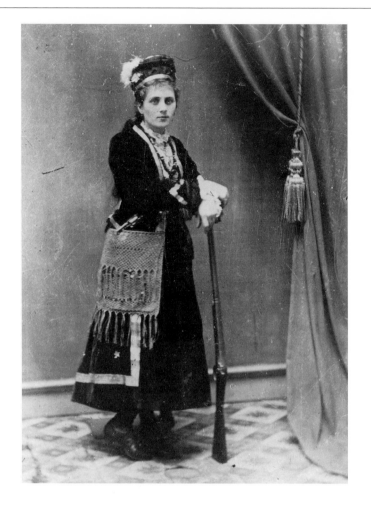

WHEELS

THE bicycle appeared in America in 1868 after the Frenchman Pierre Lallement came to New Haven, Connecticut, and began making velocipedes. The bicycle fad soon swept the country. Amateur photography became a popular diversion at about the same time. *Munsey's Magazine* reported:

> There is one reflection which can hardly fail to suggest itself to a recent arrival in Cyclonia, and that is the strange but undeniable fact that every third cyclist is a photographer. Perhaps photographer is too harsh a term to apply to these well-meaning persons; the justice of the case would be met in most instances by describing them as dabblers in photography. They are for the most part

This advertiser has capitalized on the popularity of the hand-held camera and the bicycle fad to promote both at the same time. *The Makio,* 1892. Courtesy The Ohio State University Archives.

harmless, and operate chiefly on each other, and on their friends and relations. . . . The advertising columns of the cycling papers are full of announcements of photographic materials fitted for conveyance of tricycles.[1]

1. *Munsey's Magazine* 15 (May 1896): 139.

Although the cameras that made tintypes were never screwed to bicycles, they still recorded some of the picturesque wheels and riders in "Cyclonia."

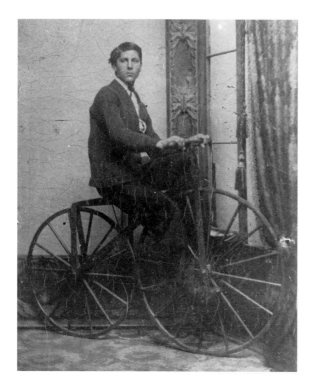

A Lallement velocipede, c. 1868. Bon-ton.

Women cyclists, c. 1896. Bon-ton. The League of American Wheelmen was founded in May 1880 at Newport, R.I., and had its headquarters in Boston. By 1896 there were more than 40,000 members, including 1,500 women. The backdrop in this tintype suggests that these two well-dressed women might have stopped at a traveling tintypist's tent to have their picture made with bikes as props. The women, with a firm grip on the handle bars and a determined look in their eyes, could not have failed to notice the absence of the rear end of their vehicles.

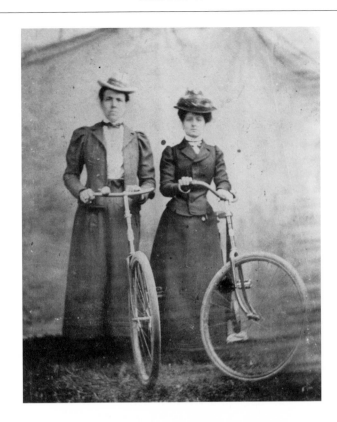

Bicycle racing outfits, c. 1881. Oversized bon-ton. The bicycle fad of the 1880s and 1890s created a demand both for bicycles and for bicycle suits made of the best English serge and cashmere. The outfits were advertised along with "Tourist Shirts, Lawn Tennis, and Base Ball Suits."

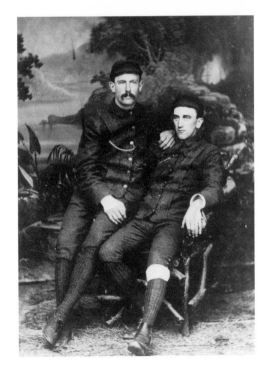

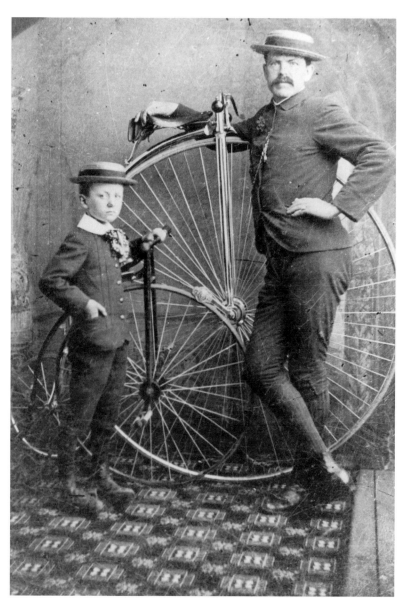

The "modern" bicycle, c. 1882. Bon-ton. Bicycles came in many sizes. The standard wheel was between twenty-eight and fifty inches in diameter, and a bicycle with a fifty-inch front wheel cost sixty dollars. Private collection.

The "Rover," c. 1889.
Bon-ton. The Rover was
sometimes called the
"Boneshaker." By 1889
bicycles with cogwheels,
chains, and pentagonal
frames were part of the
new look.

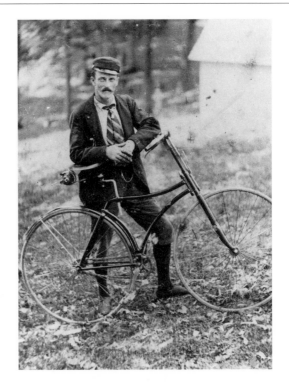

Man with bicycle, c. 1894.
Bon-ton. This bicycle has
handlebar brakes, balloon
tires, and a toolbox.

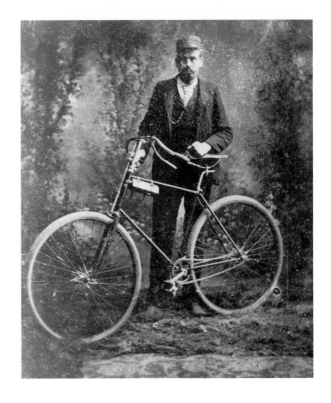

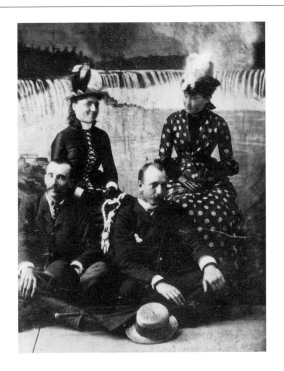

The honeymooners, c. 1885. Bon-ton. Niagara Falls was a mecca for newlyweds, and tintype studios carried backgrounds appropriate—though unconvincing in this case—to the location.

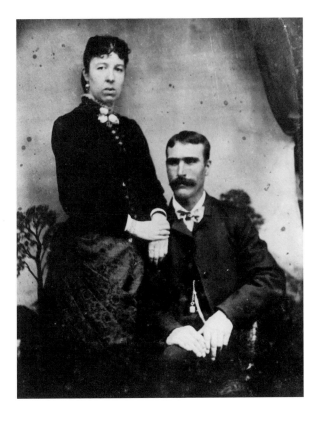

Mr. and Mrs. Henry Guptill of Cherryfield, Maine, c. 1880. 5" x 7". Although she may seem to be restraining her husband, Mrs. Guptill was undoubtedly simply following the tintypist's instructions to steady herself on his shoulder.

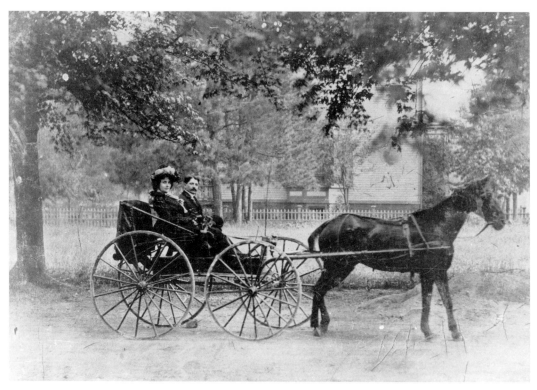

Courting in a carriage, c. 1900. 4½" x 5½". The man would leave the carriage first, then hand the lady out. Alighting from a carriage with grace required a woman to lift her dress to show just the point of the shoe.

Young woman in wedding gown, c. 1878. Bon-ton. Note the slipper on the pedestal and the painterly quality of the pose.

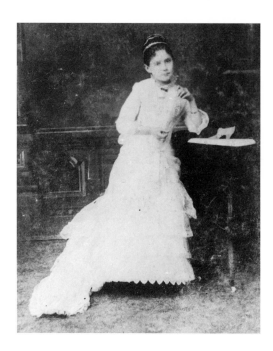

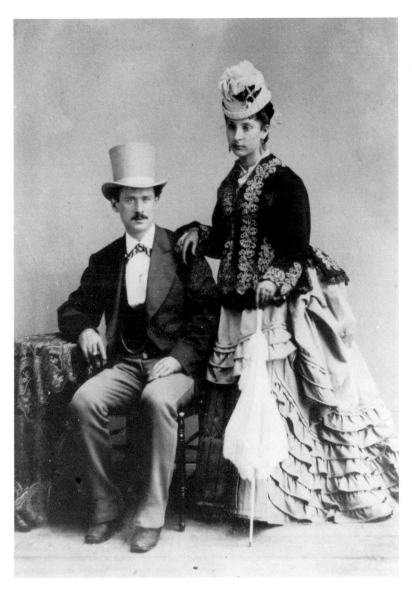

Mr. and Mrs. David Moss on their wedding day, 1872. Bon-ton. This fashionable tintype and costume piece was taken in New York City by an unknown photographer. Courtesy George Moss.

VICTORIAN CHILDREN

IMPRESSED with the American family, two Englishmen reminisced: "Where the home-life exists there is a fortunate combination of simplicity and refinement. . . . There appears to be more real harmony between the members of the family, and more confidence between the parents and children. . . . Little children are not required to be seen only and not heard, but their opinion is asked (although perhaps not followed) and thus self-reliance is inculcated from their earliest years which is of such practical importance to after-life."[1]

1. W. J. Rivington and W. A. Harris, *Reminiscences of America in 1869* (London: S. Low, Son, and Marston, 1870), 51–54.

Children, you are very little,
And your bones are very brittle;
If you would grow great and stately,
You must try to walk sedately.

You must still be bright and quiet,
And content with simple diet;
And remain, through all bewild'ring,
Innocent and honest children.

Happy hearts and happy faces,
Happy play in grassy places—

That was how, in ancient ages,
Children grew to kings and sages.

But the unkind and the unruly,
And the sort who eat unduly,
They must never hope for glory—
Theirs is quite a different story!

Cruel children, crying babies,
All grow up as geese and gabies,
Hated, as their age increases,
By their nephews and their nieces.

—"Good and Bad Children,"
Robert Louis Stevenson

Portrait of a baby, c. 1870. Bon-ton. The light and shadow on the baby's expressive face, together with the light clothing against the subdued background, provide a well-balanced tintype.

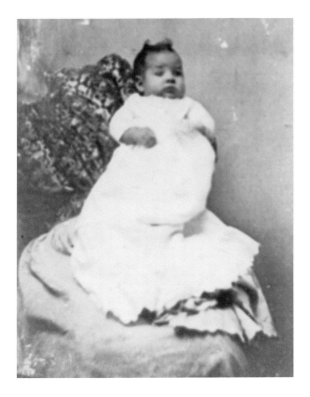

Portrait of a baby, c. 1873. Bon-ton. The mother's hand, which steadies the baby during the exposure, is concealed in the fabric.

Mother and child, c. 1859.
Bon-ton. Melainotype.
The photographer was
J. A. McHenry of Racine,
Wis.

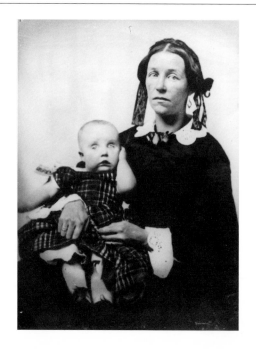

Portrait of a young girl,
c. 1861. Melainotype.
Sixth-size plate. The child
sits on an elevated stool
draped with a printed
cloth extending from the
table, while her mother
stands supporting her at
the left. When the framing
mat, whose outline is
visible, was placed over
the portrait before fitting it
into a miniature case, the
woman's face would be
hidden.

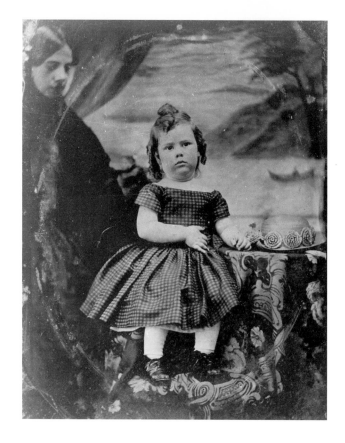

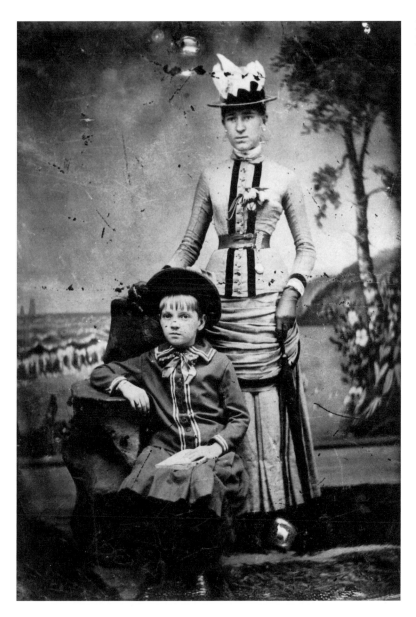

Mother and child, c. 1885.
Bon-ton.

"Little Lord Fauntleroy,"
c. 1888. Bon-ton. Inspired
by the book by Frances
Hodgson Burnett, mothers
began to dress their small
boys in fancy clothing, not
necessarily to the boys'
liking, as this woebegone
portrait seems to reveal.
Even his shaggy pet dog
seems to have shaken his
head, perhaps in despair.

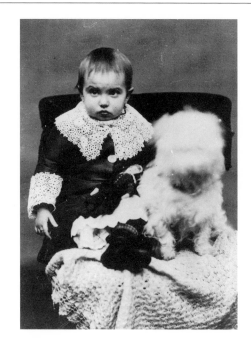

Child in Scottish dress,
c. 1884. 5" x 7".

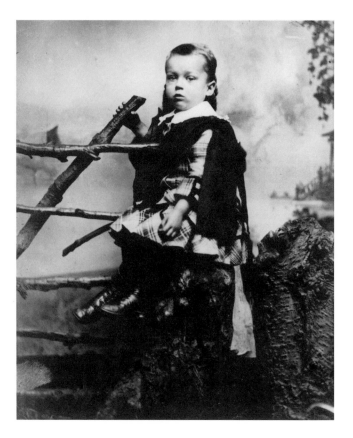

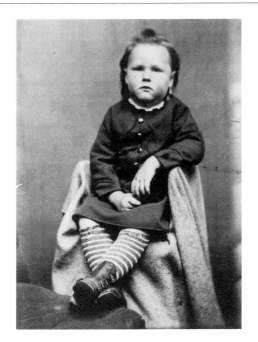

Seated child, c. 1875. Bon-ton. The tintypist has draped a high chair with a blanket and provided a footrest. The child's striped stockings draw the eye to the high-buttoned shoes.

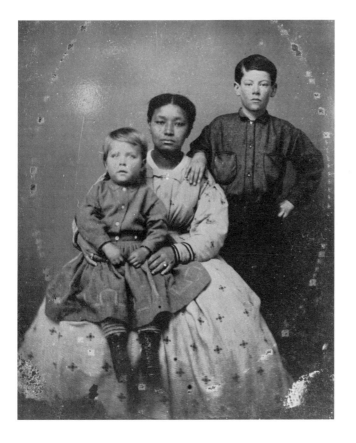

Children with nursemaid, c. 1861. Quarter-size tintype.

Girl with dog, c. 1875.
Bon-ton. Both the sitter
and her well-behaved pet
are paying attention to the
photographer.

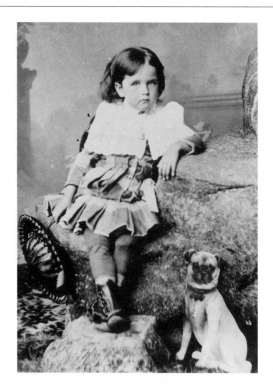

Smiling girl with doll,
c. 1895. Sixth-size plate.
An excellent costume
piece. Note the pleasant
expression of the sitter
and the clarity of the
doll's face. Courtesy
Archives, Lamar Dodd
School of Art, Univer-
sity of Georgia.

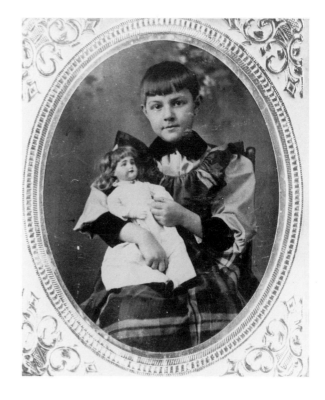

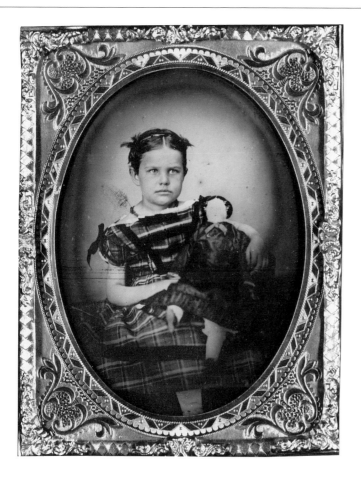

Girl with doll, c. 1858. Melainotype. Quarter-size plate. A winsome portrait taken and elaborately cased in the style of the daguerreotype. Courtesy George Whiteley IV.

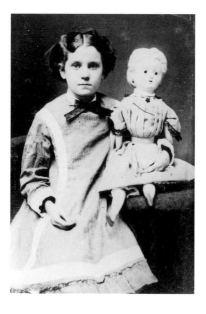

Girl with doll, c. 1878. Bon-ton. Private collection.

Girl in sunbonnet, c. 1885.
Special (2½" x 4"). A
charming studio portrait.

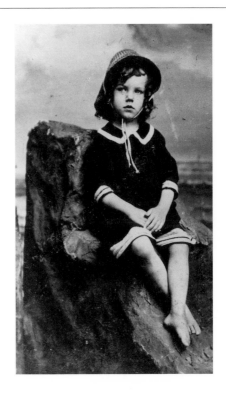

Boy with hat, c. 1869.
Ninth-size plate. This
expressive tintype was
found in Fernandina, Fla.

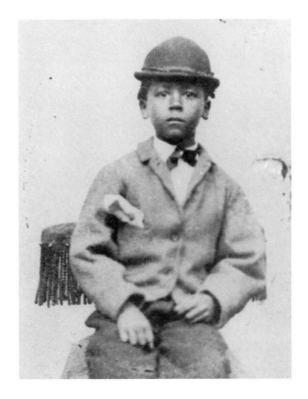

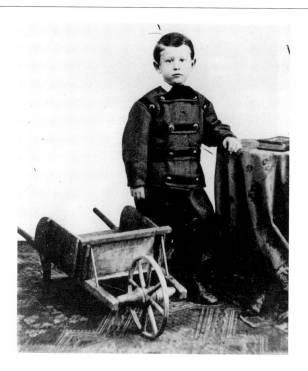

Boy with wheelbarrow, c. 1872. Bon-ton. The subject is posed with a favorite toy in the manner of the traditional daguerreotype. Courtesy Frank Dimauro.

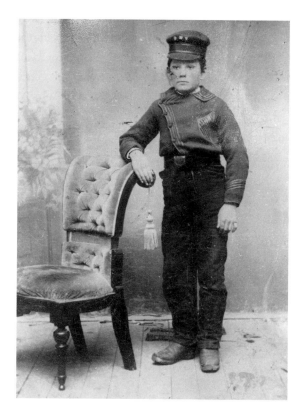

Boy in uniform, c. 1872. Bon-ton. This boy may have worked as a messenger.

Family portrait, c. 1863.
Melainotype. Sixth-size
plate. A typical family
pose. Note the graceful
arrangement of the child's
skirt and the parents'
arms. The father, wearing
his campaign hat, appar-
ently wanted it to be
known that he was a
soldier in the Civil War.

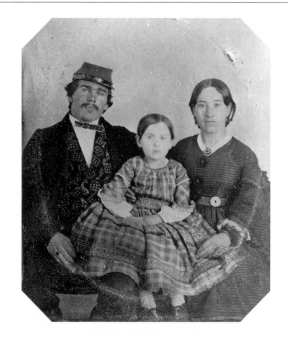

Group portrait, c. 1869.
Large gem. Class portraits
like this were an important
addition to the family
album in the nineteenth
century, as they are today.

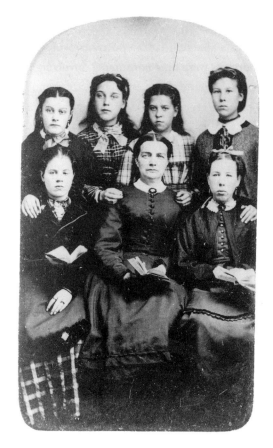

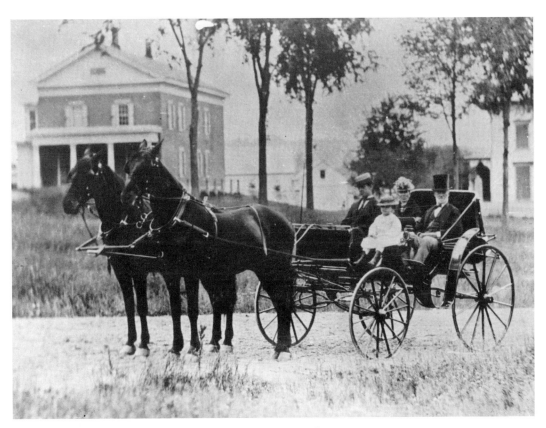

A family drive in a well-to-do neighborhood, c. 1872. 4⅛" x 5¼" plate.

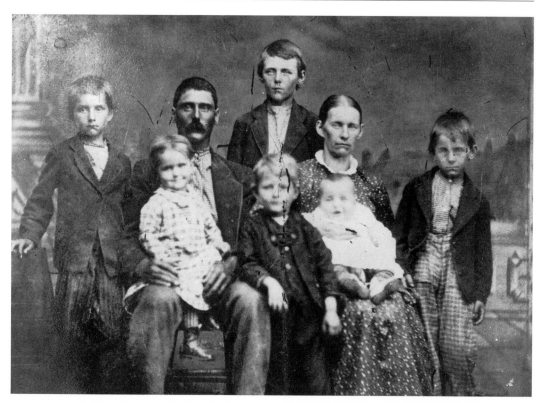

An American family, c. 1873. Victoria.

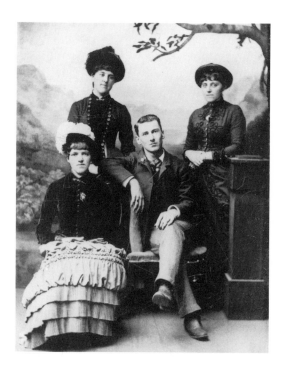

A relaxed family group,
c. 1884. Bon-ton.

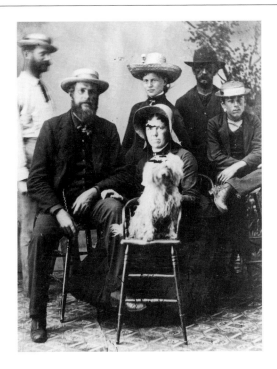

Portrait of Floridians, c. 1883. Victoria. Slight movement is seen in the pet dog and the man standing at the left of this otherwise excellent group portrait.

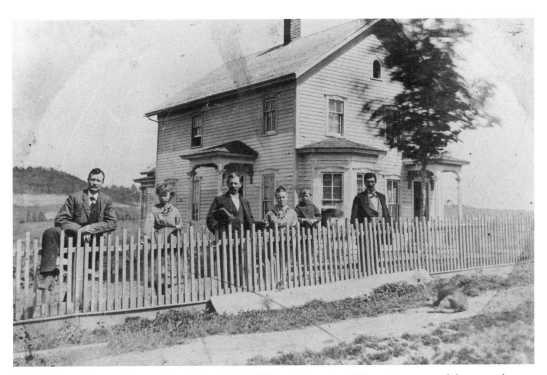

A family scene along a village road, c. 1878. 4½" x 6½". Note the imprint of the missing mat and the unusual pose of the gentleman on the left. Courtesy Mark Burnett.

A formal family group, c. 1885. Bon-ton. The studied posing and mural-like background are effective in this excellent group portrait.

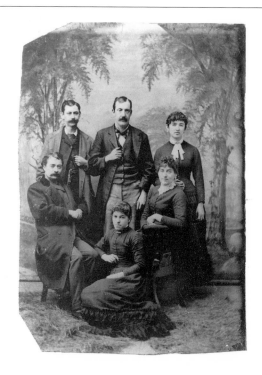

Large group portrait, c. 1880. Bon-ton. A remarkable group of fifteen, interestingly posed.

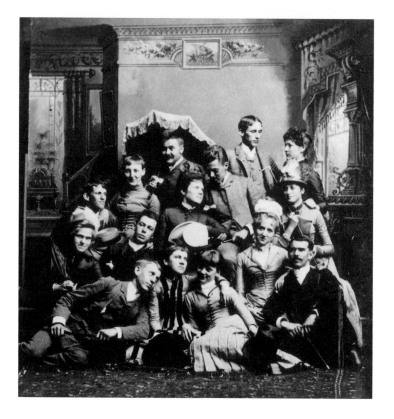

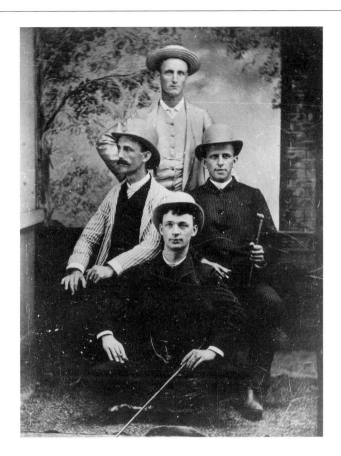

Portrait of four men, c. 1888. Bon-ton.

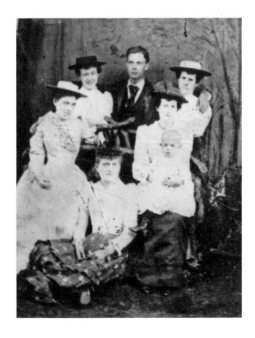

The Nodwell sisters and brothers, 1891. Bon-ton. Left to right: Isabel, Margaret, John, Elizabeth, Sarah (Riley), with Walter Riley on her lap. A first cousin, Jenny Houts, is seated.

A family outing, c. 1892. Bon-ton. It was difficult for a photographer to keep all the members of a group still during the relatively long exposures, as the blurring in this outdoor portrait demonstrates.

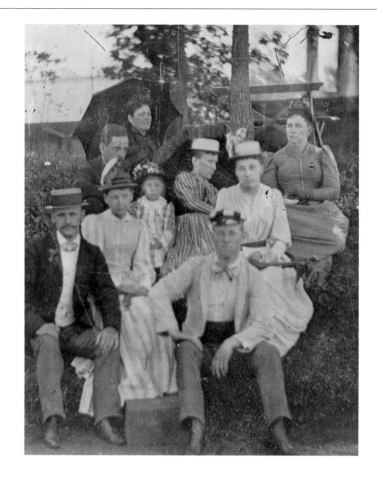

The family pet, c. 1892. Sixth-size plate. A well-behaved dog sits obediently during the long exposure required for an indoor portrait. Courtesy Archives, Lamar Dodd School of Art, University of Georgia.

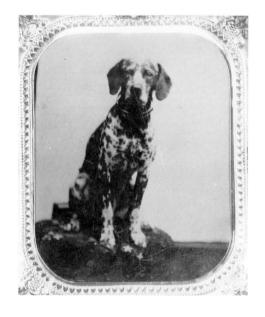

Chapter 13

ON VACATION

WHERE shall we spend our summer vacation? Today the possibilities are almost endless, but in Victorian times the typical choice for easterners was to go to a mountain retreat or to an ocean resort. Such places were magnets for tintypists, who could count on being kept busy and racking up good profits all summer at fashionable hotels in the Adirondacks or at beach resorts from Maine to Cape May.

THE SHORE

FOR those seeking a restful summer, a watering-place with a combination of blue sea and white, sandy beaches was a perfect choice. On rainy days vacationers could play billiards and tenpins, and on fine evenings they could promenade along the boardwalk in a stiff ocean breeze, then attend a band concert at one of the many hotels. Camp meetings along the seashore provided inspiration for some, while others sought the excitement of Coney Island's roller coasters, merry-go-rounds, shooting galleries, and other amusements. Almost everyone wanted to get a tintype made on the boardwalk. The tintypist would supply the painted backgrounds of sand, surf, lighthouse, boats, and amusement park scenery.

The Pacific Photograph Gallery in Santa Monica, California, advertised: "Photos and Tintypes in Bathing Costume a Specialty—Bathing Costumes Bicycle and Bloomers Furnished." You could also get a tintype

of yourself "On the Elephant; On the Donkey; In the Boat; On the Ostrich; Under the Japanese Umbrella; As a Mermaid (or) With your Best Girl." Almost as an afterthought, it was also noted that you could have your picture taken on the beach.

Advertisement for a Santa Monica, Calif., tintypist, 1895.

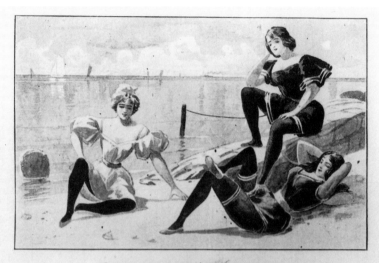

Did we have our Photo taken?

Well, we should smile. And when we did, we went to RILE

AT THE PACIFIC PHOTOGRAPH GALLERY

On the Walkway Leading from the Bridge to the Arcadia Pavilion

Photos and Tintypes in Bathing Costume a Specialty

HAVE YOUR VIEWS
Picture Taken

On the Elephant
As a Mermaid In the Boat
On the Ostrich On the Donkey
On a Bicycle in Bloomers
In your Bathing Suit
Under the Japanese Umbrella
On the Beach With your Best Gir

Of the Mammoth Wharf
Of Picturesque Santa Monica
Of the Old California Missions
Of Uncle Sam's Navy
Of the Soldiers' Home
Of the Pacific Ocean
Of Southern California

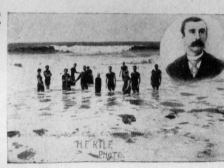

BATHING COSTUMES BICYCLE AND BLOOMERS FURNISHED TO HAVE YOUR PICTURE TAKEN IN

H. F. RILE, Artist Santa Monica, Cal.

P. S. A Duplicate of this View can be had at any time for 25 cts.

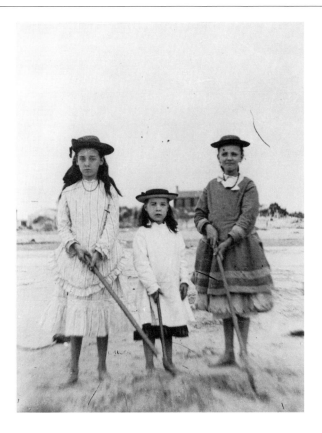

Three small girls on the beach, c. 1878. Bon-ton. This pleasant outdoor tintype, actually made on the beach, exhibits a delightful snapshotlike quality. Courtesy Frank Dimauro.

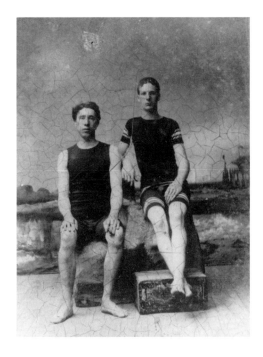

Two male bathers, c. 1885. Bon-ton. A typical boardwalk tintype. The surface suffers from cracking or reticulation of the emulsion.

Two girls in beach clothes,
c. 1885. Bon-ton.

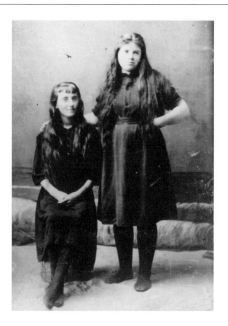

Four women in bathing
suits, c. 1890. These sitters,
posed before a background
of painted waves and
sailboats on the horizon,
may be a mother and three
similarly clad daughters.

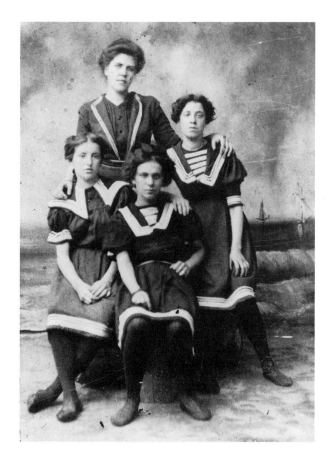

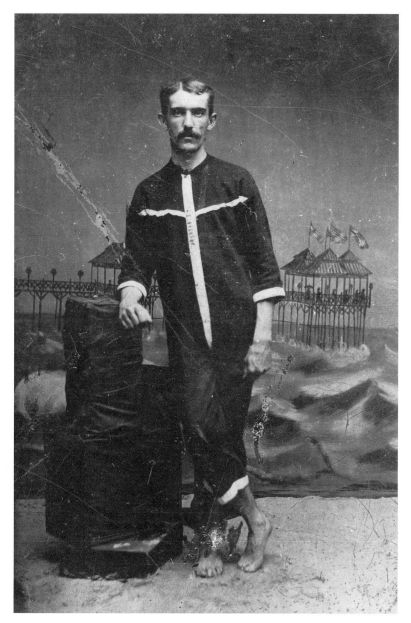

A Coney Island portrait, c. 1879. Bon-ton. The inscription on the young man's rented suit reads "Model Baths." The Brighton Beach Hotel, the second largest at Coney Island, had a bathing pavilion "500 feet long with 2700 separate rooms, with a capacity for sending away 2000 wet bathing costumes an hour along an endless belt, to be washed in the laundry" (*Scribner's*, 1880).

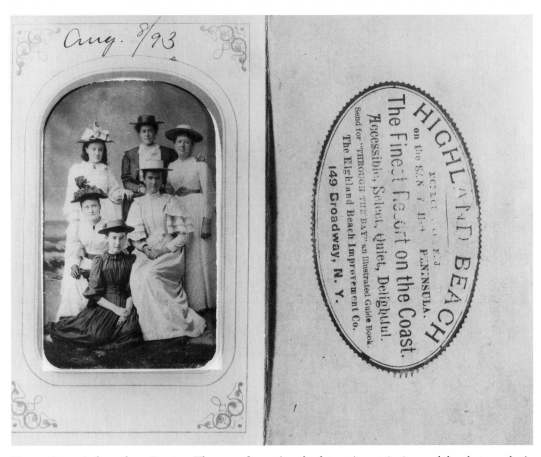

Six vacationers in fancy dress. Bon-ton. The paper frame gives the date as August 8, 1893, and the photographer's advertisement tells us it was made at Highland Beach, N.J., "The Finest Resort on the Coast."

The Hutchinson children, c. 1894. Bon-ton. Harry Kelly Hutchinson, on the left, is holding his sister Bessie. Ernest is on the right, and Clare is in the foreground. The children's parents, Addison and Harriet Hutchinson, were residents of Bradley Beach, N.J. The portrait was probably taken along the boardwalk in nearby Asbury Park. Photos of Hutchinson family courtesy Evelyn H. Bradway.

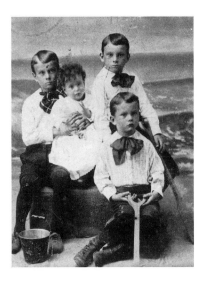

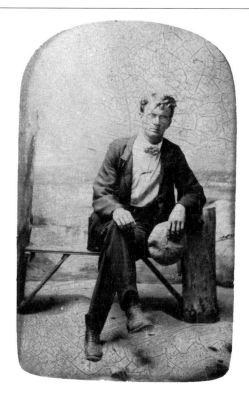

Harry Kelly Hutchinson, c. 1903. Bon-ton. The slender son of Addison and Harriet Hutchinson and son-in-law of "Wild Bill Gifford" was also photographed at Chapman's Tintype Gallery in Bradley Beach, N.J.

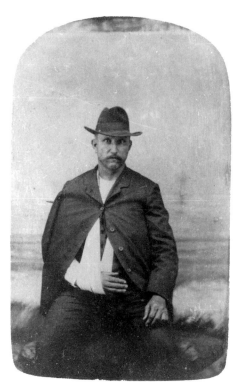

"Wild Bill Gifford," c. 1903. Bon-ton. Gifford was a resident of Bradley Beach, N.J., a quiet ocean resort bordering the famous Ocean Grove camp-meeting town, a haven for Methodists. It was said that when the 6 ft. 4 in., 300 lb. "terror" of Bradley Beach got into his car (the first automobile in town), the streets cleared in a hurry. When this portrait was made at Chapman's Tintype Gallery, near Koster's Pavilion, the sling on his left arm (the tintype is a reversed image) documented the fact that Wild Bill had been in some kind of trouble.

Addison and Harriet
Hutchinson, c. 1900. Bon-
ton. Aunt Clara is on the
right. The rocks are not
studio props, so this out-
door tintype may have
been taken near a jetty by
the ocean.

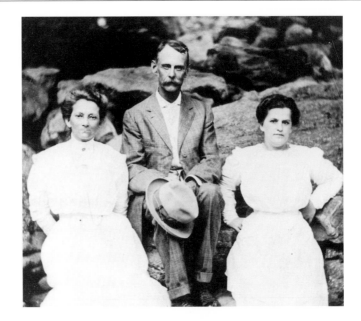

Group in stylish bathing
suits, c. 1870. Bon-ton.
"The most universally
adopted" bathing dresses,
as described in an 1868
issue of the *Lady's Friend*,
were "drawers, fastened at
the ankle, and a tunic made
with a yoke, night-gown
fashion, reaching to the
knee, and confined at the
waist by a belt . . . the
majority dress in gray . . .
some in black, some in
scarlet, many in sailor
blue . . . broad-brimmed
straw hats may be deco-
rated with large chenille
balls."

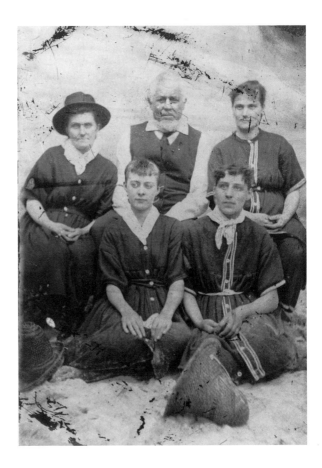

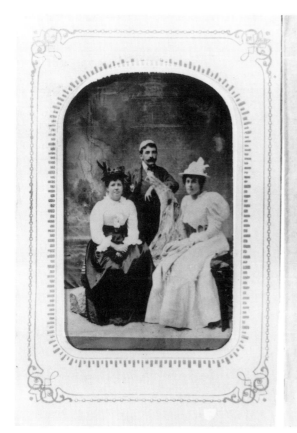

Group portrait, Old Orchard Beach, c. 1895. Bon-ton. Old Orchard Beach, Maine, with its miles of sandy beach, was a half-hour train ride from Portland. The tintypist John H. Lutz included in his advertisement, "P.S. Pictures of BATHERS, made a specialty."

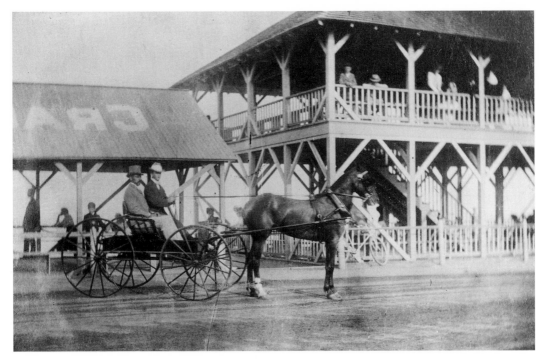

Scene at Long Branch, N.J., c. 1899. Half-size plate. As a summer resort, Long Branch dated back to the eigh-teenth century, when Philadelphians came in sailing sloops and were brought ashore by local fishing boats. In the 1870s the resort was the summer home of President Grant. Bathing was the popular morning pastime; drives were for the afternoon. Courtesy George Moss.

MOUNTAIN RETREATS

MANY vacationers found small mountain resorts a pleasant change from the city. Some stayed in old farmhouses with wide, comfortable porches. Others chose the social life of hotels by picturesque lakes. For example, in the early 1870s Kiarsage House in North Conway, New Hampshire, adver-tised: "The House is lighted with gas, contains Bath-rooms, Barber's room, Billiard Hall, and all the modern improvements found in first-class hotels. The table will be supplied with all the luxuries of the season, and served in the best manner by experienced cooks."[1]

Like most tintypes taken at the beach, tintypes of guests at mountain retreats were generally made against painted backdrops, in this case ones with rural scenes. The studio also provided appropriate artificial foliage. The traveling tintypist could not control nature, but by artifice he could create a "natural" background in which nothing moved to blur the image during a long exposure.

1. Floyd Rinhart and Marion Rinhart, *Summertime: Photo-graphs of America at Play, 1850–1900* (New York: C. N. Potter, 1978), 136.

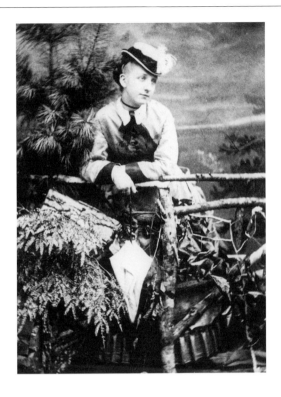

Portrait of a lady, c. 1869. Bon-ton. Louis Alman, the famous 5th Avenue photographer, made this tintype at Thompson's Hotel, Lake Mahopac, N.Y.

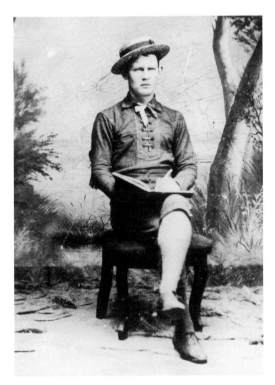

Artist with sketch pad, c. 1871. Sixth-size plate. Courtesy Frank Dimauro.

Pensive woman, c. 1872.
Bon-ton. Louis Alman
took this picture at Lake
Mohonk, a stopover and
seasonal resort along the
Hudson River.

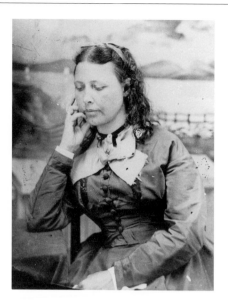

The travelers, c. 1874.
Quarter-size plate. America
was a nation on the move—
to the shore, to the moun-
tains, by train, by boat, and
by stagecoach.

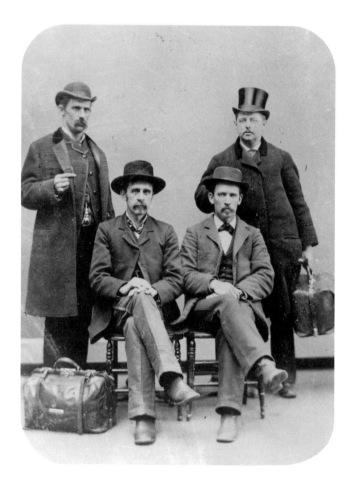

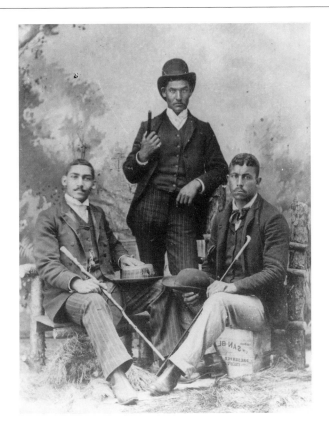

Three men relaxing, c. 1884. Victoria. The studio props—rustic benches, a wooden crate used as a seat, artificial grass or straw on the floor, and a painted glade—contrast with the formal clothing and poses of the subjects.

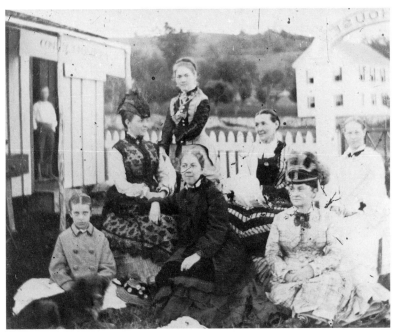

Vacationers in the Catskill Mountains, c. 1880. Half-size plate. When the weather was hot and sultry in the city, people thronged the Catskills. Rooms were hard to find, and accommodations often resembled an eighteenth-century inn where people slept six to a bed. Here an observer lounges in a doorway, watching the vacationers at play and the tintypist at work, with a certain amount of amusement. He probably did not realize that he would be part of the photograph. (As always, the tintype image is a reversed one.)

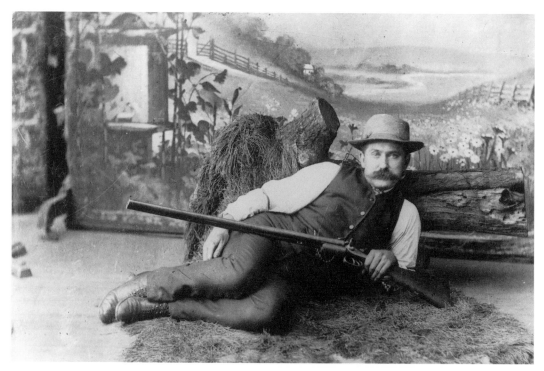

Reclining man with gun, c. 1884. Victoria. After a summer of sailing and fishing, gentlemen of leisure looked forward to the hunting season.

Seated couple, c. 1884. Bonton. Vacationers who chose the quiet and solitude of the mountains over the noisy, busy shore usually wanted simply to sit and contemplate nature. Private collection.

Chapter 14

FAKES, FORGERIES, AND PRECIOUS PHANTOMS

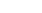

FAKES

DURING the Civil War, when loss of life was heavy, "spirit photography" became popular. Spiritualism had swept America in the 1840s after the Fox sisters, Kate and Margaret, claimed to have established communication between themselves and deceased relatives. Newspapers reported on "spiritual circles" in religious tones.[1]

1. Floyd Rinhart and Marion Rinhart, *America's Affluent Age* (South Brunswick, N.J.: A. S. Barnes, 1971), 275–77.

Both in the United States and abroad, photographers were quick to accommodate the public desire to communicate with the dead. By 1863 photographic journals had begun looking into the activities of "spirit photographers." Coleman Sellers, an American photographic pioneer and a correspondent for the *British Journal of Photography,* reported that many men of considerable talent had delved into the mysterious, ghostly images that were allegedly appearing on photographic plates.[2]

2. *British Journal of Photography,* February 2, 1863, 63.

To investigate the phenomenon, a respectable Boston photographer went to a "spirit gallery," where the proprietor allowed him to take the camera apart, remove the lenses, examine all the parts, and inspect the backgrounds and other fittings and accessories. He was also permitted to enter the darkroom, mix new solutions, clean a plate with extra care, and after coating and sensitizing it, carry the plate in its holder to the camera, which had already been focused.

At this critical point the Boston photographer was asked to seat himself in front of the camera, and the "medium" took over, withdrawing the dark-slide from the plateholder, making the exposure, and replacing the dark-slide before removing the plateholder from the camera. The investigator, who had been keeping his eyes fixed on the procedure, then took the exposed plate, in its holder, into the darkroom. Working alone, he developed the picture. Much to his astonishment, a second image appeared near his own.

Various explanations were offered for the appearances of "ghosts" on photographic plates. In 1869 Charles Woodward, M.D., of Penn Yan, New York, reported one way it could be done. His explanation was that a glass plate was placed in a rather strong solution of "caustic potassa" for a few hours. The plate was then cleaned with water and rottenstone (powdered limestone). After the plate was coated with collodion, a normal negative was made of the person who would become the "ghost." The spirit photographer developed, fixed, and thoroughly dried the plate, omitting varnishing. He then removed the negative image by scouring the plate with rottenstone and water until it looked clean. The plate, recoated and exposed with a different subject, would show the new sitter distinctly and the latent image as a "ghost." Woodward's theory was that the "potassa" solution etched the plate slightly, making the first picture's coating of collodion and iodide of silver adhere to the granular surface of the plate. Ordinary scouring would not completely remove the silver compound, although the plate would look perfectly clear. The original image remained invisible until the second portrait was developed.[3]

3. *Philadelphia Photographer* 6 (1869): 184–85.

One well-known photographer, Oscar G. Mason, produced so-called spirit pictures using a "mica dodge." Mason knew that a photograph copied on mica could be transmitted by light. A tiny positive photograph of the deceased, recorded on mica, was placed on a pin's point mounted on a thin stick. During focusing, such a positive could be placed inside the camera at or about the plane of focus, so that the image of the deceased would be recorded while a living sitter was having a picture taken. After the exposure, the "ghost" positive on mica could be surreptitiously removed along with the plateholder.

William H. Mumler, a New York City spirit photographer, was tried in 1869 for deceiving the public. Although he was acquitted, the newspapers called the decision "ridiculous," and when Mumler's lease on his gallery expired in May 1869, he was forced to close shop.[4]

4. Ibid., 200–203. Also see p. 167, which notes that Mumler was denounced by spiritualists and arrested for taking money under false pretenses.

In 1888 one photographer recalled the episode and remembered that Mumler had "a society man" in his employ who obtained photographs of deceased relatives from drawing-room albums. After Mumler made copies, the agent returned the originals to the albums. Under the right circumstances, the agent would let drop the remark that Mumler was a medium. Once he succeeded in getting people to Mumler's gallery, it was a simple matter to produce spirit photographs of their loved ones. Mumler's secret was not discovered for a long time.[5] Oliver Wendell Holmes, referring to the making of spirit photographs, wryly advised: "First, procure a bereaved subject with a mind 'sensitized' by long immersion in credulity."[6]

The author, and amateur photographer, Emile Zola declared (with some justification) that no one has seen anything until he has seen a photograph of it. But the early belief that "the camera never lies" dwindled as the artifices of the spirit photographer were laid bare and as the practice of retouching negatives gained popularity.[7]

5. *Photographic Times and American Photographer*, 1888, 189.
6. Oliver Wendell Holmes, "Doings of Sunbeams," *Atlantic Monthly*, 1863.
7. One of the first to introduce negative retouching in America was the Cleveland photographer J. F. Ryder. The fact that a photograph could be made not only to record but also to enhance the sitter's image was demonstrated by the German portrait photographer Franz Hanfstaengl, who amazed visitors to the 1855 Exposition Universelle in Paris with prints made before and after retouching. On June 1, 1896, at the first convention of the National Photographic Association, Ryder won acclaim for prints made from his negatives and retouched by Karl Leutgib, whom Ryder had brought to his Cleveland studio from Munich.

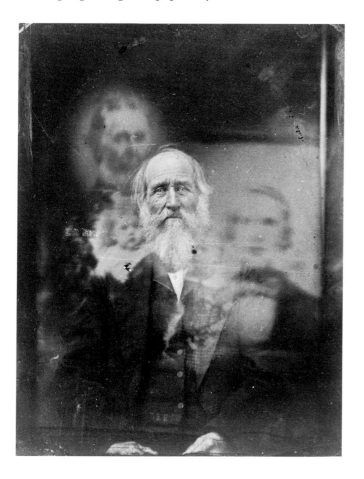

A rare tintype "spirit photograph," c. 1869. Bon-ton.

An illustration showing
how to make spirit photo-
graphs by the photographer
Oscar G. Mason. From the
Philadelphia Photographer,
1869.

Spirit photography and other unconventional, amateur, snapshotlike,
and sometimes even surrealistic tintypes helped show the camera's poten-
tial as something more than a simple recording instrument. Photography
became an effective medium for deception and propaganda, for informa-
tion, and for art.[8]

8. Dawn Ades, in the introduc-
tion to her book *Photomontage*
(London: Thames and Hud-
son, 1976), points out, "Manip-
ulation of the photograph is as
old as photography itself," and
refers to both Oscar Rejlander's
Two Ways of Life (1857), a com-
posite of thirty-eight negatives,
and Marcel Duchamp's *Family
Portrait* (1964), which includes
a daguerreotype of a family
group made in 1839.

FORGERIES

DUPLICATION of artworks, common in the past, has become even more
common in the age of digital imaging. The replication of a tintype is diffi-
cult, but as the popularity and the price of good tintypes rise, technology
makes it possible to meet the demand.

The authenticity of a tintype is established first by the fact that it is
on an iron plate, not on aluminum, as are most contemporary "tintype"
images. Some forgers, however, copy a silver print or even a published
halftone photograph onto a vintage iron plate from which a second-rate
original image has been removed.

9. Elmo Scott Watson,
"Orlando Scott Goff, Pioneer
Dakota Photographer," *North
Dakota History* 29, nos. 1–2
(January–April 1962): 210–15.
Goff is credited with taking the
first photograph of Sitting Bull
on August 1, 1881. An original
silver print of this portrait is in
the collection of the State His-
torical Society of North Dakota
and is the identical pose found
in the tintype of Sitting Bull
discussed here.

A ninth-plate (2" x 2½") tintype of Chief Sitting Bull, for example,
although based on what seemed to be a vintage plate, under microscopic
scrutiny exhibited the dots of a very fine halftone, indicating that it was
copied from a reversed reproduction of the original wet-plate photograph
of Sitting Bull.[9] The soft varnish of the surface was lifting, and because it

was several generations away from the original, the portrait lacked the detail common in a tintype.

Forgers usually work through one or more intermediaries, including dealers, collectors, and innocent victims. Genuine tintypes may exhibit rust or signs of oxidation on the plate's back and edges, while the edges of a forged tintype may seem freshly cut from a new plate or from a larger vintage plate.

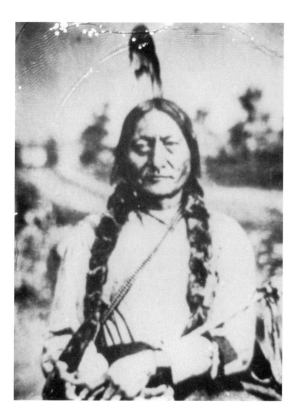

A forged tintype of Chief Sitting Bull. Bon-ton. Some fakes and forgeries may also eventually become collector's items. Courtesy Bruce Soble.

PRECIOUS PHANTOMS

THE authentic American tintype is a durable artifact. Preserved on iron, in plastic cases, in leather-bound albums, and even embedded in tombstones, the tintype, if properly cared for, is likely to have a longer life than most contemporary photographic images. It could be colored, copied, and even censored by clipping off an unwanted figure with tin snips, but most tintypes are examples of "straight photography." (Spirit photographs are rare finds.) Tintypes have become prized for their place in the history of American photography and for their value as nineteenth-

century collectibles, but also because they are part of our individual and social history—phantoms of pleasant, precious, and often poignant moments of the spirit of an age.

Boy with flag, c. 1892.
Bon-ton.

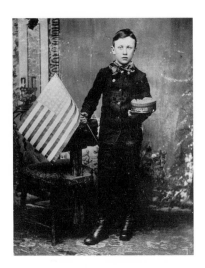

"A TIN-TYPE"

by Ella Wheeler

In the wreck of an old worn album
 That a child unearthed at play,
I found this little picture—
 A leaf from a long-closed day.
That face of boyish beauty
 Must now be lined with care;
And the locks of raven blackness
 Must gleam with a silver hair.

Somewhere he lives and labors
 And takes his part in the strife
That is not at all the poem
 We dreamed in early life.
The ways we planned together
 We must tread apart through time

For the years stepped in between us,
 And they spoke in prose—not rhyme.

And so I hid his picture
 Away from my own sight,
And bravely looked for sunshine
 Through clouds as black as night.
It has glimmered often upon me,
 But never as of old
Has dropped in a royal shower
 Of pure and melting gold;
And I know, through all the darkness,
 It is all for the best, someway:
Yet I wish that little tin-type
 Had not been found to-day.

—Peterson's Magazine, 1884

APPENDIXES

Appendix 1

FLOYD AND MARION RINHART ON COLLECTING, PRESERVING, AND ENJOYING TINTYPES

≈

WE began collecting early photographs in the late 1950s while vacationing in North Carolina. One day, in Henderson, we saw a sign for an antique show. We went in, and while browsing we came across six images in small cases. We purchased the lot. When we reached our car we said: "This is history!"

After we returned to Florida we gently removed the photographs from their cases and examined them with care. Two were tintypes, and four were on glass. Later we learned that the ones on glass were called "ambrotypes." We already had a few family tintypes, so we knew what tintypes looked like. Judging by the costumes, however, some of the images we found must have been made much earlier than the 1880s. The placement of photographs in miniature cases was also new to us.

In this way we became collectors. We were living in Deerfield Beach, and the nearest town of any size was Boca Raton. We lost no time in going to an antique shop there, where we found more photographs in cases, two of which turned out to be daguerreotypes. The others were ambrotypes. The first two daguerreotypes we found in Boca Raton were of a man in military uniform who turned out to be the famous Union general George Meade. We began reading books about Meade, having discovered on one plate a faintly scratched signature and the date 1842.[1]

1. This portrait of Meade is reproduced in Floyd Rinhart and Marion Rinhart, *America's Affluent Age* (South Brunswick, N.J.: A. S. Barnes, 1971), 246.

From then on we collected early photographs all over Florida. Because so many elderly Americans live in Florida, the concentration of early photographs, their prized possessions, cannot be matched in any other place in the country. We also began a serious study of nineteenth-century photographs, taking them out of their cases, identifying their various characteristics, and making written records of each, including where and when we found them, the sizes of the photographs, the poses, the photographs' physical condition, the style of the cases, coloring, and the photographer's name, if given.[2]

In our early days of collecting we saw an advertisement announcing the availability of a collection of nineteenth-century photographs in cases. The collection belonged to a woman from Baltimore who had been accumulating photographs for many years. We bought her entire collection, sight unseen, for what was at the time a lot of money, but it turned out that there were incredible and rare photographs in the lot—daguerreotypes, ambrotypes, and tintypes. It was a thrilling time for us, as we opened a door to forgotten images of history and art.

Another interesting and rewarding episode unfolded when we received a call from an antique dealer in St. Petersburg, Florida. The owner said she had two boxes full of photographs that an older man had just brought into her shop. We lost no time in going to St. Petersburg. What we found were some tintypes of high quality, among other early photographs, including daguerreotypes. Of course, we bought them all, without haggling.

During our years of collecting we did intensive research, reading books, manuals, periodicals, newspaper files, and patent and census records of the decades in which we were interested. Our research included social as well as photographic history. As we pursued our research, we found many facts and theories that contradicted the platitudes of history and the opinions of historians.

In the summer of 1963 we took a six-month tour of museums, including the George Eastman International Museum of Photography, the Museum of Fine Arts in Boston, and the Metropolitan Museum of Art. We also visited many libraries in New England, where we found information that enabled us to positively identify some of the rarest photographs in our collection. Finally, we spent a few months in the Washington, D.C., area. There we worked daily at the Library of Congress, going through card files for research material and taking voluminous notes from rare books. In the basement of the Library of Congress we went through old

2. The records are in our two collections at The Ohio State University Library. The content of the Rinhart I Collection is found in volumes 1–30 of the research guide. Tintype listings appear in volume 8, "Photographs on Iron Sheet Metal: Melainotype, Ferrotype, and Tintype." These give collectors a pattern for listing their photographs and offer an index for researchers. Other volumes include some tintypes as well as daguerreotypes and ambrotypes. Volume 23 includes outdoor scenes; volume 24, images of the aged and of African Americans; volume 25, occupations, hobbies, and afflictions; volume 26, notable personages, Lincolniana, military; volume 27, death portraits and mourners. The Rinhart I Collection has more than a hundred examples of early tintypes. The Rinhart II Collection has more than five hundred tintypes, both single and in albums. This collection covers the early days of the art, but also the rest of the century and beyond. It shows a wide range of types, including daguerreotypes, tintypes, stereo views, and many paper prints. Also in the collection are European photographs, many in large albums.

city and state directories. All our notes were handwritten, as photocopiers were not available then. We also went through census records for information about photographers. Early photographs in the Print Division of the Library of Congress were also of great interest. We spent time at the National Archives as well, where, in looking over their early photographs, we found many important and helpful items.

Encouraged by our 1963 tour, we decided in the fall of 1964 to spend a two-year study period in the Washington area. This time we added the Patent Office to our list of places in which to carry out research. One day Marion was researching patents for miniature cases and thermoplastic cases. A worker at the Patent Office argued that "plastic was not known back then," until he saw the patent record.[3]

During this time we hit upon the idea of writing a book about the daguerreotype's influence on art and traditional art's influence on the daguerreotype, as demonstrated by many specimens in our expanding collection. We began work on *American Daguerreian Art,* which was published in 1967, signaling the official beginning of our writing career.

For information on the early history of the tintype we found Estabrooke's, Neff and Waldack's, and Griswold's manuals to be excellent sources. Photographic journals started publishing interesting articles about the tintype in the 1860s, and such articles continued for a long period. John H. Fitzgibbon's periodical, *St. Louis Practical Photographer,* first published in 1877, was especially useful.[4] Robert W. Wagner has also helped to bring many important twentieth-century references to the tintype to light.

While we were collecting information about the history of the tintype, of course, we were also collecting tintypes. We began to look for unusual poses that would add variety and interest to our collection; studio portraits with different backgrounds or special props; and outdoor scenes of shops, resorts, or rural towns. We also looked for tintypes of persons holding tools or other instruments symbolizing their occupation. Other subjects that attracted our attention were hobbies, human afflictions, notable persons, military uniforms, war scenes, and sports activities.

In any one of the categories above there are likely to be unusual and valuable tintypes among the many that a collector comes across in antique shops, flea markets, yard sales, or estate sales. Sometimes we found boxes containing a mixture of paper photographs and tintypes. Many tintypes (like many daguerreotypes) had unfortunately been removed from their cases to be sold separately. After climbing the creaky stairs to the attic of

3. Cases for miniature portrait paintings were quickly adapted for enclosing and protecting the delicate daguerreotype. At first these cases, embossed with a variety of designs, were made of leather-covered wood or of papier-mâché. On October 3, 1854, the daguerreotypist Samuel Peck was issued a patent (11.758) for a case "composed of gum shellac and woody fibers or other suitable fibrous material dyed to the color that may be required and ground with the shellac and between hot rollers so as to be converted into a mass which when heated becomes plastic so that it can be pressed into a mold between dies and made to take the form that may be imparted to it by such dies." The result was the beautiful Union cases, which were popular well into the 1860s until gradually replaced by the photo album.

Our fascination with these unique and elegant forms resulted in our book *American Miniature Case Art* (New York: A. S. Barnes, 1969).

4. For a biography of John Fitzgibbon, see Floyd Rinhart and Marion Rinhart, *The American Daguerreotype* (Athens: University of Georgia Press, 1981), 390.

one old antique shop, we found tintypes that had remained untouched for years! The larger sizes could look rather like primitive paintings. Some of them were framed. On the edges of a few might be the patented imprint of the platemaker (e.g., Griswold) or the process (e.g., melainotype). Such examples, like stereo tintypes, are rare.

Associating with other collectors of nineteenth-century photographs is, of course, a good way to learn about the sources of tintypes, daguerreotypes, ambrotypes, and paper prints, and to share the enjoyment that these historic and often artistic forms evoke.[5] Workshops on making, collecting, and preserving old photographs are also conducted by local and state historical societies, by the George Eastman House International Museum of Photography and Film, and by the Library of Congress.

It is very difficult to place a dollar value on a tintype, since prices continue to rise and to vary widely as more collectors, curators, and historians enter the field. We feel that the worth of a tintype or a collection is based on the buyer's experience, knowledge, and interest. The value of a tintype, like that of any other image, is in the eye of the beholder.

The preservation of the tintype should be of concern to every serious collector. More is being written on the subject as time goes by.[6] While they are very durable, tintypes can be bent and are subject to rust. People who remove them carelessly from their albums, envelopes, or cases can scratch the emulsion. The same thing can happen during inspection, when we have seen them being shuffled like a deck of cards!

To preserve them it is best to place them in acid-free plastic jackets or sleeves, file them vertically in archive boxes, and keep them in an area of low humidity (about 50 percent relative humidity) where the temperature does not exceed 70°F. The amateur should never attempt to clean a tintype or a photograph of any type. This should be left to a specialist in photographic restoration and preservation, although the collector should keep in mind that there is some value in the original patina of age, if it does not contribute to the image's deterioration.

The ultimate joy in collecting tintypes, of course, is in displaying and sharing them with friends, with other collectors, with the growing number of interested photographers, artists, historians, curators, and students, and with a public intrigued by the curious and charming tintype images of their average, garden-variety American ancestors during the latter half of the nineteenth century.

5. The American Daguerreian Society is one such association. Its address is 3045 West Liberty Ave., Suite 7, Pittsburgh, PA 15216. Another is the National Stereoscopic Association, P.O. Box 14801, Columbus, OH 43214.

6. See Roger C. Watson, "Preservation of Wet Plate Collodion Images," in *Wet Plate Collodion Workbook*, by Notch Miyake, Mark Osterman, and Roger Watson (Rochester, N.Y.: George Eastman House International Museum of Photography and Film, 1996), 1–12. See also James M. Reilly, *Care and Identification of Nineteenth-Century Photographic Prints* (Rochester, N.Y.: Eastman Kodak Co., 1986); *Caring For Photographs: Display, Storage, Restoration* (New York: Time-Life Books, 1972); William Welling, *Collector's Guide to Nineteenth-Century Photographs* (New York: Collier Books, 1976); and Richard Blodgett, *Photographs: A Collector's Guide* (New York: Ballantine Books, 1979).

TINTYPE PATENTS

UNITED STATES PATENT OFFICE.

H. L. SMITH, OF GAMBIER, ASSIGNOR TO WM. NEFF AND PETER NEFF, JR., OF CINCINNATI, OHIO.

PHOTOGRAPHIC PICTURES ON JAPANNED SURFACES.

Specification forming part of Letters Patent No. 14,300, dated February 19, 1856.

To all whom it may concern:

Be it known that I, HAMILTON L. SMITH, of Gambier, in the county of Knox and State of Ohio, have invented certain new and useful Improvements in Photographic Pictures; and I do hereby declare the following to be a full, clear, and exact description of the same, and of the manner of making and using my invention or discovery.

The nature of my invention or discovery relates to the taking of positive pictures by the photographic process upon a black japanned surface, prepared upon iron or any other metallic plates or sheets; and it consists in the use of collodion and a solution of salt of silver and an ordinary camera.

To enable others skilled in the art to make and use my invention, I will proceed to describe the manner of preparing and applying it which I have found to answer well in practice, not confining myself, however, to the special process or processes herein described, so long as the characteristics of the invention remain the same.

I first take metallic sheets, preferring for the purpose iron, as this metal is the only one, except the precious metals, which is without action on the silver salts generally used, as also the other chemicals; but other metallic or mineral sheets may be used; and I do not therefore confine myself specially to any particular metal. Upon each of the sheets is prepared a black japanned or varnished surface, such as is used by tinners or japanners for coating metallic and other surfaces. The japan or varnish may be made and applied as follows: Take one quart of raw linseed-oil. Add to this two ounces of asphaltum and sufficient umber or lamp-black to give the desired shade. Boil these ingredients until a portion dropped on a cool surface will remain in a round spot without flowing away. It is then thick enough to use. If it should be too thick, it can be readily thinned with spirits of turpentine. Apply the japan to the sheets or plates with a brush, and after allowing it to stand a short time, until the marks of the brush disappear, place the sheets or plates in a drying-oven, and submit them to heat until the surface will bear the finger to be drawn over it without bringing off the japan. It may, if found necessary, be coated again and treated in a similar way, and finally polished with rotten-stone and oil or other polishing material. Other ingredients may be used in making the japan—such as mastic, lac, or copal varnish—and other shades of coloring matter may be used.

By "collodion" I mean any solution of gun-cotton or pyroxyline; and by a solution of "salt of silver" I mean any of the salts thereof which can be used in photography for obtaining positive impressions by a camera.

A japanned surface may be prepared on glass or on leather and other fibrous materials; or glass may be made black by means of coloring-matter introduced or embodied with the glass, so as to be in instead of on the glass; but foreseeing the difficulty of embracing all these preparations in one application, I do not desire to have them so considered, but reserve the right to hereafter apply for such application of my general principle as I may deem essential or of sufficient importance to be protected by Letters Patent; and it might be proper to add that vulcanized gutta-percha or indurated rubber may be used as the basis upon which or in which the japanned surface may be made. The invention, however, consists mainly on the surface, so that a silver picture may be made upon it, said surface forming the background of the picture. The ingredients for fixing and developing the positive impression upon the japanned surface may be the same as those heretofore essayed by me on a former application, and need not again be repeated here, though other chemicals or other proportions of the same chemicals may be used.

Having thus fully described the nature of my improvement in photographic pictures, and shown how the same may be accomplished, what I claim therein as new, and desire to secure by Letters Patent, is—

The obtaining of positive impressions upon a japanned surface previously prepared upon an iron or other metallic or mineral sheet or plate by means of collodion and a solution of a salt of silver and a camera, substantially as herein described.

HAMILTON L. SMITH.

Witnesses:
GEO. I. CHAPMAN,
JAMES H. LEE.

Hamilton L. Smith's patent for Photographic Pictures on Japanned Surfaces. February 19, 1856.

Victor M. Griswold's patent for Improved Collodion for Photographic Pictures. July 15, 1856.

UNITED STATES PATENT OFFICE.

VICTOR M. GRISWOLD, OF LANCASTER, OHIO.

IMPROVED COLLODION FOR PHOTOGRAPHIC PICTURES.

Specification forming part of Letters Patent No. 15,286, dated July 15, 1856.

To all whom it may concern:

Be it known that I, VICTOR M. GRISWOLD, of the city of Lancaster, in the county of Fairfield and State of Ohio, have invented certain improvements in the Art and Mode of Taking Photogenic Pictures; and I do hereby declare that the following is a full and exact description thereof.

The nature of my invention consists in an improvement in the photographic art of taking pictures.

Albumenized collodion.—To one quart of collodion, prepared in the usual way or manner, I add three ounces of a solution prepared thus: the clear solution which results from the whites of eggs which have been well beaten and one equal bulk of pure soft water. When this is added to the collodion it is thrown to the bottom in long, stringy white masses, which, after a few days, impart to the liquid albuminous properties, rendering the film closer in texture and bringing out all the minor details more sharply and perfectly than by the ordinary collodion, and giving to the picture a glossy and sparkling tone, unlike any produced by other means.

Another method which I frequently adopt is thus: albumen, as above, without water, to which is added iodide of potassium forty grains. This throws down the albumen in jelly-like masses, and when added to the collodion not only iodizes it, but produces the same effect upon the collodion as by the formula above.

Also another method: one ounce of chloroform, to which is added one-half ounce of albumen, prepared as above, iodized. This forms also a soft semi-transparent jelly, which, on being added to the collodion, produces the best effect of any of these preparations. This addition of albumen also answers a far better purpose than any that has hitherto been employed for freeing old samples of collodion from free iodine held in suspension, by which they can be rendered as clear and limpid as they were when first mixed.

What I claim as my invention, and desire to secure by Letters Patent, is—

The addition of albumen to collodion, in the manner and for the purpose herein and above specified.

V. M. GRISWOLD.

Witnesses:
ALFRED McVEIGH,
I. C. HENLEY.

Victor M. Griswold's patent for Bituminous Ground for Photographic Pictures. October 21, 1856.

UNITED STATES PATENT OFFICE.

V. M. GRISWOLD, OF LANCASTER, OHIO.

BITUMINOUS GROUND FOR PHOTOGRAPHIC PICTURES.

Specification forming part of Letters Patent No. 15,924, dated October 21, 1856.

To all whom it may concern:

Be it known that I, VICTOR M. GRISWOLD, of Lancaster, in the county of Fairfield, State of Ohio, have invented a new and valuable Process for Sensitizing Bitumen for Taking Photogenic Pictures on Paper or other Material; and I do hereby declare that the following is a full and exact description thereof.

The nature of my improvement consists in the preparation of bitumen by the following processes: Dilute asphaltum-varnish (which has been prepared by boiling one-half gallon linseed-oil, one pint Japan varnish, and five or six ounces asphaltum to such a consistency that it will, when cool, roll into a hard ball) to a proper consistency with spirits of turpentine. Add to eight ounces turpentine one-half ounce bromine and one ounce iodine—a small quantity at a time—as they unite with great heat and must be managed with care. When thoroughly united this is bromoiodized turpentine, which, added to a half gallon bath of the prepared bitumen, forms what I call "bromoiodized bitumen;" or I take finely-pulverized bromide of potassium one hundred and fifty grains, to which add one hundred and fifty grains crystallized nitrate of silver dissolved in four ounces distilled or pure soft water; wash the precipitate through nine or ten changes of water, filter dry in a dark place, put the dry powder (bromide of silver) into a long eight-ounce vial containing four to six ounces turpentine, and add to it one and a half ounce iodide potassium very finely pulverized. This will form the bromoiodide of potassium and silver in turpentine, which add to the half-gallon of bitumen prepared as above.

Bitumen sensitized as above will give impressions without the aid of collodion, and renders a collodion film more sensitive, and gives a more sharply-defined image than by any other process, and may be used for taking pictures on paper or any other smooth hard substance.

What I claim as my invention, and desire to secure by Letters Patent, is—

A sensitized bitumen for taking photogenic pictures on paper or other substance prepared by the above-described or other similar process substantially the same, and producing the desired effect.

V. M. GRISWOLD.

Witnesses:
P. B. EWING,
G. STEINMAN.

UNITED STATES PATENT OFFICE.

SIMON WING, OF WATERVILLE, MAINE.

IMPROVEMENT IN PHOTOGRAPHIC CAMERAS.

Specification forming part of Letters Patent No. 30,860, dated December 4, 1860.

To all whom it may concern:

Be it known that I, SIMON WING, of Waterville, in the county of Kennebec and State of Maine, have invented certain Improvements in Cameras for Taking Photographic Impressions, of which the following is a full, clear, and exact description, reference being had to the accompanying drawings, making part of this specification, in which—

Figure 1 is a perspective view from the rear side of a camera with my improvements attached. Fig. 2 is a longitudinal vertical section through the middle of the same; Fig. 3, a front view of the lens-box; Fig. 4, detail to be referred to hereinafter.

Letters Patent of the United States were granted on the 10th day of April, 1855, to A. S. Southworth, of Boston, Massachusetts, for an improved plate-holder for cameras, in which the plate-holder was permitted to move for the purpose of bringing different portions of the same plate successively into the field of the lens of the camera. The device shown by him for adjusting and defining the position of the plate-holder was sufficient where but a few impressions were to be taken on a single plate; but where a larger plate is to be used and a greater number of impressions are to be taken on it for the purpose of economizing time and labor and where different-sized plates are used and a varying number and size of impressions on the plates are taken it requires a greater scope of adjustment for the plate-holder and a more convenient and accurate method of moving and regulating the position of the plate-holder. To furnish these is the object of the first part of my present invention, which consists in a mechanical means of moving the plate-holder, in combination with a scale or index for defining its position with respect to the lens, to accord with the required number of impressions to be taken on the plate.

The second part of my invention consists in the application of convenient mechanism for simultaneously adjusting the several lens-tubes in position, where two or more of these tubes are used in the same camera, it being now customary to use more than one lens-tube where several impressions of the same object are to be taken.

That others skilled in the art may under-

stand and use my invention, I will proceed to describe the manner in which I have carried out the same.

In the said drawings, A is the frame of the camera, from the front side of which projects a table B, on which slides the lens-box C. (Shown detached in Fig. 3.) This box C, which contains the lens-tubes *a b c d*, slides in a casing *e*, attached to the front of the frame A, and is moved in and out to change the foci of the lenses by means of a rack *f* and pinion *g*, operated by a hand-wheel D. A side board *a* extends back from each side of the frame A, and two rails *i* extend across from one to the other of these side boards. On these rails slides a frame E, to one side of which is attached a rack-bar *k*. A pinion *l* on a short shaft *y*, to which is attached the hand-wheel F, engages with this rack, and by the revolutions of the hand-wheel F moves the frame E laterally across the instrument.

Immediately in front of the frame E is placed the "ground-glass" frame G, (shown detached in Fig. 4,) which is connected with the frame E in the following manner: A pin *m*, projecting from each side of the frame G, passes through a hole in the frame E. Two springs *n*, attached to the frame G, bear against the frame E and tend to press the frame G toward the front of the frame A. Immediately in front of the frame G is placed the plate-holder H, which has a back *o* hinged at *5*, which will open to allow the plate I to be introduced into place, where it is held by the springs *p* and a slide or shield J, which is to be withdrawn after the focus of the lens is adjusted. I may here remark that when the plate-holder H is removed the ground glass *q* is thrown by the springs *n* into the place of the plate I. To the back of the plate-holder H is attached a rack-bar *r*. A short shaft *s*, which carries a hand-wheel K and a pinion *t*, has its bearings in the top of the frame E. The pinion *t* engages with the rack *r*, so that by revolving the wheel K the plate-holder H is raised or lowered vertically, and in order to guide this motion of the plate-holder a tongue *u* on each side of the front of the frame G slides in a groove *v* in the back of the plate-holder. By the above arrangement of mechanism I am enabled to move the plate I quickly and accurately into

Simon Wing's patent for Improvement in Photographic Cameras, December 4, 1860. (*continued on following page*)

2 **30,850**

any definite position to bring different portions of it successively into the field of the lens.

In order to assist the operator in defining the position of the plate with respect to the lens, I have made use of indices, either the marks 20 on the back face of the frame A, which fix the position of the corner w of the plate-holder, or else circular plates x, secured on the shafts y and s, the position of which is defined by a spring-pawl 8, which drops into notches in the plate x. If different-sized plates I are to be used and a different number of impressions are to be taken on the plate, a different scale 20 will be used or a different-sized plate x on the shafts y or s will be used. The various scales 20 may occupy different corners of the frame A or the various-sized plates x may be placed on the shafts y and s, as at 9, Fig. 1.

Having now described the first and second parts of my invention, I will proceed to describe the mechanism by which the lens-tubes are adjusted. As before stated, it is customary where several impressions of the same object are to be taken at one time to use two or more lens-tubes. It is necessary that these lens-tubes be moved not only toward and from the ground glass or plate to adjust the focus and size of the picture; but also that these tubes should be moved toward and from each other to bring the picture opposite to the holes 15 in the diaphragm O, through which it is thrown onto the ground glass or the plate. To facilitate this latter movement, I use the following mechanical device. The lens-tubes $a\ b\ c\ d$, as before stated, are carried in the lens-box C, to the front of which is attached the brackets $a^1\ b^1$. A shaft c^1 has its bearings in the brackets a^1, and has cut on it at its opposite ends right and left hand screws 9 and 10, which pass through and engage with nuts d^1 on rods, which slide freely in sleeves or sockets e^1, attached to the tubes $a\ b\ c\ d$. In the same manner another shaft f^1 has its bearings in the brackets b^1, and its screws 11 and 12 engage with the nuts h^1 on rods which slide in the sockets i^1, attached to the lens-tubes. This allows the sockets e^1 to slide vertically on the rods to which the nuts d^1 are attached, and the sockets i^1 to slide horizontally on the rods to which the nuts h^1 are attached, so that as the shaft c^1 is revolved by the thumb-nut 13 the tubes $a\ d$ and $b\ c$ will approach toward or recede from each other. And in the same way as the shaft f^1 is revolved by the thumb-nut 14, the tubes $a\ b$ and $d\ c$ will approach or recede from each other. Thus by simply turning the thumb-nuts 13 and 14 I can quickly and accurately adjust the positions of the lens-tubes $a\ b\ c\ d$ with respect to the different portions of the diaphragm O and the plate I. A different diaphragm O will be used, with holes 15 of a different size and position, when different-sized impressions are to be taken. The inner ends of the tubes $a\ b\ c\ d$ are secured in blocks 16, which slide in the box C against the inside of the front of it.

What I claim as my invention, and desire to secure by Letters Patent, is—

1. A mechanism for moving the plate-holder II, in combination with an index for defining its position, operating substantially in the manner described.

2. The mechanical means herein described or its substantial equivalent for varying the positions of the lens-tubes $a\ b\ c\ d$.

 SIMON WING.

Witnesses:

 THOS. R. ROACH,
 EDMUND MASSON.

Appendix 3

STANDARD TINTYPE FORMATS

1856–1930

Common Nomenclature	Size of Plate (inches)[a]	Mounts and Holders	Period of Popularity
Gem	¾ x 1	Card-mounted or in gem album	1862–c. 1868
Large gem (Oriental or small bon-ton)	⅞ x 1⅛ to 2 x 3	Mounted on 2½" x 4" cards (cartes)	1863–c. 1875
Bon-ton (paper c.d.v. or paper cabinet)	2⅜ x 3½ 2⅜ x 3⅞ 4 x 5¾	Picture envelope or in c.d.v. or cabinet card album	1865–c. 1910
Victoria	3½ x 5	Picture envelope or picture frame	1870–c. 1910
Tin cabinet or imperial	4¼ x 5½	Picture envelope or cabinet card album	1866–c. 1900
Extra sizes	5 x 7 7 x 10 8 x 10 10 x 14 11 x 14	Picture frame and mat (all sizes)	1865–c. 1885
Stereo views	3¼ x 5½ 3¼ x 6¾	Unmounted; mounted on card	c. 1860
Jewelry	½ x ½	Lockets, pins, brooches	1856–?

continued

Common Nomenclature	Size of Plate (inches)[a]	Mounts and Holders	Period of Popularity
Ninth-plate	2 x 2½	Miniature case[b]	1856–c. 1870
Sixth-plate	2¾ x 3¼	Miniature case	1856–c. 1870
Quarter-plate	3¼ x 4¼	Miniature case	1856–c. 1870
Third-plate	4 x 5	Miniature case	1856–c. 1870
Half-plate	4¼ x 5½	Miniature case	1856–c. 1870
Whole-plate	6½ x 8½	Miniature case	1856–c. 1870
Special	2½ x 4	Miniature case	1856–c. 1870

[a]As every collector knows, the dimensions of tintypes vary. In the literature of photography some descriptions refer to the image size and others to the size of the mount. Tintypes were often shaped and trimmed by photographers for their own purposes, or by patrons who wished to excise part of the image. New sizes and shapes of tintypes appeared as competition among the manufacturers increased. The cards on which both c.d.v. paper prints and tintype c.d.v.'s were mounted also vary in size.

[b]Made of leather-covered wood, papier-mâché, and plastic.

Appendix 4

TINTYPE PLATE MAKERS

1856–1904

Plate Name	Manufacturer	Agent or Wholesaler	Dates Produced	Price per Case[a]
Adamantean	Dean & Emerson	E. & H. T. Anthony	c. 1863–90	$17.00 (1875)
Centennial	E. & H. T. Anthony	E. & H. T. Anthony	c. 1885–1904	$5.00 (1886)
Champion	Scovill Mfg. Co.	Scovill Mfg. Co.	c. 1874–1904	$13.00 (1874) $12.00 (1904)
Chapman's O.K. Plate	Horace Hedden	Levi Chapman	1862–67	$1.50 per dozen whole plates (1864)
Columbia	M. Roche	Holmes, Booth & Hayden	1862–72(?)	Unknown
Columbia	Unknown	Various	?–1886(?)	Unknown
Diamond	Unknown	Unknown	1860s	Unknown
Eureka	Bowden, Pierson & McLorinan	Successors to Holmes, Booth & Hayden	1862–70	Unknown
Eureka	Attributed to E. & H. T. Anthony	E. & H. T. Anthony	1880–?	$10.00 (1886)
Excelsior	Peter Neff Jr.	Jas. O. Smith & Sons	1861–64	Unknown

continued

Plate Name	Manufacturer	Agent or Wholesaler	Dates Produced	Price per Case[a]
Ferrotype	Victor M. Griswold	Various	1856–67	Dozen whole plates: $3.75 (1859) $2.50 (1863) $1.13 (1864)
Helion	H. Hedden	J. W. Willard & Co.	1862–67	Unknown
Melainotype	Peter Neff Jr.	Various	1856–64	Unknown
Phenix	H. Hedden	Scovill Mfg. Co.	1872–1904	$12.00 (1872)
Phoenix	H. Hedden	Various	1862–63	Unknown
Phoenix (chocolate)	H. Hedden	Various; in England through Estabrooke only	1870–72	$14.00 (1872)
Special	Unknown	Andrew W. Lloyd	c. 1904	$3.75 (1904)
Star	Wm. B. Holmes	Wm. B. Holmes	1863–69	Unknown
Sun	Scovill Mfg. Co.	Scovill Mfg. Co.	1870–72	Unknown
Union	E. & H. T. Anthony	E. & H. T. Anthony	c. 1880–1904	$7.50 (1886)
Vernis	Wm. Campbell	Wm. Campbell	1860–65	Unknown

[a] The price a photographer had to pay for a case of 10" x 14" plates.

Appendix 5

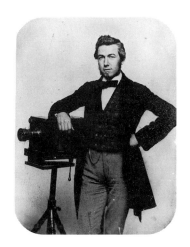

BIOGRAPHIES OF
AMERICAN TINTYPISTS

THESE brief biographies contain only the citations we were able to obtain. Galleries very probably operated before or after the dates indicated. Some nineteenth-century photographers referred to themselves as "tintypers." To be consistent with the standard use of the terms "daguerreotypist" and "ambrotypist," we use "tintypist" here. Many tintypists' existence is known only from examples of their work. An asterisk indicates that the photographer also had a background in art.

Pictured above, unknown photographer, c. 1858. Melainotype. Ninth plate. Courtesy Norman Mintz.

ABBREVIATIONS

ACB	*Appleton's Cyclopaedia of American Biography* (New York: D. Appleton and Co., 1888)
AI	*Transactions of the American Institute*
AJP	*American Journal of Photography*
APB	*Anthony's Photographic Bulletin*
BD	Business directory or register for the city and state noted
BJP	*British Journal of Photography*
BN	Beaumont Newhall, *The Daguerreotype in America* (New York: Duell, Sloan & Pearce, 1961)
CAS	Charles A. Seeley catalogue, 1859, New York City
CD	City directory for the date noted
c.d.v.	Carte-de-visite
DJ	*Daguerreian Journal*
HJ	*Humphrey's Journal*
n.d.	No date (date unknown)
n.p.	No place (place unknown)
Nsp	Newspaper for the city and date noted
NYHS	George C. Groce and David H. Wallace, *The New York Historical Society's Dictionary of Artists in America, 1754–1860* (New Haven: Yale University Press, 1957)
OSU	Floyd and Marion Rinhart Collection, Cartoon, Graphic, and Photographic Arts Research Library, The Ohio State University
PAJ	*Photographic Art Journal; Photographic and Fine-Art Journal*
PP	*Philadelphia Photographer*
RBD	Regional business directory for area and date noted
RT	Robert Taft, *Photography and the American Scene* (New York: Macmillan, 1938)
SA	*Scientific American*
SBD	State business directory for state and date noted
SLP	*St. Louis Practical Photographer*
SV	William Culp Darrah, *Stereo Views: A History of Stereographs in America and Their Collection* (Gettysburg, Pa., 1964)
USC	U.S. census for the date noted

Abbot, ——. Tintypist, ambrotypist, and photographer. Gallery at 480 Broadway, Albany, N.Y., c. 1865. C.d.v.

Abbott & Co. Tintypists. Gallery at 143 Nassau St., New York City, c. 1861. Cased tintype.

Adams, George. Daguerreotypist, tintypist, and photographer. Daguerreotypist from 1847. Gallery at 271 Main St., Worcester, Mass., c. 1861. Sold gallery to William H. Fitton, 1867. CD; Nsp; *HJ;* BD. C.d.v., c. 1864.

Alden, Augustus E. Tintypist, photographer. Bought rooms of Manchester Bros. and Francis Hacker, Nos. 59, 61, 63, and 65 Arcade, Providence, R.I., 1864 (listed there with A. J. Alden, 1866). Galleries in Troy, N.Y.; Saratoga Springs, N.Y.; and 954 Broadway, New York City, 1865. New York and Providence galleries still open in 1870; gallery at Main and Worthington, Springfield, Mass., extant c. 1872. CD; *APB* (1870); *PAJ* (1865); *SV.* C.d.v.

Alman, Louis. Photographer, ambrotypist, tintypist. Gallery at 840 Broadway, New York City, 1865–66; Lake Mahopac, N.Y., summer 1869. Opened new gallery in 1873 at corner of 5th Ave. and 22d St., New York City; was at 172 5th Ave. in 1874; Alman & Co. occupied the same address, 1880–97. Exhibited at opening of Eagle Dry Plate Works, 1895. Mentioned along with the famous photographers Fredericks, Pach, and Sarony. Had branch gallery, Newport, R.I., 1898–99. Louis Alman & Co. located at 346 5th Ave., New York City, 1900–1901. Returned to Italy c. 1898 or 1899. Over the years Alman became one of New York's famous photographers. *APB* (1873); CD; *PP* (1869); *Photographic Times* (1895); *SV.*

Alter, C. F. Tintypist, photographer. Gallery at Larimer St., Denver, Colo., c. 1865–68(?). Advertised melainotypes, photographs, and porcelain pictures. Nsp; Ralph W. Andrews, *Picture Gallery Pioneers of the West* (1964), 120.

Anderson, G. E. Photographer, tintypist. Gallery at E. Temple between Temple St. and 1st St., Salt Lake City, Utah. Advertised tintypes at $2.00 a dozen, 1879. CD.

Anderson (S.) and Blessing (S. T.). Photographers, ambrotypists, and tintypists. Galleries at 120 Canal St., New Orleans, and on Tremont St., Galveston, Texas, 1857. Advertised in 1857 that fifteen months had been devoted to ambrotyping. Located at 134 Canal St., New Orleans, 1858–59, where they advertised taking melainotypes; 61 Camp St., New Orleans, 1861. Anderson and Blessing parted company sometime between 1862 and 1865. CD; BD. *See also* Blessing, Samuel

Applegate, J. B. Tintypist, photographer. Gallery at northwest corner of 5th and Main Sts., Cincinnati, Ohio, 1861; had moved to Vine and 8th Sts., Philadelphia, c. 1871–72. CD. C.d.v. dated 1872.

Aten, Isaac. Tintypist, photographer. Active in Pine Castle, Orange Co., Fla., 1885. *Photographic Times and American Photographer* (1885).

Auburn Photographic Rooms. Tintypists, photographers. Active in Auburn, Maine, c. 1867. C.d.v.

Ayer, George F. Tintypist. Gallery at 161 Middle St., Portland, Maine, c. 1867. C.d.v.

Babb, G. W. Tintypist, photographer. N.p. Wrote article on tintyping for *PP,* 1881.

Bachelder, ——. Tintypist. Active in Nashua, N.H., late 1860s. C.d.v.

Bachman & Vance (R. H.). Photographers, ambrotypists, tintypists. Gallery located at corner of J and 3d Sts., Sacramento, Calif., 1861. CD. *See also* Vance, Robert

Bachrach, David. Photographer, tintypist, and inventor. During the Civil War Bachrach worked primarily with tintypes. A noted Baltimore photographer, he made

a modification of the "swelled-gelatin" method of making photorelief plates for illustrations that he and Louis E. Levy refined and patented in 1875. A partner of the Levytype Co., Bachrach wrote articles for *Wilson's Photographic Magazine* in the 1890s. RT, 426; *APB* (1875, 1881). Civil War information courtesy of Josephine Cobb.

Bailey, James. Daguerreotypist, ambrotypist, tintypist. Had rooms (refitted 1857) over Barnard's Drugstore in Tallahassee, Fla., 1853. Listed as Kuhn & Bailey, 1854–56. Nsp. *See also* Kuhn, William

Ball, James P. African American daguerreotypist, ambrotypist, tintypist, photographer. Learned art from John B. Bailey, a black tintypist, at White Sulphur Springs, W.Va., 1845. Itinerant traveling in mid-1840s to Pittsburgh, Pa., 1846, and on to Richmond, Va. Opened gallery in Cincinnati, Ohio, 1847; gallery listed Weeds Bldg., 1849; 28 & 30 W. 4th St., with brothers Thomas and Robert, 1852. Associated in 1852 with Alexander Thomas. Listed as Ball & Thomas at 120 W. 4th St. (J. P. Ball, A. S. Thomas, and Thomas C. Ball), 1854–58. Branch photographic studio, Hamilton, Ohio, 1866. Gallery located at 30 W. 4th St. as late as 1874. In 1855 a large panorama of black life along the Ohio, Susquehanna, and Mississippi Rivers was displayed in the gallery. A lecture commenting on the panorama, by James P. Ball, was published by Achilles Pugh, Cincinnati publisher and abolitionist: "Ball's splendid Mamoth Pictorial Tour of the U. S. comprising Views of the African Slave Trade of Northern and Southern Cities of Cotton and Sugar Plantations of the Mississippi, Ohio and Susquehana Rivers, Niagra Falls, etc." Ball also employed the black artist Robert S. Duncanson in his gallery and displayed six landscape paintings by him. SBD (1852, 1866); CD, 1857; *Southern Pictorial Advertiser* (1858); Wendell P. Dabney, *Cincinnati's Colored Citizens* (1926); information also courtesy of Romare H. Bearden and James de T. Abajian. *See also* Thomas, Alexander

Ball, Thomas C. African American daguerreotypist, ambrotypist, tintypist. Brother of James P. Ball. Associated with brother's Cincinnati gallery, 1852; listed as Ball & Harlan at 28 W. 4th St., Cincinnati, 1857, and as Ball & Thomas, 120 W. 4th St., 1858–61. CD; *Southern Pictorial Advertiser* (1858); information also courtesy of Romare H. Bearden and James de T. Abajian. *See also* Thomas, Alexander

Ball (T. C.) & Thomas (A. S.) Photographers, ambrotypists, tintypists. Gallery at 120 W. 4th St., Cincinnati, Ohio, 1858–61. *See also* Ball, Thomas C.; Thomas, Alexander

Barnett, ———. Tintypist. Gallery at 73 Fulton St., Brooklyn, N.Y., 1860s. C.d.v.

Bays, J. W. Tintypist. Active in Canton, Ill., c. 1869. C.d.v.

Beers & Mansfield. Daguerreotypists, ambrotypists, tintypists. Gallery at 144 and 146 Chapel St., New Haven, Conn., 1858–59. Advertised melainotypes among other offerings. CD.

Bell, William. Daguerreotypist, tintypist. Born Liverpool, England, 1831; died Philadelphia, 1910. Came to America as a young man. Well-known daguerreotypist; veteran and official photographer during the Civil War. Bought photograph gallery from J. E. McClees of Philadelphia in 1867. Photographer, Army Medical Museum, 1868; listed at 1200 Chestnut St., Philadelphia, 1869. Cited in *PP* in 1869 as talented artist; made porcelain pictures using patent owned by E. G. Fowx of Baltimore. Had moved to 12th and Chestnut Sts. by 1872. Bell was an official photographer during the Centennial Exhibition, 1876; one of the founders

of the Philadelphia Photographic Society and one of the first makers of dry plates in America. In 1886 he became professor of photography at Lehigh University, Bethlehem, Pa. *PP* (1868, 1869, 1886, 1887); *Photographic News* (1872), 555; *Bulletin of Photography and Photographers,* January 26, 1910.

Beneke, Robert. Daguerreotypist, ambrotypist, tintypist. Born in Stiege, northern Germany, 1836. Became interested in photography while serving in the German army. Emigrated to the United States, arriving in Missouri in 1856, where he worked first on a farm and then as a cooper; joined company with a traveling daguerreotypist, E. Meir, who taught him the trade. Had a studio for a short time in Brunswick, Mo., then worked in a studio in Knoxville, Tenn. Ran gallery at 4th and Market Sts., St. Louis. Entered into partnership with H. Hoelke, formerly owned by the well-known daguerreotypist Enoch Long. Opened a photomechanical establishment in St. Louis in 1883 and became one of the first photoengravers. Began making his own dry plates in 1883 and came to the attention of Gustav Cramer, a dry-plate manufacturer. Worked for Cramer as chemist and plant superintendent. *Early Photography in St. Louis* (booklet, n.p., n.d. [c. 1900]).

Benjamin, Orrin J. Daguerreotypist, teacher, photographer, and tintypist. Born De Ruyter, N.Y.; died September 9, 1895. Moved to New Jersey at twenty and taught school. Learned daguerreotyping from R. A. Lewis of New York City. Had gallery in Milburn, N.J., then in Rahway, finally settling in Newark, where his gallery was at 274 Broadway, 1857–58. Advertised melainotypes among other offerings. In 1865 lost everything in fire. Bought farm in Elmira, N.Y., and ran gallery in Corning. Settled in Orange, N.J., in 1867. CD; *APB* (1895).

Berger, ——. Tintypist. N.p., n.d. C.d.v.

Bergstresser Bros. (A. J. and J.). Photographers, tintypists. Briefly operated a business taking portraits of soldiers during the Civil War. J. Bergstresser, of Berrysburg, Pa., obtained a patent for photographs on tombstones, February 8, 1859. RT, 160, 480; *New York Tribune,* August 20, 1862.

Berlin, E. H. Photographer, tintypist. Active in Blairsville, Pa., 1897. *Photographic Mosaics* (1887).

Berth, J. W. Photographer, tintypist. Chester, Pa., 1871. *PP* (1871).

Biffar, H. W. Photographer, tintypist. Gallery at 91–93 Broadway, Brooklyn, N.Y., c. 1869. C.d.v.

Billinghurst, C. J. Photographer, tintypist. Active in McArthur, Ohio, 1869; Orange Heights, Fla., 1893. Wrote article on tintyping in 1893. *Photographic Mosaics* (1893); *PP* (1869).

Bingham (Benjamin) & Meacham (Samuel L.). Photographers, ambrotypists, and tintypists. Benjamin was born in 1837 and died in 1897. The partners operated a gallery at 180 Main St., Memphis, Tenn., 1860–61. Of Meacham little is known. CD; Nsp.

Bishop, Frank J. Tintypist. Gallery at 97 Wisconsin St., Milwaukee, Wis., c. 1872. C.d.v.

Black & Case. Photographers, tintypists. Active in Boston, c. 1865. C.d.v.

Blessing, Samuel. Ambrotypist, tintypist, and photographer. Died November 18, 1897, in St. Louis. Gallery at 134 Canal St., 1859–61 (Anderson & Blessing); Blessing & Bros., c. 1865–70, New Orleans; active Galveston, Tex., 1870–81, advertised porcelain photographs among offerings; new gallery at 117 Market St., 1881; New

Orleans gallery on Canal St. carried on by sons in his name from the late 1880s. *APB* (1872), 675; *APB* (1881), 16; *APB* (1886), 448; CD; *Daily Picayune,* New Orleans, November 19, 1897.

Bolton, W. H. Photographer, tintypist. Gallery at 130 8th Ave., New York City, c. 1880. C.d.v.

Boston Tintype Gallery. Tintypists. Active in Boston, c. 1868. C.d.v.

Bowery Photo Gallery. Tintypists. Gallery opposite Branch's Dancing Hall, Coney Island, N.Y., 1905. Bon-ton.

Bowring, T. D. Photographer, tintypist. Active in Depere, Wis., 1872–74. C.d.v.

Brengel, J. N. Tintypist. Gallery at 391 Canal St., New York City, c. 1868. C.d.v.

Brewster, J. C., & Co. Ambrotypist, photographer, and tintypist. Gallery at 35 Main St., Helena, Mont., 1868. C.d.v.

Brighton Beach Photo Studio. Tintypists. Active in Coney Island, N.Y., c. 1897. Bon-ton.

*Britt, Peter. Portrait and landscape painter, daguerreotypist, photographer, tintypist. Born March 11, 1819, Obstalden, Switzerland. Died in Oregon, 1909(?). Came to America in 1843. Practiced daguerreotyping in Highland, Ill., 1844–47(?). Studied with J. H. Fitzgibbon in St. Louis, 1847. Itinerant in Oregon Territory, 1850–53, then settled in Jacksonville, Ore., establishing first gallery in the territory, 1854, where he displayed his oil portraits and landscapes. In 1859 he had an 11" x 14" tintype camera. RT; R. Peattie, *The Pacific Coast Range;* NYHS; information also given by Alan Clark Miller.

Brown, Henry S. Photographer, daguerreotypist, ambrotypist, and tintypist. Active in 1846–52 as daguerreotypist in Milwaukee, Wis. Listed at 201 E. Water St. in that city, 1852–62. CD; *DJ;* BD.

Brown, S. B. Photographer, ambrotypist, tintypist. Gallery at 101 Westminster St., Providence, R.I., 1861. Advertised "Photographs and Patent ambrotypes, Crystalotypes (a new style of glass pictures), melainotypes, patent leather pictures, cloth pictures." CD; OSU.

Bruce & Fisher. Photographers, tintypists. Active in Everett, Pa., c. 1880s.

Bryan & Bros. Ambrotypists, tintypists, photographers. Gallery at 142 Main St., Racine, Wis., 1861. Advertised photographs, melainotypes, ferrotypes, ambrotypes.

Buchtel, Joseph. Daguerreotypist, ambrotypist, tintypist, and photographer. Born Stark Co., Ohio. Journeyed west with wagon train, 1852, but left group to complete trip on horseback. Worked a few months as a deckhand on river steamers. Purchased Wakefield's Gallery, Portland, Ore., 1853. Did business as Buchtel & Cardwell in Portland, 1863–65. Worked alone at residence (N.W. 6th and Madison Sts., Portland), 1866–67, and at 89 1st St., 1868–70. CD; Ralph W. Andrews, *Picture Gallery Pioneers of the West* (1964).

Buchtel & Cardwell. *See* Buchtel, Joseph

Bundy (Horace L.) & Williams. Photographers, tintypists. Active in Middletown, Conn., 1857–78. Also operated in New Haven, Conn., n.d. *HJ; PP* (1869); *SV.*

Burcaw, S. W. Photographer, ambrotypist, tintypist, inventor. Ran gallery at 7 East Hamilton St., Allentown, Pa., 1860. Inventor of "Focussing Plate-Holder," for which a patent was issued on October 24, 1865. BD.

Cadwallader (J. D.) & Tappan (S. C.). Photographers, ambrotypists, tintypists. Had gallery at Front St. over bank, Marietta, Ohio, 1864–66. CD.

Cambell's (Wm.) Sky Light Gallery. Ambrotypist, tintypist. Gallery at corner of Main and 3d Sts., Kansas City, Mo., 1859. No listing in 1860. CD.

Carleton, C. G. Photographer, tintypist. Gallery at 161 Middle St., Portland, Maine, 1866; Waterville, Maine, 1869–78. CD; *PP* (1869); *SV*.

Carpenter's (M.) Melainotype and Photograph Rooms. Photographer, tintypist. Gallery at 20 West 5th St., Cincinnati, Ohio, 1857–61. CD.

Carter, Milton T. Photographer, tintypist. Active in Worcester, Mass., 1860–78. *SV*. C.d.v.

*Carvalho, Solomon N. Portrait and landscape painter, daguerreotypist, photographer, tintypist, explorer, author, inventor. Born 1815, Charleston, S.C.; died 1899, New York City. Moved to Baltimore in 1828 and to Philadelphia in 1835. Began career as artist after being shipwrecked in West Indies in 1835. Lived in Charleston, S.C., and Washington, D.C., in the 1840s. Had galleries in Washington, D.C., and Baltimore, Md., 1849. Gallery in Charleston operating 1850–51. Invented enameled daguerreotype, 1852. Worked with J. Gurney, New York City, 1853. Exhibited paintings at Maryland Historical Institute, 1850, 1856. Went with Fremont's expedition as artist and daguerreotypist, 1853–54. Published *Incidents of Travel and Adventure in the Far West with Col. Fremont's Last Expedition,* 1860. Returned to Baltimore in late 1850s and to New York City, c. 1860, where in 1869–70 his gallery was at 765 Broadway. Received first medal at the 38th annual fair of the American Institute in New York City for large-sized ferrotypes. Listed as artist or photographer, New York City, 1869–80. NYHS; BN; RT; CD; Josephine Cobb, *Mathew B. Brady's Photographic Gallery in Washington* (1955); *PP* (1869).

Central Park Photographic Gallery. Tintypists, photographers. Active in New York City in 1870. Sales catalogue.

Chapman's Tintype Gallery. Tintypists. Gallery near Koster's Pavilion, Bradley Beach, N.J., c. 1902. Bon-tons.

City Gate Photographer. Tintypists. Gallery on St. George St. in St. Augustine, Fla., c. 1895.

City Photograph Rooms. Tintypist. Gallery at 1109 Market St., Philadelphia, n.d. Sales catalogue.

Clark, E. H. Tintypist. Gallery on Main St., Great Barrington, Mass., c. 1864. C.d.v.

Cleveland Fine Art Hall. William North's gallery. Photographer, ambrotypist, tintypist. Located at 205 Superior St., Cleveland, Ohio, 1861–63. CD. *See also* North, William C.

Critcherson (George P.) & Leland (Edwin J.). Photographers, ambrotypists, tintypists. Successors to Henry J. Reed. Gallery at Harrington and Main Sts., Worcester, Mass., 1865. Advertised large photographs and views. Critcherson earlier worked for the George Adams Gallery. Made stereo views of Worcester, c. 1868–78. CD; *SV*.

Cummings, Thomas. Tintypist. Active in Lancaster, Pa., 1869–70. *PP* (1869). C.d.v.

Daliet, ———. Tintypist. Gallery at 35 Frenchmen St., New Orleans, c. 1870. C.d.v.

Dampf, J. H. Tintypist. Active in Corning, N.Y., c. 1872–74. Bon-ton.

Davis, A. R. Ambrotypist, photographer, tintypist. Active in Biddeford, Maine, late 1850s and 1860s. OSU. C.d.v.

Davis, Alonzo. Ambrotypist, photographer, tintypist. Gallery at 80 Middle St., Portland, Maine, 1863–75. CD. C.d.v.

Davis, E. G. Photographer, tintypist. Active in Leominster, Mass., 1870s. C.d.v.

Davis, J. D. Daguerreotypist, photographer, tintypist. Gallery located first at 101 Fulton St., Brooklyn, N.Y., 1856–60, then at 239 Fulton St., 1874. CD.

Davis & Co. Tintypists. Active in Boston, c. 1859. Quarter-size plate mat.

Denison, ———. Tintypist. Operated 10' x 30' floating gallery at Lonwoods Landing, Miss., 1871. *APB* (1875).

De Shong, W. H. Daguerreotypist, ambrotypist, photographer, tintypist. Active in Mobile, Ala., in 1852, then in Memphis, Tenn., 1857; 182 Main St., Memphis, Tenn., 1858. Exhibited a large collection of 4" x 4" melainotypes at Fair of Southern Central Agricultural Society, October 28, 1859. CD; *HJ* (1859).

Dessaur, Fernando. Daguerreotypist. Gallery at 145 8th Ave., New York City, n.d. Sales catalogue.

Dikeman, Mrs. M. E. Photographer, ambrotypist, tintypist. Active in Geneva, Ohio, c. 1863. Studio may have continued to 1880s. C.d.v.

Doremus, John P. Photographer, tintypist. Born 1829; died Paterson, N.J., spring 1890. Operated galleries at 85 Main St. (1863–66), 172 Main St. (1867–68), and 219 Main St. (1871–78) in Paterson. Doremus had a luxurious floating gallery built at Minneapolis in 1874 and traveled along the Mississippi River taking stereo views. He was a notable New Jersey photographer. *APB* (1873, 1875); also information courtesy of Thomas Peters, Paterson Museum.

Downs, ———. Tintypist. Location uncertain, probably New Orleans, c. 1865. C.d.v.

Draper, A. J. Ambrotypist, photographer, tintypist. Had gallery on Broad St., Columbus, Ohio, 1859–60. SBD.

Duer, W. T. Daguerreotypist, ambrotypist, photographer, tintypist. His gallery was at 33 Main St., Peoria, Ill., 1858. Not listed in 1860. CD.

Dunbar, S. M. Tintypist. Active in Baldwinsville, Mass., 1888. Supposed to have made tintypes at 9:30 P.M., obtaining good detail in shadows. *APB* (1888).

Dupee & Co. Tintypists. Gallery at 478½ Congress St., Portland, Maine, 1875. CD; *SV.*

Eastbrook, Thomas S. Tintypist. Active in Brooklyn, N.Y., 1869. *PP* (1869).

*Eaton, Joseph Oriel. Portrait, genre, and landscape painter, photographer, ambrotypist, tintypist. Born Newark, Ohio, February 8, 1829; died Yonkers, N.Y., February 7, 1875. Studied painting in New York City. Worked in Indianapolis, Ind., 1846–48; in Cincinnati, Ohio, 1850–51, 1853, 1857–60. In 1851 he painted a full-length portrait of Louis Kossuth, the "George Washington of Hungary" (as he was known in the United States), from a photograph by Thomas Faris (q.v.) for the National Portrait Gallery. Had moved to New Orleans by c. 1854–57. Eaton & Webber's "Artists Photographic and Picture Gallery" offered ambrotypes, photographs, daguerreotypes, and melainotypes at 106 W. 4th St., Cincinnati, Ohio, 1861–62. Eaton became a successful painter of children's portraits in New York City and was an associate member of the National Academy. CD; NYHS; BN. *See also* Webber, Charles T.

*Eaton & Webber. *See* Eaton, Joseph Oriel; Webber, Charles T.

*Eckert, Mrs. M. A. Artist, ambrotypist, photographer, music teacher, tintypist. Ran gallery at Main and Wood Sts., Helena, Mont., 1868; also listed in 1879. CD.

Elliott, J. Perry. Photographer, tintypist. Active in Indianapolis, Ind., 1877. Wrote: "I find ferrotypes the style that most persons call for these times, though if money

was not scarce their 'tastes' might manifest themselves in another direction." *BJP* (1877).

Estabrooke, Edward M. Photographer, tintypist, author. Gallery at 31 Union Sq., New York City, 1872. Author of *The Ferrotype, and How to Make It* (1872).

Estabrooke & Thompson. Tintypists. Gallery at 130th St. and 3d Ave., New York City, c. 1871. C.d.v. *See also* Estabrook, Edward M.; Thompson, S. J.

*Faris, Thomas. Daguerreotypist, ambrotypist, tintypist, photographer. Began daguerreotyping 1861. Faris's early partner was Ezekiel C. Hawkins, and their business was located on 5th St. in Cincinnati, Ohio, as early as 1843. Faris was also listed as a portrait painter. Ran galleries in Cincinnati, 1844–57, as Faris & Erwin (q.v.), 1856–57, and also as Faris & Hawkins, 1856–57. Received bronze medal for heliographics on glass, American Institute, New York City, 1856. Later worked as photographer for Kurtz Gallery at 23d St., near Broadway, New York City, 1877, and was in charge of one of the gallery's departments. One of America's notable nineteenth-century photographers. BN; CD; BD; *AI* (1856); *SLP* (1877); *PAJ* (1857).

Faris & Erwin. Photographers, ambrotypists, tintypists. Bought out Samuel Root's (q.v.) gallery at 363 Broadway, New York City, c. 1867–70. Advertised December 6, 1856, offering melainotypes. In January 1857 advertised photographs, ambrotypes, melainotypes, and daguerreotypes. *Albion* (1856); *The Day Book* [booklet] (January 1857). *See also* Faris, Thomas

Farrar, A. B. Photographer, tintypist. Had galleries at 2 South Block and 1 Main St., Bangor, Maine, c. 1867–70. C.d.v.

Faul, Henry. Tintypist. Active in Central City, Colo., 1861–63. Gallery located at Black and Cherry Sts., Denver, 1864.

Field, ———. Tintypist. Gallery at 112 W. 5th St., Cincinnati, Ohio, 1865. C.d.v.

Filley, Myron W. Photographer, daguerreotypist, tintypist. Gallery at 75 Chapel St., New Haven, Conn., 1859. CD.

Fitzgibbon, John H. Daguerreotypist, ambrotypist, photographer, tintypist, and publisher. Born 1816(?), London, England; died 1882. Worked as a saddler, Philadelphia, 1839. Moved to Lynchburg, Va., by 1841, where he was a hotel owner and daguerreotypist, 1841–46. Became itinerant daguerreotypist, roaming from Cincinnati westward, 1846. Ran gallery in St. Louis, Mo., 1846–60, 1866–76. Itinerant in southwest Missouri, 1853. Traveled in Central and South America, 1858. Living in Vicksburg, Miss., 1860–63; in New Orleans and New York City, 1863–65. Exhibited at the Crystal Palace, New York City, 1853. Bought Vance daguerreotypes of California views same year. Made large-sized photographs with C. D. Fredericks, 1854–55, and views for *Leslie's Illustrated Weekly* and other illustrated publications, 1856–60. Sent editor of *PP* several c.d.v.'s and ferrotypes made at night with Proctor's apparatus. Edited and published *SLP*. (The magazine was later carried on by his wife, also a photographer.) "Fitz," as he was known, was probably the most widely traveled and the most popular of the pioneer photographers. CD; *HJ; PP* (1869); *PAJ* (1858); Missouri Historical Society; *APB* (1875); BN.

Fredericks & Hopkins. Tintypists. Gallery at 132 Genesee St., Utica, N.Y., c. 1862–70. Used Wing's multiplying camera for tintypes. C.d.v.

French (J. A.) & Sawyer (D. A.). Ambrotypists, tintypists, photographers. Opened

ambrotype rooms on November 1, 1861, in Richard's Building, Keene, N.H., where they stayed until 1864. Occupied a photographic car for fifteen months on Crystal Sq., then moved to Bridgman's Building in 1867. French purchased Sawyer's interest in 1871 and continued producing portraits and views. *Souvenir of Keene* (1890); *APB* (1891).

FRLY Bros. Tintypists. Advertised as "The World's Fair Tintype Gallery," 1893. Gallery was located at 5604 Lake Ave., Chicago. Bon-ton, 1893.

Gard, E. R. Photographer, daguerreotypist, ambrotypist, and tintypist. Gallery at 10½ E. Washington St., Indianapolis, Ind., 1857. His photography won first diploma at Indiana State Fair, 1856. Advertised melainotypes among his offerings. CD.

Gardner's Gallery. Photographer, tintypist. Operated gallery at 805 6th Ave., New York City, c. 1866. C.d.v.

Gigrich, Adam. Photographer, tintypist. Had gallery at 53 Ave. A, corner of 4th St., New York City, c. 1865. C.d.v.

Glen Island Photo Gallery. Tintypists. N.p., 1898. Bon-ton.

Godfrey, George W., & Co. Photographers, tintypists. Gallery at 81 Main St., Rochester, N.Y., c. 1868. Used Wing's multiplying camera. C.d.v.

Goodridge Bros. (William and Wallace). Black photographers, ambrotypists, tintypists. Active in Saginaw, Mich., c. 1867–1922. Among their achievements were stereo views of Michigan. *PP* (1869); information courtesy of John V. Jezierski, Saginaw, Mich.

Gorgas, John M. Daguerreotypist, ambrotypist, tintypist, photographer. Active in Pittsburgh, Pa., 1847. Operated a floating gallery on the Ohio and Mississippi Rivers, 1853–56. Listed in Madison, Ind., 1863–69. BN, 145; *PP* (1869).

Gorman, H. C. Photographer, tintypist. Active in Bayou Sara, La. (160 miles from New Orleans), 1858. BD.

Granger, ——. Ambrotypist, tintypist. Gallery corner of Owego and Geneva Sts., Ithaca, N.Y., 1865. C.d.v.

Green, B. F. Tintypist. Gallery at 97 Wisconsin St., Milwaukee, Wis., c. 1872. C.d.v.

Green, G. B. Ambrotypist, tintypist, and photographer. Gallery located two doors south of Exchange in Fond du Lac, Wis., 1857. Advertised photographs, plain and tinted ambrotypes, transparent ambrotypes, and melainotypes. CD.

Green, J. T. Tintypist. Gallery at 36 and 38 Montgomery St., Jersey City, N.J., c. 1867. C.d.v.

*Griswold, Victor M. Daguerreotypist, ambrotypist, ferrotypist, landscape painter, lawyer, chemist, inventor, and manufacturer. Born Worthington, Ohio, April 14, 1819; died Peekskill, N.Y., June 18, 1872. Gave up law in early 1840s to take up portrait painting. Studied with William Walcutt in Columbus and exhibited at the American Art Union and National Academy, 1848–58. Began daguerreotyping with his brother, Manfred Marsden Griswold, in Tiffin, Ohio, 1850–53, also Lancaster, Ohio, 1852. Manufactured ferrotype plates in Lancaster, 1856–61. Moved to Peekskill, N.Y., 1861–69. Held many patents. Two examples are a patent for addition of albumen to collodion (no. 15,326; July 15, 1856), and one for addition of bitumen to collodion (no. 15,924; October 21, 1856). Griswold stamped his ferrotypes "Griswold's Patent," but we have found no record that he was issued a patent for his plates.

Griswold produced ferrotypes in various colors, 1857 (not patented). Patented "Opal Pictures on the Ferrotype Plate" (no. 53,815; April 10, 1866). Author of *A Manual of Griswold's New Ferro-Photographic Process for Opal Printing on the Ferrotype Plates* (1866). NYHS; BN; SBD; *PP* (1869).

Gurley & Harris. Tintypists. Gallery at 132 Genesee St., Utica, N.Y., c. 1887. Bon-ton.

Gurney, H. D. Daguerreotypist, ambrotypist, tintypist, and photographer. Gallery at Washington and Clay, Vicksburg, Miss., 1859 (operator, R. Richardson, 1858–?); located in Canton, Miss., 1863, where he advertised ambrotypes, melainotypes, and oil-colored photographs painted by M. Sidway, portrait artist; listed in Natchez, Miss., 1868. CD; handbill, 1863; University of Georgia Libraries; *PP* (1868).

Hall's Tintype and Ferrotype Gallery. Gallery at 122 Lake St., Chicago, 1865. C.d.v.

Hamilton, J. F. Daguerreotypist, ambrotypist, tintypist, and photographer. Gallery at Broughton and Whitaker Sts., Savannah, Ga., 1855–58. Nsp; CD; *PAJ*.

Hankins & Clark. Photographers, tintypists. Gallery at 6 Main St., Norfolk, Va., 1858. CD.

Hannay, ———. Tintypist. Gallery at 73 Fulton Ave., Brooklyn, N.Y., n.d. (1870s). Bon-ton.

Hanway, D. Itinerant photographer, tintypist. During 1860s active in Oakland, Calif., using itinerant car. (Traveled in wagon with photographic supplies and took photographs along the way.) Information courtesy of Bruce Diggelman, Oakland, Calif.

Harmany, ———. Tintypist. Active in Lancaster, Pa., c. 1869. C.d.v.

Harris, Prof. Hiram V. Daguerreotypist, actor, tintypist, photographer. Gallery at 333 Broadway, 1849–51; at 132 Bowery St., 1851–54; at 236 Grand St., 1854; at 109 Middle St., c. 1868–69; and at 228 Middle St., 1875, all in New York City. Harris was secretary of the American Histrionic Association, which met in his gallery in the fall of 1851. CD; BD; *New York Times; SV.* C.d.v.

Hatch, S. R. Tintypist, photographer. Active in Milford, Mass., 1869. *PP* (1869). C.d.v.

Highland Beach Gallery. Tintypists. Active in Monmouth Co., N.J., on the Sandy Hook peninsula, 1893–95. Bon-ton.

Hilliard, ———. Tintypist. Gallery at 120 S. 2d St., Philadelphia, c. 1870. C.d.v.

Holten & Robinson Bros. Active in Boston, 1869. Exhibited ferrotypes at National Photographic Convention in Boston, 1869. *PP* (1869).

Hooker, F. S. Tintypist. Active in Addison, N.Y., c. 1873. C.d.v.

Horgan, S. H. Tintypist. Ran "Travelling Ferrotype Gallery," n.d. *Journal or Annual of Photography,* September 8, 1922.

Hover, Warren D. Tintypist. Active in Warsaw, Ind., 1890s. Information courtesy of J. C. King.

Hovey & Baker. Photographers, tintypists. Gallery at 711 Broadway, New York City, 1862. CD.

Howard, L. B. Tintypist. Ran gallery on Main St. in Bridgewater, Mass., c. 1868. C.d.v.

Howe, O. P. Tintypist. Gallery located at 115 Water St., Augusta, Maine, n.d. Sixth-size tintype.

Hughes Bros. (F. M. and C. C). Daguerreotypists, wholesalers, ambrotypists, tintypists, photographers. Gallery at 59 N. College and Union Sts., Nashville, Tenn.,

1855–59. In 1859 they advertised ambrotypes and melainotypes. One of the largest supply houses in the South in the late 1850s and 1860s. CD; BD.

*Jacobs, Edward. Portrait painter, art dealer, daguerreotypist, ambrotypist, tintypist. Partner with Johnson (C. E.) & Jacobs, located at corner of Camp and Canal Sts., New Orleans, 1844–46. Worked for E. White & Co. photographic supplies, 1847. Listed at 93 Camp St. in New Orleans, 1851–59. Displayed paintings by Old Masters in his gallery, 1858. NYHS; CD; *The East,* 1845; *PAJ* (1858).

Jacoby, W. H. Tintypist, photographer. Gallery at corner of Bridge Sq. and 2d St., 1867; at 61 and 63 Bridge Sq., c. 1868; and at corner of 2d and Nicollet, 1869, all in Minneapolis. CD. C.d.v.

Jaeger, Henry. Tintypist. Gallery at 31 Van Houten St., Paterson, N.J. Information courtesy of Thomas Peters, Paterson Museum.

James & Carpenter. Tintypists. Gallery at 267 Fulton St., Brooklyn, N.Y., c. 1869. C.d.v.

Jeffers, ———. Photographer, tintypist. Ran gallery at corner of King and Market Sts., Charleston, S.C., 1857. Advertised new-style portraits, likenesses on iron. Nsp, February 2, 1857.

Jenks, J. B. Photographers, tintypists. Gallery located at 131 Main St., Paterson, N.J., c. 1871–76. Information courtesy of Thomas Peters, Paterson Museum.

Johnson, George G. Daguerreotypist, ambrotypist, tintypist. Gallery at 90 Main St., Galena, Ill., 1858–59. Advertised melainotypes among offerings. CD.

Johnston, Frances Benjamin. Photographer, tintypist, author. Born Grafton, W.Va., January 15, 1864; died May 16, 1952. Famous woman photographer with widely exhibited photographs and many honors. Her tintype of a Virginia county fair, May 1903, is found in Pete Daniel and Raymond Smock, *A Talent for Detail: The Photographs of Miss Frances Benjamin Johnston, 1889–1910* (New York: Harmony Books, 1974), 6; *Who Was Who in America.*

Jones, Walter N. Ambrotypist, tintypist, photographer. Gallery at No. 60, third door east of Exchange Hotel, Worcester, Mass., 1859–60. Advertised melainotypes. CD.

Jordan, J. L., and Jordan, H. A. Tintypists. Active in New London, Conn., c. 1867. C.d.v.

Jordan Bros. Tintypists. Active in Syracuse, N.Y., 1865, and in Utica, c. 1867–68. Used Wing's multiplying camera. C.d.v.

Keim, J. H. Photographer, tintypist. Gallery in A. Rise's Building, Lebanon, Pa., 1860.

Kneeland, ———. Tintypist. Gallery at 143 Federal St., Allegheny City, Pa., c. 1880. C.d.v.

Knight, F. M. Tintypist. Active in Henry, Ill., c. 1866. C.d.v.

Knight, Willard M. Daguerreotypist, tintypist, photographer. Active in Racine, Wis., 1851, as daguerreotypist. Operated gallery at 238 Main St., Buffalo, N.Y., 1857–59. Advertised melainotypes with offerings. Listed at 256 Main St., Buffalo, 1869. Made forty whole-size portraits of "Eagle Hose Co., no. 2." CD; *PP* (1869).

Knowlton Bros. Tintypists. Active in Northampton, Mass., c. 1873. Gem card.

Krause, Herman. Ambrotypist, tintypist, photographer. Had gallery at Forest Hill, Placer Co., Calif., 1858–59. Advertised ambrotypes, stereo views, melainotypes, lamprotypes (glass photographs, from the Greek word *lampros*), and leather photographs. CD.

Kuhn, William. Daguerreotypist, photographer, tintypist. Tallahassee, Fla., resident active as partner in Kuhn & Bailey in 1854–56, and as Kuhn only in 1856. Was still taking photographs, tintypes, etc., in Tallahassee in February 1874. Nsp; BD. *See also* Bailey, James

Lamb, Colby. Daguerreotypist, tintypist, photographer. Gallery at 4 Pleasant St., Newburyport, Mass., 1858–60. CD; OSU.

Lamsom, George L. Tintypist, photographer. Active in La Fargeville, Jefferson Co., N.Y., c. 1875. C.d.v.

Lane, Colwell. Ambrotypist, tintypist, photographer. Active in Long Branch, N.J., 1865. Ran gallery at 5 Atlantic Block, Long Branch, 1866 or before; listed in Red Bank, N.J., 1867. In 1872–73 associated with Daniel N. Carvalho to form the New Jersey Stereoscopic View Co., Red Bank. Lane was president and Carvalho manager. The company dissolved c. 1876, and Carvalho moved to New York City. Lane operated a studio at 145 8th Ave., New York City, 1888–90. George H. Moss Jr., *Double Exposure: Early Stereographic Views of Historic Monmouth County, New Jersey, and Their Relationship to Pioneer Photography* (Sea Bright, N.J.: Ploughshare Press, 1971), 109–10.

Lasselle, G. P. Tintypist. Gallery at Summer St., Boston, c. 1870. C.d.v.

Laudy, ——. Tintypist. Active in Peekskill, N.Y., c. 1864. C.d.v.

Lawrence, Frank. Ambrotypist, tintypist, photographer. Gallery at 188 Main St., Worcester, Mass., 1864–65, 1867. Successor to Charles Claflin, daguerreotypist. CD.

Lawton, Mrs. Tintypist. N.p., n.d. (c. 1869). C.d.v.

Leamon (W. K.) & Lee. Active in Reading, Pa., 1869. Gallery located at northwest corner of Penn St. in Reading, c. 1870. *PP* (1869). C.d.v. *See also* Lee, ——

Lee, ——. Tintypist. Active in Reading, Pa., 1869. Gallery at 5th and Penn Sts., Reading, Pa., c. 1864–94. C.d.v. *See also* Leamon & Lee

Leland, E. J. Ambrotypist, tintypist, photographer. Gallery at Harrington Corner, Worcester, Mass., 1866–71. CD.

Le Roy's Gem Gallery. Tintypist. Gallery listed at 78 Water St., Newburgh, N.Y., c. 1867. C.d.v.

Lesman, W. K. Tintypist, photographer. Active in Reading, Pa., 1869. *PP* (1869).

Lesure, H. A. Ambrotypist, tintypist, photographer. Galleries listed at 62 Elm St., Manchester, N.H., c. 1866; in Rochester, Vt., c. 1869; and in Orange, Mass., 1868–75. *SV.* C.d.v.

Lothrop, E. Tintypist, photographer. Gallery at 43 N. 8th St., Philadelphia, c. 1868. President of the Ferrotype Association of Philadelphia, 1868–69(?). *PP* (1868, 1869). C.d.v.

Lovejoy, Charles K. Tintypist, photographer. Gallery at 429 N. 2d St., Philadelphia, c. 1864–67. Secretary of the Ferrotype Association of Philadelphia, 1864–67(?). *PP* (1868, 1869). C.d.v.

Low, Frederick C. Tintypist, photographer. Active in E. Cambridge, Mass., 1869–c. 1880. *PP* (c. 1880). Bon-ton, c. 1880.

Lutz, John H., & Co. Tintypists, photographers. Gallery on the sand near Hotel Fiske, Old Orchard Beach, Maine, c. 1895–97. Published article in *St. Louis Practical Photographer,* 1880. Bon-ton, c. 1897.

*Lydston, Francis A. Miniature and fresco painter, photographer, ambrotypist, tintypist. Born 1819 in Massachusetts. Worked as fresco painter in Boston, 1841–43.

Moved to Milwaukee in the early 1860s, where he had a gallery at 194 E. Water St. in 1862. He was partner in Lydston & Mosher at Main and Wisconsin Sts. in 1863, and he advertised his business in 1864 as a "Photographic and Art Studio—ambrotypes, melainotypes, India Ink, oil, and water color, all sizes." He was listed as an artist and photographer in 1865 with Arthur F. Lydston as the gallery's operator. CD; NYHS.

McFadden, J. Tintypist, photographer. Gallery at 385 Broadway, New York City, 1864. CD.

McHenry, J. A. Daguerreotypist, ambrotypist, tintypist, photographer. Gallery at 138 Main St., Racine, Wis., 1861. CD.

Mahler, Henry. Ambrotypist, photographer. Active in Athens, Ga., April 1857. Advertised melainotypes. Information courtesy of W. Robert Nix.

Marsh, C. M. Tintypist. Active in Tanghannock Falls, N.Y., c. 1874. Quarter-size tintype.

Martin, J. E. Daguerreotypist, ambrotypist, tintypist, photographer. Practiced daguerreotyping in Detroit, 1849–53. Sold out to Sutton & Bro., 1853. Exhibited at Michigan State Agricultural Fair in 1849, winning first prize. Had gallery on 3d St., St. Paul, Mich., 1858–64; at 264 3d St., 1866 (listed galleries under "Views," 1868). *HJ; CD; PP* (1868).

Mason's Art Gallery. Tintypist. Active in Helena, Ark., n.d. Operated a floating gallery along Mississippi River, 1876. *APB* (1876).

Masters, W. H. Ambrotypist, tintypist. Gallery listed on north side of public square, west of Main St., Princeton, Ill., 1858. CD.

Mather, John A. Tintypist. Pioneer photographer of Titusville, Pa. *PP* (1869); *Bulletin of Photography* (1907).

Matthews, S. Tintypist, photographer. Operated Sea Side Photograph Gallery, Holly Beach, Calif.(?), c. 1900.

Miller, Adam R. Daguerreotypist, ambrotypist, tintypist, photographer. Galleries listed in Terre Haute, Ind., 1858 (no address), 1860 (87 Wabash St.). Advertised patent rights for melainotypes and hyalotypes. CD.

Millis, I. T. Daguerreotypist, ambrotypist, tintypist, photographer. Gallery at corner of Woodward and Larned Sts., Detroit, 1862. CD.

Milstead, J. W. Tintypist. Active in Benton, Ky., 1872. Gave formula for tintypes to *APB*, 1872.

Minner, John W. Daguerreotypist, ambrotypist, tintypist, photographer. Had gallery on Main St. in Sparta, Ill., 1859. SBD.

Moffet, Prof. C. R. Daguerreotypist, ambrotypist, tintypist. Practiced daguerreotyping in Danville, Mo., in 1848; ran gallery on High St. in Mineral Point, Wis., 1859. Advertised taking pictures on silver, copper, iron, glass, leather, and paper. Price: 0.75–$10.00. Sales catalogue; CD.

Morel, G. Tintypist. Active in St. Anne de Beaupré, Canada, 1903. Bon-ton.

Morgan, H. W. Tintypist, photographer. Active in New London, Conn., c. 1860–78. *SV.* C.d.v.

Morris, Charles Y. Daguerreotypist, ambrotypist, tintypist. Gallery at 109 Genesee St., Auburn, N.Y., 1859. CD.

*Moulthrop, Major. Daguerreotypist, ambrotypist, tintypist, photographer, landscape artist, and portrait painter. Born New Haven, Conn., 1805; died 1890. Learned

daguerreotyping c. 1840 and later took up the wet-plate process, becoming well known among photographers. Operated gallery in Brewster's Exchange Building (with partner, T. Hart), 1846–48; at 6 and 15 Phoenix Building, 1849–50; and at 24 Phoenix Building, 1851–59, all in New Haven. Advertised melainotypes in 1857. Won two silver medals and a diploma at state fair, 1857. Active in gallery (Bundy, Williams & Hart) located at 314 Chapel St., New Haven, in 1860. CD; RBD; *APB* (1890).

Moulton, J. C. Daguerreotypist, ambrotypist, tintypist, photographer. Active in Fitchburg, Mass., 1853–78. Gallery at 159 Main St., 1857–60. Advertised melainotypes in 1859. Highest prize at state fair for eight years. CD; SBD; *SV.*

Mudgett, ——. Active in Fitchburg, Mass., 1860s. Sales catalogue.

Narick, J. M. Tintypist, photographer. Active in Long Branch, N.J., 1867. Nsp.

Naylor, Charles. Tintypist, photographer. Active in Philadelphia, 1869. *PP* (1869).

Neff, Peter, Jr. Inventor, clergyman, tintypist. Born Cincinnati, Ohio, April 13, 1827; died Cleveland, Ohio, May 11, 1903. Educated at Yale College and Kenyon College, Gambier, Ohio, graduating in 1849. Studied at Bexley Hall Theological Seminary, Gambier, graduating in 1854. While at Gambier associated with Hamilton L. Smith, experimenting with photographs on iron plates. Smith secured patent (no. 14,300, February 19, 1856) for photographic pictures on japanned surfaces (assignors were William Neff and Peter Neff Jr.). Neff opened gallery in spring 1856 at 229 W. 3d St., Cincinnati, and began to advertise his melainotypes. Awarded bronze medal for best melainotypes by the American Institute, New York City, 1856. Established factory for manufacturing sheet-metal plates for tintypes. In summer 1857 fire destroyed the factory, and platemaking operations moved to Middletown, Conn. Neff stopped making plates in fall 1863. In 1864 made study of oilfields in western Pennsylvania. Began boring wells in Coshocton Co., Ohio, and met with success in June 1865. Discovered in 1866 that lampblack obtained from natural gas was superior in quality and invented machinery for the manufacture of gas black with large sales ensuing at home and abroad. To Cleveland in 1888 where he became librarian of the Western Reserve Historical Society. *National Cyclopedia of American Biography; AI;* CD.

Newburger, F. Tintypist. Gallery located at corner of Lake and Webb Sts., Asbury Park, N.J., c. 1900. Bon-ton.

North, William C. Daguerreotypist, ambrotypist, tintypist, photographer. Gallery listed at 142 Washington St., Boston, 1849; at Roundout, N.Y., 1848–50. Went to Cleveland, Ohio, 1850, where he bought out Tilton's daguerreotype gallery in the Melodeon Building on Superior St. Exhibited at Crystal Palace, New York City, 1853–54. Photographed the North Star, 1855. Sold business to nephew in 1856, but bought it back in 1857. Advertised melainotypes in 1857. Listed at 205 Superior St., 1859; called his gallery "Cleveland Fine Art Hall," 1861–63. Employed artist Schwerdt for coloring, 1863. Doing business as North & Schwerdt, 1864–66. Located at 211 Superior St. in 1867. CD; SBD; Nsp, 1850; *PAJ; SLP;* Georgia Historical Society. C.d.v., 1860s.

Nunn, R. J. Daguerreotypist, tintypist, photographer. Active in Savannah, Ga., with P. M. Cary, mid-1850s, and in Athens, Ga., 1858. Listed at Broughton and Bull Sts., Savannah, 1858. Advertised melainotypes. CD; Nsp; *Southern Pictorial Advertiser* (1858); Athens information courtesy of W. Robert Nix.

Oldershaw, J. Tintypist, photographer. Gallery located at 181 Main St., Hartford, Conn., n.d. C.d.v.

Ormsbee, Marcus. Daguerreotypist, ambrotypist, tintypist, photographer, inventor. Opened rooms at 62 Milk St., Boston, 1842. Listed in Portland, Maine, at 144 Middle St., 1844–51, then at 203 Washington St., Boston, 1851–62. Bought out Holden's Gallery (formerly Morand's), 411 Broadway, New York City, 1862. Became involved with Simon Wing in developing multiplying camera, c. 1860. Also held patents for "Photographic Printing Frame" (no. 38,326; April 28, 1863); "Mounting Photographs" (no. 39,166; July 7, 1863). CD; BD; Nsp, 1844; BN; *HJ* (1862).

Owen, I. G. Tintypist. Active in Newton, N.J., c. 1873. Bon-ton.

Parker, T. L. Ambrotypist, tintypist. Gallery at 9 Public Sq., Cleveland, Ohio, 1864–65. Advertised four pictures for twenty-five cents, 1864. CD.

Patterson, James L. Ambrotypist, tintypist, photographer. Did business as Eureka Photographic Gallery at 33 Union St., Nashville, Tenn., 1859. BD.

Peck, John M. Tintypist. Gallery listed at 174 Middle St., Portland, Maine, c. 1876, and at 518½ Congress St., 1875. CD. C.d.v.

Perkins, E. R. (Elijah). Daguerreotypist, ambrotypist, tintypist, photographer. Active in Topsfield, Mass., 1853. Ran gallery at 31½ State St., Newburyport, Mass., 1856, and at 33 State St., 1858–59. Advertised melainotypes in 1859. CD; *DJ;* OSU.

Pierce, A. J. Tintypist. Active in Rockland, Maine, c. 1866. C.d.v.

Pirrong & Son. Tintypists. Gallery, 323 N. 2d St., Philadelphia, c. 1869. C.d.v.

Pope, J. H. Tintypist, photographer. Gallery, 91 W. Baltimore St., Baltimore, Md., 1869. *PP* (1869).

Powers, J. D. Tintypist. Active in Springfield, Vt., c. 1865. C.d.v.

Proctor, George K. Tintypist, photographer, inventor. Active in Salem, Mass., 1869. Invented a process for photography at night, including tintypes. *PP* (1869); *Journal of the Franklin Institute* (1869).

Quarterly, Charles. Tintypist. Gallery at 7th and D Sts., Washington, D.C., late 1870s. Information courtesy of Josephine Cobb.

Quimby & Co. Ambrotypists, tintypists, photographers. Successors to Tyler & Co. (daguerreotypists), Charleston, S.C., 1857. After emigrating from England, Quimby worked for Tyler & Co. Advertised in 1857 that he employed twenty "manipulators and artists." Ran gallery at 233 King St. until 1868, and at 261 King St. in 1869, both in Charleston. Nsp, February 1857; CD; *PP* (1868).

Ramsdell, D. F. Tintypist. Operated Sunbeam Gallery at 297 Chapel St., New Haven, Conn., c. 1860–70. Advertised "card Ferrotypes and Gem miniatures taken with Patent Multiplying Camera only at the Sunbeam Gallery." C.d.v.

Reed, Mrs. Warren A., and Miss C. J. McCormick. Ambrotypists, tintypists. Gallery located at northeast corner of public square, Quincy, Ill., 1857. Advertised as "Excelsior Gallery," 103 Hampshire St., Quincy, with McCormick as operator and Mrs. Warren Reed as proprietor, 1859. CD.

Rhoads, Wm. H. Tintypist, photographer. Born 1835; died February 3, 1885, at Melrose, Fla. Member of the solar eclipse expedition, August 7, 1869. Active in Philadelphia in the 1870s as ferrotypist. *PP* (1869). C.d.v.

Richards, S. S. Tintypist. Gallery, 84 State St., Carthage, N.Y., n.d. Sales catalogue.

Richardson, C. P. Ambrotypist, tintypist, photographer. Itinerant "at his Large Travelling Saloon," c. 1859. Card.

Rideout's Star Gallery. Tintypist. Gallery, Lisbon St., Lewiston, Maine, c. 1875. Card.

Rile, H. F. Tintypist, photographer. Active in Santa Monica, Calif., c. 1895. Card.

Robinson, Charles. Daguerreotypist, ambrotypist, tintypist. Gallery over post office, Minneapolis, 1859. CD.

Robinson & Locke. Tintypists. Their (c. 1867) gallery at 144 Washington St. in Boston had been Wing's gallery. C.d.v.

Robinson Bros. Tintypists, photographers. Firm's gallery located at corner of Merrimack St., Haverhill, Mass., c. 1865. Still in Haverhill in 1869. Produced stereo views, c. 1869–75. *PP* (1869); *SV.* C.d.v.

Rollins, ——. Tintypist. Active in Gloucester, Mass., c. 1868. C.d.v.

Root, Samuel. Daguerreotypist, ambrotypist, tintypist, photographer. Born in Ohio; died at Rochester, N.Y., March 11, 1889. Had gallery at 363 Broadway, New York City (in partnership with brother, Marcus A. Root), 1849–51, then worked alone at the same address from 1851 until 1857. Sold gallery to Thomas Faris in late November 1856. Root advertised melainotypes in the *New York Daily Tribune,* November 22, 1856, saying: "These pictures resemble miniatures upon ivory." Root repossessed gallery in 1859, although he had moved to Dubuque, Iowa, about 1857. He continued to work as a photographer in Dubuque until his retirement around 1885. Exhibited at the American Institute, New York City, 1850 (silver medalist), 1851 (gold medalist), 1852 (silver medalist for crayon daguerreotypes). Pioneered glass and paper photographs (Whipple's crystalotypes) in 1852 in New York City. With his brother Marcus, Root experimented with microphotography, 1850–51. CD; BD; *AI; SA; SV; PAJ; DJ; PP; Photographic Times and American Photographer* (1889).

Ross, Wm. M. Daguerreotypist, ambrotypist, tintypist. Gallery, 82 Main St., Norwich, Conn., 1857. CD.

Russell, Frank. Tintypist. Gallery, 335 8th Ave., New York City, c. 1872. C.d.v.

Rutherford, Frank. Ambrotypist, tintypist, photographer. Active in Bath, N.Y., 1859. SBD.

Ryan, David J. Tintypist, photographer. Born Ireland, 1837. Active 1870s–80s in Savannah, Ga. Ryan was also a photographic jobber, and he advertised Georgia and Florida scenery. USC; *PP* (1870); CD. Stereo card.

Sache & Potter. Ambrotypists, tintypists, photographers. Located first in Galveston, Texas. "Pictures taken on patent leather, convenient for sending letters." Advertised in Tallahassee, August 1859, that their Skylight Gallery "will remain during hot season." In Tallahassee again November 13–December 25, 1860. Nsp.

Salt, D. I. Tintypist. Gallery, 239 Fulton St., Brooklyn, N.Y., 1860s. C.d.v.

Saltsman, T. F. Ambrotypist, tintypist, photographer. Gallery located first at 44 Union St., Nashville, Tenn., in 1855, then upstairs next to Wessell & Thompson in 1859. Still listed in Nashville in 1869. BD; *PP* (1869).

Sawyer, S. W. Tintypist, photographer. Active in Bangor, Maine, 1869–78. *PP* (1869); *SV.* C.d.v.

Scholten, John A. Photographer. Born at Hesse in Prussia, October 18, 1829; died March 7, 1886, in St. Louis, Mo. Came to the United States at fourteen and settled

in Herrmann, Mo. Three years later was in St. Louis in the dry-goods business. Became an independent photographer in 1857 after two years' apprenticeship to A. J. Fox. His first known gallery was at 297 S. 5th St., St. Louis, 1859–60. Exhibited "exquisite burnt-in-porcelains in colors, of great perfection" at the National Photographic Association, Boston, 1869. Gallery, located at the corner of 10th and Olive Sts. in St. Louis from 1874 to 1878, destroyed by fire. Resumed business May 1878. Scholten was the first to introduce the carte-de-visite to St. Louis. Missouri Historical Society; *PP* (1869); *APB* (1886).

Schoonmaker & Hill. Tintypists, photographers. Gallery, 282 River St., Troy, N.Y., c. 1860s. C.d.v.

Seeler, W. W. Tintypist. Gallery listed at southeast corner of 8th and Spring Garden Sts., Philadelphia, n.d. Information courtesy of Thomas Peters, Paterson Museum, Paterson, N.J.

Seel(e)y, Charles A. Ambrotypist, photographer, inventor, editor. Born Ballston, N.Y., November 28, 1825; died 1896. In 1832 his family moved to Rochester, N.Y. At thirteen Seeley was a laboratory assistant at the Collegiate Institute. Later entered Union College, graduating in 1847. Received his M.A. in 1850 and Ph.D. in 1878. Editor on staff of *Scientific American,* 1853; established *American Journal of Photography and the Allied Arts and Sciences,* which he edited until publication was discontinued in 1867. Manufactured photographic chemicals at 324 Broadway in New York City, at first alone, and then with Henry Garbanati and others (at 94 Duane St. and 424 Broadway). Sold his interest in the business in 1865. Among his nineteen patents are many related to photography. A list of improvements in the photographic art invented and introduced by Seel(e)y appeared in the June 15, 1857, issue of *American Journal of Photography,* and in advertisements from 424 Broadway. One of the organizers of the American Electric Light Co., March 1867; analytical and consulting chemist at New York Medical College, 1859; professor, New York College of Dentistry. *Photographic Times* (1896).

Sellers, ——. Tintypist. Active in Cedar Springs, Mich., c. 1870. C.d.v.

Shaw's Spectrotype Gallery. Tintypists. Active in Atlantic City, N.J., n.d. Sales catalogue.

Sheid, H. Tintypist. Gallery listed at 7th and D Sts., Washington, D.C., late 1870s. Information courtesy of Josephine Cobb.

Sherman, O. G. Tintypist. N.p. Wrote article for *PP,* 1881.

Sherman, W. H. Daguerreotypist, ambrotypist, tintypist, photographer. Gallery in Cogswell's New Block, 16 Wisconsin St., Milwaukee, Wis., 1861–68. CD.

Shipman, John S. Tintypist, photographer. Gallery at 146 Court St., Brooklyn, N.Y., 1863–64.

Simkins, J. H. Tintypist. Active in Salem, N.Y., 1865. C.d.v.

Simonds, F. A. Ambrotypist, tintypist, photographer. Born Winchester, Mass., 1828; died June 13, 1884. Active in Chillicothe, Ohio, from 1858 on. CD; *APB* (1884); *PP* (1868).

Sleight, ——. Tintypist. Active in New York City in the 1860s. C.d.v.

Smith, Hamilton Lamphere. Educator, scientist, chemist, inventor, author, photographer on glass, paper, metal. Born New London, Conn., November 5, 1819. Experimented with daguerreotyping in Cleveland, Ohio, 1840. Experimented with glass negatives, 1850–55. Patented melainotype process, 1856. In 1839, while

a student at Yale, he and E. P. Mason constructed the largest telescope in the United States. Professor of natural philosophy and astronomy at Kenyon College, Gambier, Ohio, 1853–68. Smith published a number of scientific papers from 1844 to 1887. *ACB;* BN; *American Journal of Sciences and Arts* (1839–40); *Annals of Science* (1853).

Smith, Harry. Tintypist. Worked in England for Bennett's in Cheapside. Emigrated to Atlantic City, N.J., c. 1876, where he worked for eighteen years or more, specializing in portraits of bathers. *Cornhill Magazine,* November 1894.

Snell, Wm. Daguerreotypist, tintypist, and photographer. Active in Newburyport, Mass., 1848–51; in Salem, Mass., 1853; listed at 208 Essex St. in Salem, 1859. Advertised melainotypes. CD; SBD.

Spenser, H. W. Tintypist. Operated floating gallery along the Mississippi River, 1875. *APB* (1875).

Staples, Wm. F. Tintypist, photographer. Gallery located at 701 Elm St., Dallas, Texas, 1880. Advertised four gems for fifty cents. CD.

Starbird, ——. Tintypist. Active in Augusta, Maine, c. 1864; in Farrington, Maine, 1868–78. *SV.* C.d.v.

Stark, A. D. Tintypist, photographer. Gallery located at 62 Elm St., Manchester, N.H., 1865–78. *SV.* C.d.v.

Swain, Mrs. L. A. Ambrotypist, tintypist, photographer. Gallery located at 3d St. between Minnesota and Robert Sts., St. Paul, Minn., 1863; not listed in 1864; listed under Allen Swain, 130 3d St., St. Paul, 1866–71. CD.

Swanell, C. R. Tintypist. Gallery located at 483 Fulton St., Brooklyn, N.Y., c. 1874. C.d.v.

Taylor & Co. Tintypists. Gallery located at 150 Fulton Ave., Brooklyn, N.Y., c. 1868. C.d.v.

Teller, Charles W. Ambrotypist, tintypist, photographer. Gallery located at 78 Water St., corner of 3d St., Newburgh, N.Y., 1858–60. CD.

Tennant & Maurice. Tintypists. Gallery located at 311 N. 4th St., St. Louis, Mo., c. 1865. C.d.v.

Thomas, Alexander. Afro-American ambrotypist, tintypist, photographer. Spent early youth in New Orleans in lucrative trade of "steamboating" (working on a boat equipped for taking photographs). Associated with James P. Ball, daguerreotypist, Cincinnati, Ohio, 1852. Married Elizabeth Ball, sister of J. P. Ball. Listed as Ball & Thomas, 120 W. 4th St., Cincinnati, 1854–58. Member of black high society in Cincinnati. SBD (1852); *Southern Pictorial Advertiser* (1858); Wendell P. Dabney, *Cincinnati's Colored Citizens* (Cincinnati, Ohio: Dabney Publishing, 1926); information also furnished by Romare H. Bearden and James de T. Abajian. *See also* Ball, J. P.; Ball, Thomas C.

Thomas, Wm. C. Tintypist. Gallery located at Perkins Block, Clyde, N.Y., 1870. C.d.v.

Thompson, S. J. Daguerreotypist, tintypist, photographer. Active in Albany, N.Y., 1850–60. Nsp, 1850; *DJ;* CD; *HJ. See also* Estabrooke & Thompson

Thompson's Ferrotype Gallery. Tintypist. Gallery located at 305 Main St., Poughkeepsie, N.Y., c. 1864. C.d.v.

Thorn, Guillermo. Tintypist, photographer. Born Catskill, N.Y., 1836; died Plainfield, N.J., March 12, 1920. Moved to Plainfield in 1861, where he continued in

business until 1908. One of the first to use the tintype. *Bulletin of Photography* (1920).

Tinsley, J. W., and Tinsley, F. R. Tintypists. Gallery located at 136 S. Clark St., Chicago, c. 1865. C.d.v.

Trask, Albion K. P. Daguerreotypist, tintypist, photographer, author. Born Bangor, Maine, 1830; died 1900. Began photographing about 1858. Gallery located in Philadelphia from 1865. His gallery skylight was illustrated in *APB* in 1871 and was used at sessions of the National Photographic Association in Philadelphia in the same year. Author of *Practical Ferrotyper,* 1872. Retired in 1890. *APB* (1871); *Wilson's Practical Photographic Magazine* (1900). C.d.v. *See also* Trask & Marston

Trask, M. G. Tintypist, photographer. Active in Bangor, Maine, c. 1863–78. *PP* (1869); *SV.* C.d.v.

Trask & Marston. Tintypists. Gallery located at 40 N. 8th St., Philadelphia, 1860s. C.d.v. *See also* Trask, Albion K. P.

Tubbs, Andrew B. Daguerreotypist, tintypist, photographer. Born 1801. Employed by George W. Collomar, Harrisburg, Pa., 1850; listed in Covert, N.Y., 1867, and in Harrisburg, Pa., c. 1858. USC; CD. Tintype, c. 1858, courtesy of George Whiteley IV.

Tull, B. H. Tintypist. Active in Lena, Ill., 1870s. Sales catalogue.

Tyson Bros. (Isaac G. and Charles J.). Ambrotypists, tintypists, photographers. Advertised melainotypes. Operated Excelsior Gallery, northeast corner of Sq., Gettysburg, Pa., 1859. Took 8" x 10" views of Gettysburg battlefield several days after the battle, as well as stereo views of the area (c. 1863–65). In 1865 Charles sold out to Isaac, who changed gallery's name to "Isaac G. Tyson, successor to the Tyson Brothers." Moved to Philadelphia, late 1866. In December 1866 Charles bought the business back from Isaac, and in October 1868 he sold out to his assistants, Robert Myers and William H. Tipton. BD; William A. Frassanito, *Gettysburg: A Journey in Time* (New York: Charles Scribner's Sons, 1975), 41–46.

*Upson, Jefferson T. Daguerreotypist, ambrotypist, tintypist, artist. Active in Buffalo, N.Y., 1857. First prize at fair, Buffalo, 1861; listed at 324 Main St. in Buffalo, 1862–65. CD; NYHS.

Vance, Robert H. Daguerreotypist, ambrotypist, tintypist, and photographer. Born 1824; died New York City, 1876. Galleries in San Francisco, Sacramento, and Maryville, Calif. Took three hundred or more scenes of gold mining camps and views of California, etc. Sold collection to J. Gurney, 1852. Gallery at Kearny and Commercial Sts., San Francisco, 1852; corner of Montgomery and Sacramento Sts., 1855. Operator, before 1857, S. P. Howes. Held Cutting's patent for ambrotypes. Won all prizes for photographs at the state fair, Stockton, 1857; opened new gallery with eight reception rooms and twelve operating rooms, 1859. Sold gallery to Charles L. Weed, 1861. Gallery at 1 North D, Virginia City, Nevada, 1863; "Picture Gallery" with Frank G. Ludlow, Carson City, at the corner of Ormsby and 2nd, 1863; 4th North F, Virginia City (listed R. H. Vance daguerrean rooms), 1864. No listing, 1868. Left California, 1865. CD; *HJ;* BN; *AJP*; BD; *PAJ* (1857). *See also* Fitzgibbon, John H.

Van Ogden, ——. Tintypist. Active in Chicago, 1870s. Sales catalogue.

Vose, S. S. Tintypist. Gallery located on Madison St., Skowhegan, Mass., c. 1875. Bon-ton.

Wagner, Frederick, & Son. Gallery located at 63 W. Baltimore St., Baltimore, Md., n.d. Sales catalogue.

*Waldack, Charles. Ambrotypist, photographer, painter, author. Born in Belgium; died December 31, 1882, in Ghent. Gallery located at 31½ W. 3d St., Cincinnati, Ohio, 1857. Traveled to Europe with photographer John Carbutt, 1862. First to photograph interior of Mammoth Cave, Kentucky, by magnesium light, 1866. Active in Cincinnati from 1868 on. Wrote *A Treatise of Photography on Collodion* with Peter Neff Jr. in 1857. RT, 285, 493; *SV; PP* (1868); *HJ;* CD; *APB* (1883).

Walzl, Richard. Tintypist, photographer. Died in Baltimore, Md., May 10, 1899. Active in Baltimore from 1860 to the 1880s. Wrote "The Ferrotype Picture" for *Photographer's Friend.* Gallery located at 205 W. Baltimore St. in 1883 was described as huge—30' x 200'—and decorated in black and gold with a number of rooms. *BJP* (1871); *Photographic Times and American Photographer* (1883); Nsp.

Ward, Charles E. Tintypist. Gallery located on Franklin St. opposite City Building, Schenectady, N.Y., c. 1888. Bon-ton.

Warren, Joseph W. Ambrotypist, tintypist, photographer. Gallery located at 36 S. Main St., Fall River, Mass., 1866–69. CD.

Wasson, ——. Tintypist. Gallery located at 73 Fulton Ave., Brooklyn, N.Y., 1866. C.d.v.

Wearn, Richard. Daguerreotypist, ambrotypist, tintypist, photographer. Died 1874, Columbia, S.C. Active 1856–74; awarded four prizes at the South Carolina Fair (in 1856, 1857, and 1858). Gallery located at 170 Richardson St., Columbia, 1861. Advertised ambrotypes, melainotypes, stereoscopes, photographs plain, oil, water, or pastel. Prices ranged from one to one hundred dollars. Opened new gallery, Wearn & Hix, in 1873. CD; *PP;* Nsp.

*Webber, Charles T. Artist and photographer. Portrait, historical, and landscape painter and sculptor. Born December 31, 1825, Cayuga Lake, N.Y. Moved to Springfield, Ohio, in 1844, and to Cincinnati in 1858, where he spent the remainder of his life. Organizer of McMickin School of Art; charter member of Sketch Club (1869), Art Club (1890). Webber and Joseph Eaton traded as "Artists Photographic and Picture Gallery," offering daguerreotypes, ambrotypes, melainotypes, and photographs, at 106 4th St. in Cincinnati, 1861–62. CD; NYHS. *See also* Eaton, Joseph Oriel

Weeks, R. E. Daguerreotypist, ambrotypist, tintypist, photographer. Gallery located at 145½ Water St., Sandusky, Ohio, 1855, and over Old's Book Store in Sandusky, 1858. Still listed in Sandusky, 1869. CD; *PP* (1869).

*Wenderoth, Frederick A. Artist, photographer on glass and paper, inventor. Born c. 1824, Hesse Cassel, Germany; died 1884. Studied painting with Frederick Mueller at the Academy of Fine Arts in Hesse Cassel. Went to Paris in 1846 to continue studies, where he was taught by Leon Coignet until the revolution of 1848. Arrived in New York City in 1849; painted pictures for the Art Union until 1851. Traveled in several states and in Central America, the South Sea Islands, and Australia. In 1854 became partners with Charles C. Nahl, a painter living in San Francisco. (Nahl was from the same region of Germany as Wenderoth.) In January 1857 Wenderoth, with the photographer Jesse Bolles, took all prizes in all categories of photography at the Charleston Fair of the South Carolina Institute. Moved to Philadelphia in 1858 and went into partnership with Samuel Broad-

bent. Engaged in introducing the "ivorytype," an exquisite color photograph on glass. Invented a "photozincographic process" and made other improvements in photography. Well known for his painting of the Battle of Gettysburg. Wrote for *BJP* during the 1860s. Exhibited zincographs at the 1876 Centennial. *BJP* (1872); CD; *PAJ* (1857); NYHS (the artists listed as August Wenderoth and Frederick A. Wenderoth in NYHS are the same person); *Photographic Mosaics.*

Wenderoth & Bolles. Ambrotypists, tintypists, photographers. Gallery located at 281 King St., Charleston, S.C., 1857. Advertised melainotypes and ambrotypes in color among their offerings. Nsp, March 10, 1857. *See also* Wenderoth, Frederick A.

Whitman, J. Tintypist, photographer. Operated floating gallery *Baltimore* named after his home city. Made many portraits of blacks and many landscapes. *APB* (1876).

Wide Awake Gallery. Tintypists, photographers. Gallery located between 19th and 20th Sts., New York City, 1860s. Gem card.

Williams, ———. Tintypist. Active in Somerset, Pa., c. 1876. C.d.v.

Wilson, Jerome N. Tintypist, photographer. Born 1829 in New York City. Gallery located at Whitaker and Broughton Sts., 1865; corner of Bull and Broughton Sts., 1866; southeast corner of Whitaker and Broughton Sts., 1867–77; and 21 Bull St., 1877–78, all in Savannah, Ga. Did business at 149 Broughton St. as Wilson & Vaughn from April 1879 until 1882. Worked alone at 21 Bull St., 1882–84. Last listed as photographer in Savannah in 1896. USC; CD; Nsp.

Winchester, Daniel D. Daguerreotypist, ambrotypist, tintypist. Gallery located on High St., Columbus, Ohio, 1853–57. Advertised melainotypes in 1856. SBD; CD.

Winder, J. W. Photographer, tintypist. Gallery located in Cincinnati, Ohio, at 373 Central Ave., 1861; at 160 5th St., c. 1867; and at 142 4th St., sometime in the 1860s. CD. C.d.v.

Wing, Simon. Daguerreotypist, photographer, tintypist, inventor. Active as daguerreotypist in Waterville, Maine, 1855. Listed at 144 Washington St. and 4 Summer St., Boston, c. 1863. Obtained several patents: Nos. 30,850 and 78,408, issued December 4, 1860, and May 26, 1868, were for a photographic camera; no. 40,302, issued October 13, 1863, was for photographic card mounts. BD; SBD; *PP* (1869); U.S. patent records. C.d.v.

Wood, John H. Tintypist, photographer. Born 1829; died August 15, 1900. Gallery located at 496 Broadway, Albany, N.Y., 1860s. Nsp. C.d.v.

Woodworth's Superior Gems. Tintypist. Gallery located at 444 Broadway, Albany, N.Y., c. 1867. Advertised gem cards for twenty-five cents a dozen; "Orientals," four for twenty-five cents; bon-tons, twenty-five cents each. C.d.v.

Wormel, E. S. Tintypist. Gallery located at 316 Congress St., Portland, Maine, c. 1868–69. *PP* (1869). C.d.v.

Young, J. M. Daguerreotypist, tintypist, photographer. Daguerreotypist in 1850s at 145 8th Ave., near 17th St., New York City. Listed in 1858 at three locations in the city—198, 145, and 418 2d St. OSU; CAS.

SELECT BIBLIOGRAPHY

Ades, Dawn. *Photomontage.* London: Thames and Hudson, 1976.

Beaton, Cecil. *British Photographers.* London: William Collins, 1944.

Black, Alexander. *Photography Indoors and Out: A Book for Amateurs.* Boston: Houghton, Mifflin, 1898.

Black, Mary, and Jean Lipman. *American Folk Painting.* New York: Clarkson N. Potter, 1966.

Blodgett, Richard. *Photographs: A Collector's Guide.* New York: Ballantine Books, 1979.

Bowen, Catherine. *Yankee from Olympus.* Boston: Little, Brown, 1945.

Burgess, Nathan G. *The Photograph Manual.* New York: D. Appleton, 1863.

Card, James. *Seductive Cinema: The Art of the Silent Film.* New York: Alfred A. Knopf, 1994.

Caring for Photographs: Display, Storage, Restoration. New York: Time-Life Books, 1972.

Chapnick, Howard, ed. *The Illustrated Leaves of Grass by Walt Whitman.* New York: Grosset and Dunlap, 1972.

Coe, Brian. *Cameras: From Daguerreotypes to Instant Pictures.* New York: Crown Publishers, 1978.

———. *Colour Photography: The First Hundred Years, 1840–1940.* London: Ash & Grant, 1978.

Collins, Kathleen, ed. *Shadow and Substance: Essays on the History of Photography.* Bloomfield Hills, Mich.: Amorphous Institute Press, 1990.

Crawford, William. *The Keepers of Light: A History and Working Guide to Early Photographic Processes.* Dobbs Ferry, N.Y.: Morgan & Morgan, 1979.

Crow, Duncan. *The Victorian Woman.* London: George Allen & Unwin, 1971.

Dody, Robert, ed. *Photography in America.* New York: Random House, A Ridge Press Book, 1974.

Eder, Josef Maria. *History of Photography.* Translated by Edward Epstean. 1945. New York: Dover, 1978.

Estabrooke, Edward M. *The Ferrotype, and How to Make It.* Cincinnati: Gatchel & Hyatt, 1872.

Faithful, Emily. *Three Visits to America.* New York: Fowler & Wells, 1884.

Gagel, Diane VanSkiver. *Ohio Photographers, 1839–1900.* Nevada City, Calif.: Carl Mautz Publishing, 1998.

Gassner, John, ed. *Best Plays of the Early American Theatre: From the Beginning to 1916.* New York: Crown, 1967.

Goldberg, Vicki. "Social Climbing Tintypes, Yearning to Be Paintings," *New York Times,* August 1, 1993.

Goldsmith, Arthur. *The Camera and Its Images.* New York: Newsweek Books, A Ridge Press Book, 1979.

Green, Jonathan, ed. *The Snap-Shot.* Millerton, N.Y.: Aperture, 1974.

Griswold, V. M. *A Manual of Griswold's New Ferro-Photographic Process for Opal Printing on the Ferrotype Plates.* Peekskill, N.Y.: Author, 1866.

Guimond, James. *American Photography and the American Dream.* Chapel Hill: University of North Carolina Press, 1991.

Heighway, W. "The Ferrotype—How It Is Made." *St. Louis Practical Photographer* 5 (1881): 81.

Hill, Levi L. *A Treatise on Heliochromy; or, The Production of Pictures, by Means of Light, in Natural Colors.* 1856. Facsimile edition with introduction by William B. Becker. State College, Pa.: Carnation Press, 1972.

Hulick, Diana Emery, and Joseph Marshall. *Photography 1900 to the Present.* Upper Saddle River, N.J.: Prentice Hall, 1998.

Hunt, Robert. *A Manual of Photography.* London: Richard Griffin, 1854.

Jenkins, Reese V. *Images and Enterprise: Technology and the American Photographic Industry, 1839 to 1925.* Baltimore: Johns Hopkins University Press, 1975.

Jensen, Oliver, ed. *American Album: How We Looked and How We Lived in a Vanished U.S.A.* New York: American Heritage Publishing Co., n.d.

Jones, Bernard E., ed. *Cassell's Cyclopaedia of Photography.* London: Cassell and Co., 1911.

Kuhnhardt, Dorothy Meserve, and Philip B. Kuhnhardt Jr. *Mathew Brady and His World.* Alexandria, Va.: Time-Life Books, 1977.

Miyake, Notch, Mark Osterman, and Roger Watson. *Wet Plate Collodion Workbook.* Rochester, N.Y.: George Eastman House International Museum of Photography and Film, 1996.

Newhall, Beaumont. *The History of Photography.* New York: Museum of Modern Art, 1982.

Ostroff, Eugene. *Western Visions and Eastern Views.* Washington, D.C.: Smithsonian Institution, 1981.

Pearsall, Ronald. *The Worm in the Bud: The World of Victorian Sexuality.* Harmondsworth: Penguin Books, 1983.

Reilly, James M. *Care and Identification of Nineteenth-Century Photographic Prints.* Rochester, N.Y.: Eastman Kodak Co., 1986.

Rinhart, Floyd, and Marion Rinhart. *The American Daguerreotype.* Athens: University of Georgia Press, 1981.

———. *American Miniature Case Art.* New York: A. S. Barnes, 1969.

———. *America's Affluent Age.* South Brunswick, N.J.: A. S. Barnes, 1971.

———. *Summertime: Photographs of America at Play, 1850–1900.* New York: C. N. Potter, 1978.

Rivington, W. J., and W. A. Harris. *Reminiscences of America in 1869 by Two Englishmen.* London: S. Low, Son, and Marston, 1870.

Ryder, James F. *Voightlander and I: In Pursuit of Shadow Catching.* Cleveland: Cleveland Printing and Publishing Co., 1902.

Sobieszek, Robert, ed. *The Collodion Process and the Ferrotype: Three Accounts, 1854–1872.* New York: Arno Press, 1973.

Szarkowski, John. *Looking at Photographs.* New York: Museum of Modern Art, 1973.

Taft, Robert. *Photography and the American Scene: A Social History, 1839–1889.* New York: Macmillan, 1938. Reprint, New York: Dover, 1964.

Waldsmith, John. *Stereo Views: An Illustrated History and Price Guide.* Radnor, Pa.: Wallace-Homestead, 1991.

Welling, William. *Collector's Guide to Nineteenth-Century Photographs.* New York: Collier Books, 1976.

Witkin, Lee D., and Barbara London. *The Photograph Collector's Guide.* Boston: New York Graphic Society, 1970.

In addition to the sources listed above, many websites on the Internet offer information on contemporary sources, dealers, collectors, reproduction prices, and so on.

INDEX